LOST

FARMS AND ESTATES
OF WASHINGTON, D.C.

LOST
FARMS AND ESTATES
OF WASHINGTON, D.C.

Kim Prothro Williams

THE
History
PRESS

Published by The History Press
Charleston, SC
www.historypress.net

Front cover, top: 1830 Watercolor of "Gisborough." *George Washington University Museum, The Albert H. Small Washingtoniana Collection, AS 2016.21*; *bottom*: The Ruppert Farm in today's Petworth neighborhood. *Historical Society of Washington, D.C.*
Back cover, top: Camp Brightwood. *Courtesy of the Library Company of Philadelphia*; *bottom*: 1839 Watercolor sketch by Augustus Kollner, *One Mile from Washington City Hall. Library of Congress, Prints and Photographs Division.*

First published 2018

Manufactured in the United States

ISBN 9781625858306

Library of Congress Control Number: 2017963228

This book is dedicated to historic preservationists everywhere

Contents

CONTENTS

FOREWORD

The city of Washington is widely known as a planned national capital whose form expresses the structure of American government and the aspirations of the American people. Its national monuments and civic landscapes are not only familiar but also officially recognized and protected by both national and local historic preservation laws. Much less familiar is the story of local Washington, the home of those who have made their livelihoods here. Until well into the twentieth century, this included not just the residents of the capital city but also the inhabitants of the countryside outside the city limits yet within the boundaries of the District of Columbia. Most of the farmsteads and country estates in that once rural landscape have long since disappeared, as the modern metropolis has sprawled far beyond the District lines. But traces of it do remain. Those who are curious and observant enough can pick out the bits of old country lanes quietly snaking through the city's street grid and the occasional odd old house, sometimes sitting askew from its neighbors, that seems to come from a different age.

Even those of us engaged in serious study of the city have never quite known the full story of these ghosts from another world, but in this book Kim Williams returns them to life. She set about this study somewhat by chance, when investigating the origins of a springhouse near Rock Creek Park. Searching old maps and archives, she discovered the connection between the springhouse and its original owners, whose farmhouse still remains, now lost many blocks away in the midst of a typical Washington neighborhood. The open farmland that once united these buildings is long gone and with it all

sense that the buildings have anything to do with each other. It is impossible to understand their common origin by reading the city fabric alone.

This book is not just a fascinating story of how the nation's capital grew, managed to feed itself and landscaped its parks and gardens. It reminds us of the dependence on enslaved labor and the devastation and personal cost of the Civil War. It introduces us to the everyday workings of a world of struggling farmers and prosperous businessmen, of prize livestock and hybrid plants, of Sunday outings in the country and of advertising and mortgages and lawsuits that seems more like our own once it becomes more familiar.

This study is also the means of survival for the rare structures that remain as evidence of a country life transformed by that war, even as it continued for decades afterward. Of well over 100,000 buildings in the District of Columbia, only a tiny fraction built before 1865 still survive. Most of these are in Georgetown and on Capitol Hill, the city's oldest neighborhoods, which are protected as historic districts. Fewer than 50 remain from the former Washington County, the countryside outside the original city. Many of those, especially the large estate houses, are designated historic landmarks. But those structures tell a one-sided story of rural life, leaving out the many modest farm families, butchers and field hands who sustained life in the capital. This study has already led to the designation of a handful of modest country homes as historic landmarks, and should lead to the protection of others, thereby ensuring that the stories and the lives they record will not be forgotten.

—DAVID MALONEY
State Historic Preservation Officer
for the District of Columbia

PREFACE

I f one were asked to describe Washington, D.C., the word *rural* would not come to mind. Yet, like all of America, the District of Columbia was rural before it became urban, and it remained so, in places, for the next 150 years. So, this book is about that rural Washington. It is a broad-based story that spans the immediate period before the city's establishment in 1791 through its urbanization and suburbanization and is told, for the most part, through buildings. Some of these buildings represent the city's oldest and most celebrated landmarks that have long been appreciated and preserved within the city's cultural landscape. Other buildings associated with the city's rural past are much lesser known or are unrecognized, while still others have only recently been discovered. One such discovery—that of a stone springhouse—is ultimately what led to this book. Located on the present site of the Lowell School on upper Sixteenth Street, the springhouse was originally part of a 125-acre, mid-nineteenth-century farm, and as with many landscapes, this one had a story to tell. Built around 1855 by farmer and slave owner Phillip Fenwick, it was a rare survivor as one of only two other springhouses in the city. But I wondered, if this springhouse had remained obscure for so long, what other resources might also survive that could similarly contribute to the narrative of rural Washington?

My curiosity piqued, I encouraged the Historic Preservation Office to undertake a comprehensive architectural survey of surviving rural buildings in the District of Columbia. The study began in a conventional manner with a systematic comparison of historic and current-day maps to aid us

in identifying extant buildings that had been part of the District's rural countryside. While we were looking at maps, we also examined local histories of the city's many neighborhoods, reviewing the documents for information on farms and estates and cross-checking that information with the map findings. This process helped to identify several buildings that had escaped the map study, such as those buildings that had been moved from one site to another in their histories, which it turns out was a common phenomenon. Using this approach, we identified approximately eighty-four buildings that were once part of a rural Washington landscape. An annotated list of those buildings forms the appendix of this publication.

This list is a mere fraction of buildings that once made up the agrarian landscape. The buildings do not begin to represent all the different types of agriculture-related buildings that historically dominated the countryside, nor do they represent all phases of the city's rural legacy. But together, the buildings, their individual ownership histories and their relationships to one another present a fairly comprehensive understanding of rural Washington. And they, along with demolished ones, have provided a framework around which this narrative has been written.

The book is divided into eight chapters that follow three major moments in history that contributed to the transformation of rural Washington: the establishment of the federal city, the Civil War and suburbanization. The first chapter provides an overview of the seventeenth- and eighteenth-century cultural landscape that defined the area that would become the District of Columbia. Chapters 2 and 3 describe the houses of the original city proprietors and those planters who controlled much of the land just outside the federal city proper. Chapter 4 is dedicated to the gentlemen farms and country estates that emerged on the city's outskirts in the early nineteenth century when the federal government moved to the fledgling city, bringing with it politicians, businessmen, entrepreneurs and people of wealth who introduced the ancient tradition of the country retreat to the city's rural landscape. Chapters 5 and 6 present a picture of rural Washington's quiet years of when small and large farmsteads dominated the landscape and served as the growing city's source of food during the first half of the nineteenth century. Chapter 7 illustrates how in the name of war, the defenses of Washington completely transformed the rural countryside, destroying many of the farmsteads and the farmers' lives and livelihoods. The last chapter addresses the progressive elimination of farming from the landscape due to suburbanization.

Despite the complete eradication of farming by the mid-twentieth century, evidence of rural Washington abounds in its historic country homes and surviving farmhouses, in its few remaining domestic and agricultural buildings and most of all in its open spaces. The many parks, educational and institutional campuses, cemeteries, military bases, public works facilities and other open landscapes were all the sites of former farms and fields and often bear their names in some capacity. Whether obvious or not, these are all remnants of rural Washington, and together they contribute to the exceptional character of this City of Trees.

Acknowledgements

M any people have contributed to this book, but the idea and its contents largely stem from an historic architectural resources survey of D.C.'s farms and estates conducted by the D.C. Historic Preservation Office (HPO) under the guidance and leadership of State Historic Preservation Officer David Maloney. David, who also wrote the foreword to this book, committed staff time and other resources to undertake this city-wide survey in-house to identify surviving buildings, structures and objects associated with the city's rural past and to develop a historic context for evaluating the identified properties for historic designation and preservation protection. My fellow HPO colleagues, historians Tim Dennée and Patsy Fletcher, contributed their expert research skills to the project, including Dennée's fascinating and invaluable analysis of a Civil War circular on farmhouses in the District that he discovered while researching the history of a pre-Civil War farmhouse. Mapmaker Brian Kraft built a map of the surveyed sites, illustrating the geographic breadth and range of rural resources still standing. Student interns Molly Hutchings and Courtney Ball spent their summers combing the local archives for primary source documents and traversing the city to conduct site visits and take photographs. I appreciate the excellent research and commitment of all of those who supported and participated in the survey effort.

I am particularly grateful to the many archivists and librarians in D.C. who have taken an interest in this publication and who have helped me locate and secure images to illustrate the book. Special thanks goes out to

everyone at the Historical Society of Washington, especially Library and Collections Director Anne McDonough and Research Services Librarian Jessica Smith; and to Derek Gray at the Washingtoniana Division of the Martin Luther King Jr. Memorial Library. I am indebted to James Goode not only for his past scholarship but also for sharing his deep knowledge of graphic images associated with Washington and for providing me access to the B.F. Saul Company's private collection and the Albert Small Washingtoniana Collection. Ann Dobberteen and Tessa Lummis at the Albert Small Collection have been most generous in accommodating my particular requests.

I have benefitted tremendously from all of the research and published works on early Washington by our local community of historians, including scholars Pam Scott, Don Hawkins, Kenneth R. Bowling, Priscilla W. McNeil, and many others, including Laura Henley for her excellent research and PhD dissertation from Catholic University, "The Past Before Us: An Examination of the Pre-1880 Cultural and Natural Landscape of Washington County, Washington, D.C." I also want to acknowledge the excellent research and depth of knowledge of the District's amateur historians and local preservationists who have researched the history and built environment of their own neighborhoods and communities. Research by the Tenleytown Historical Society to identify and document the pre-subdivision houses of Tenleytown was an inspiration for me for the city-wide survey of farms and estates and ultimately for this publication.

I am truly grateful to my readers Pam Scott, Joey Lampl, Tim Dennée, Matthew Gilmore and Amanda Phillips for their critical readings of portions of the text, reorganizational suggestions and written contributions but am most indebted to my reader and editor, Anne Rollins. Anne's knowledge of Washington history, insightful inquiries and editorial commentary were critical to me in the writing and editing process, and she was instrumental in helping me develop a narrative out of the compiled bits of information.

A big thanks goes to my friends and family who have endured my singular preoccupation with this book for the past year. Thanks especially to Dianna, Sarah and Sheila, who on a lovely afternoon on a porch in the Bahamas helped me push through some writer's block by letting me tell the story that I was trying to write and offering suggestions to help me get it from head to paper. Thanks also to my husband, Richard, who contributed important insights on how to present the content within a broader historical perspective and throughout the process figured out when to leave me to my writing

and when to pull me away from the computer screen and to my twenty-something children: Katie, for her consistent enthusiasm, encouragement and contributions, and Jamie, for being a fun home companion these past few months during a time of transition from college to the real world. Thanks everyone!

1

FROM FARMS TO

FEDERAL DISTRICT

*This country, intended for the permanent residence of Congress, bears no more
proportion to the Country about Philadelphia, and German-Town, for either
wealth or fertility, than a Crane does to a stall-fed Ox!*
*—excerpt from a letter from surveyor Andrew Ellicott to his wife,
Sarah Ellicott, June 26, 1791*

Writing to his wife, Sarah, about the land that would become the seat
of the federal government in June 1791, surveyor Andrew Ellicott
cautioned her to keep his musings private. After all, his employer,
President George Washington, had personally selected the site, which was
close to his own home and heart. And in spite of Ellicott's sentiments about the
future District of Columbia, the site at the confluence of the Potomac River
and the Eastern Branch (today's Anacostia River) had much to recommend
it. Located just below the fall line of the Potomac at a time when commerce
and trade were dominated by river travel, its topography ranged in elevation
from forty to three hundred feet, varying from coastal plain to Piedmont
plateau, offering river access below and cooler, clear air above. There was
a diversity of mineral deposits, including the famous quarries of soapstone
and granite that had been worked by Native Americans before white settlers
arrived and would be used to build the city in years to come. The water
supply was excellent. Rock Creek, then wide and deep, was navigable to
sailing vessels from its broad harbor at the Potomac up to and beyond K
Street, where wharves lined the creek's eastern bank. Numerous streams and

area springs offered an abundant supply of drinking water. The mostly rural land was both heavily forested and farmed, and although the cultivation of tobacco had taken its toll on the soil, the land was still rich in resources.

By 1791, Native Americans who had fished and hunted in the region had long been pushed out by European settlers. The maps and writings of Captain John Smith, who first explored the area around the Potomac River in 1608, document his team's encounters with the Nacotchtank, an Algonquin-speaking tribe with a large settlement of the same name located at the confluence of the Anacostia and Potomac Rivers. The Algonquins and other indigenous people who preceded them had inhabited the region for at least thirteen thousand years. But by the late seventeenth century, within a single generation of white settlement, the native peoples had been displaced or decimated by disease and warfare. Although they were no longer present when white settlers moved into the region in the early eighteenth century, they left behind the remains of vibrant villages, cultivated fields and other evidence of their long residency in the region known to us through archaeological excavations, the first of which were undertaken in the late nineteenth century and the most recent of which are underway today.

The boundaries of the ten-mile square area chosen by the president for the new federal territory, later named the District of Columbia, incorporated portions of the Virginia and Maryland countryside on either side of the Potomac and Anacostia Rivers. On the Maryland side, the District encompassed vast acreages of forests and farms, the thriving port town of Georgetown—an official Maryland tobacco inspection station—and the small crossroads community of Tennally's Tavern. Located at the intersection of the Road to Frederick (today's Wisconsin Avenue) and the new-cut River Road, the tavern, run by John Tennally, proved to be a convenient and popular stopping place for travelers and traders coming and going to the port town from the Maryland countryside, prompting the growth of the small rural village. In addition to these active trading centers, the new federal territory included the two largely unbuilt and uninhabited towns of Hamburgh and Carrollsburg, platted in 1770. Hamburgh, overlooking the Potomac on the site of today's Foggy Bottom, and Carrollsburg, set above the Anacostia in the city's present-day Southwest neighborhood, were both laid out by landowners whose vision to capitalize on the busy eighteenth-century river traffic never materialized much beyond their paper plats.

The Virginia side of the Potomac River comprised the competing and bustling port town of Alexandria and outlying farms and plantations. In 1846, however, Congress allowed the retrocession of this land to Virginia,

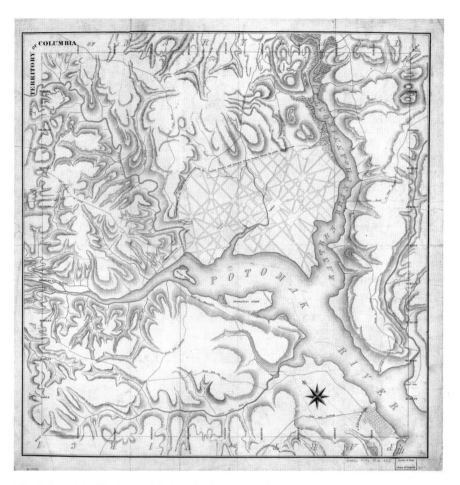

The "Map of the Territory of Columbia" by Andrew Ellicott, 1794, shows the ten-mile square boundary of the federal district with Washington City at its geographic center. *Library of Congress, Geography and Map Division.*

removing thirty-one of the one hundred square miles from the District of Columbia and establishing the river as the southern border. In so doing, Congress ceded its oversight of Alexandria's lucrative slave trade and enabled those Virginia residents to regain the important right to vote. Because of this early removal, the history of the rural landscape in Virginia is not considered here.

The Maryland landowners who were swept up into the District of Columbia were second- and third-generation men, often descended from those who had received land grants in the Upper Potomac region in the

latter half of the seventeenth century. Those original grantees were generally influential persons of wealth or societal merit, tobacco planters and merchants. They were typically absent, employing managers to reign over their planted tobacco fields and oversee their enslaved laborers while they remained on their principal holdings in the Tidewater region or western shore of the Chesapeake. These property owners would often sell off or lease out small tracts of their vast holdings to tenant farmers for income. While the sale of land offered immediate financial returns, long-term leases held other advantages for the landholder: tenants would be required to make improvements during their rental period such as clearing acreage, planting fruit orchards and fencing fields. When the leases expired, the landowners could take over already cleared and partially cultivated land.[1]

Over the course of the next century, the sparsely settled lands in the region became more densely inhabited. By the mid-eighteenth century, descendants of the original owners, their tenants and freeholders or yeoman farmers—those who owned their own farms, having purchased tracts of land that had originally been part of the larger land grants—occupied the land. The farms extended along and well beyond the rivers' edges, but most were accessible to Georgetown, a thriving tobacco inspection and shipping port established in 1751. Georgetown's tobacco factors—merchants who accepted tobacco as currency (hence the phrase *cash crop*)—operated stores in the port town, serving the area's large planter and poorer tenant alike. The factors stocked imported and other goods that customers could buy using currency or tobacco—but often at favorable prices for tobacco—and even on consignment, when purchases were delayed until the next harvest. The boundaries of the District of Columbia had largely been determined to include the thriving seaport town because its tobacco trade had already created a strong commercial presence on the Potomac River. As the population of the town multiplied beyond the wharves, so did the farms in the surrounding countryside.

> "Mr. John Bradford in Prince George's will shew… and agree upon the Terms, with any who desire to take leases.…I will take the Rent in Tobacco, Corn, Wheat, or other Product of the Land, which the Tenants can best spare, at the Price current, and give a reasonable Time for Making necessary Improvements."
>
> —*Maryland Gazette* advertisement, 1729

Together, the planters, tenants and freehold farmers lived on adjacent but dispersed plots of land, separated from one another by cultivated or fallow fields and woodlands. The 1798 federal direct tax records suggest that these owners built dwellings, barns, stables and domestic necessaries such as kitchens, smokehouses and springhouses, generally clustered together around the main living quarters. The wealthier among these farmers may also have had separate quarters for their enslaved laborers, but it was more common that those held in bondage would have lived under the same roof as their owner. Stately and sometimes ornate brick dwellings that compared to the plantation residences of the Tidewater region were rare. More often, the landowners—whether wealthy planter or freehold farmer—lived in more modestly scaled dwellings. These were typically wood frame houses, one and a half story tall and one room deep, often with high, pitched gable roofs that provided loft levels for sleeping. Owners of lesser means lived in one- or two-room cabins of log, wood frame or, more rarely, of stone.

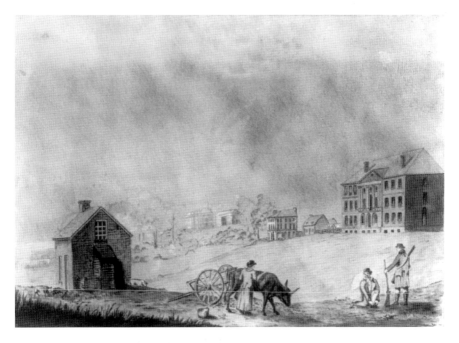

Nicholas King's "Pastoral View of Washington," circa 1803, captures a typical farmhouse of the period, with pigs and ox-drawn cart in the foreground and the President's House and Blodgett's Hotel in the background. *Library of Congress, Prints and Photographs Division.*

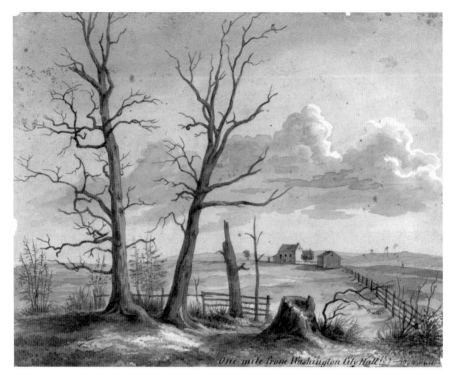

A watercolor sketch by Augustus Kollner, "One Mile from Washington City Hall," 1839, depicts the rural cultural landscape just beyond the center of the city. *Library of Congress, Prints and Photographs Division.*

Within months of selecting the site in 1791, the president hired surveyors Andrew Ellicott and Benjamin Banneker to survey the terrain and French engineer and architect Peter Charles L'Enfant to design the city plan in the first steps of building a city from scratch. The federal city, called Washington City, would be laid at the center of the new federal territory. It would occupy approximately six thousand acres of land between Rock Creek and the Eastern Branch. L'Enfant sited the city within a natural topographic bowl bounded by the rivers on its south and by a steep escarpment toward the north, at the base of which ran a road, the precursor of today's Florida Avenue and the edge of the original city. A series of irregular geological terraces gradually rose from the rivers to this northern rim.

At that point, there was little distinction in the cultural landscape between the land forming L'Enfant's federal city proper and the outlying lands out of which the city was carved. As the downtown city developed, however,

Sir: We have agreed that the Federal district shall be called the *Territory of Columbia* and the Federal City the *City of Washington*. The title of the map will, therefore, be, "A Map of the City of Washington, in the Territory of Columbia."

—excerpt from a letter from the District Commissioners to President George Washington, September 9, 1791

the difference between it and the rest of the land within the confines of the District of Columbia grew profound. During the first half of the nineteenth century, as the city slowly built up along the lines of the L'Enfant Plan, shedding its agrarian roots, the outlying territory saw only a gradual increase in its population and little change in its rural landscape. Change would come over the next century but in a more gradual way, allowing agriculture to persist in parts of the District well into the twentieth century.

CITY PROPRIETORS
AND THEIR HOUSES

*We, the subscribers, in consideration of the great benefits we expect to derive
from having the Federal city laid off upon our lands, do hereby agree and
bind ourselves, heirs, executors, and administrators, to convey in trust to the
President of the U.S., or Commissioners…the whole of our respective land
which he may think proper to include within the lines of the Federal city.*
—excerpt from the Proprietors' Agreement, signed March 30, 1791

In 1791, nineteen individuals—called the "original proprietors"—owned
some thirty tracts of land comprising approximately six thousand acres
that would become the city of Washington. This acreage was but a
small portion of the original one hundred square miles of the District of
Columbia and was laid out between Rock Creek and the Anacostia River,
in accordance with the L'Enfant Plan. Three commissioners, appointed by
President Washington, were empowered to purchase land, implement the
city plan and build "suitable buildings for the accommodation of Congress,
and of the President, and for the public offices of the Government of the
District of Columbia."[2] After much negotiation, and in an effort to give
the landowners a stake in the federal city and its future promise, President
Washington, at the suggestion of Georgetown businessman and proprietor
George Walker, devised a creative arrangement to acquire the land necessary
to build a city at little cost to the new government. According to the final
agreement, the proprietors would deed their land to the government while
the plan for the federal city was being prepared. Based on the completed

plan, the government would then pay the owners for that portion of their lands that was set aside for public buildings or other grounds, called reservations, while the proprietors would donate the land set aside for streets and avenues to the government. The remaining acreage would be divided into city blocks, known officially as squares, and each square would be further subdivided into lots. The government would retain title to half of these lots and return the other half to the original owners. In actuality, this plan resulted in the proprietors, together, giving away 84 percent of their lands.[3] Proceeds from the government's sale of lots would fund construction of the government buildings, as well as the improvement of streets and parks. Both the landowners and the federal government anticipated that the value of the land would increase significantly as the city developed.

Notably, the agreement allowed the proprietors to maintain possession of their "house lots," including their homes, associated buildings and family burial plots, and to retain full use of their land, "until the same shall be sold and occupied by the purchase of the lots laid out thereupon."[4] Once the plan for the city of Washington was executed, the landowners were free to sell their share of the city lots, if they chose to do so. Some, anticipating a significant return on the value of their land, were eager to agree to the deal. Others, perhaps less optimistic or more interested in farming than speculative land development, cashed in on their properties without signing the agreement. This allowed them to capitalize on an emerging market without as much risk to themselves. Speculation in the investment potential of the new city, or "Potomac Fever," as it would later be called, had begun. In one such instance, longtime owner and farmer Edward Pearce, clearly not convinced that the city might pan out as a source of revenue, sold 150 acres of his property to Samuel Davidson one week after signing the deed of trust with the government. Davidson, a Georgetown merchant eager to invest in the new city, traded a 500-acre farm that he owned on the Gunpowder River north of Baltimore, along with $6,000 in cash, for Pearce's land. Shortly after his purchase, Davidson wrote a friend in Virginia, "We are all here in very high spirits in consequence of the Grand Federal City being fixed in the vicinity of this town [Georgetown]. The commissioners and surveyors are now actively engaged in the business."[5]

The proprietors included both longtime property owners and those who had more recently acquired the land in speculation. Long-standing owners included Notley Young, Daniel Carroll of Duddington, David Burnes, Robert Peter, Anthony Holmead and brothers Abraham and William Young, as well as their sister, "the widow Wheeler," whose families had owned and

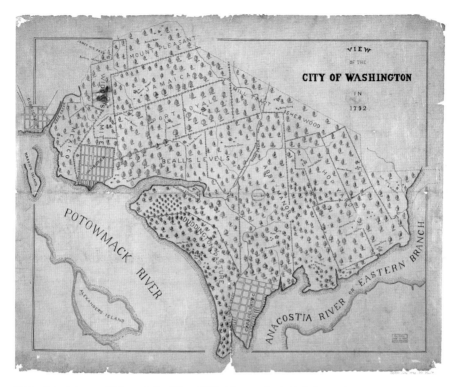

This pictorial map, "View of the City of Washington in 1792," drawn in the mid-nineteenth century, delineates the tracts of land with the names of the owners who conveyed their property to the federal government for the establishment of the federal city. *Library of Congress, Geography and Map Division.*

cultivated the land for generations before them. New investors included Georgetown businessmen Uriah Forrest and Benjamin Stoddert, George Walker and Samuel Davidson.

What we know about the built environment around 1791 is derived from the archival record, including period descriptions, maps and plats—officially recorded drawings showing boundary lines, building footprints, uses and other details. Deed and tax assessment records, images of those buildings that lasted long enough to be recorded in photographs, and plat maps drawn by city surveyor Nicholas King in the mid-1790s also help paint the picture of the area's cultural landscape before it was transformed into a city. The original city commissioners hired King in 1794 to survey the city in order to lay out its streets. In the process, King developed a set of large-scale grading plans for the city, along with plans of all of the proprietors' "mansion lots." These maps, executed in pen and ink and watercolor wash, reveal the range

Left: The "mansion lot" of proprietor Samuel Davidson, circa 1796, consisted of a log dwelling house and attached kitchen. *Library of Congress, Geography and Map Division.*

Below: The "mansion lot" of proprietor Notley Young, depicted in this plat, included Young's house, outbuildings, stables and barns, an overseer's house, two graveyards and twenty-seven log slave quarters, circa 1796. *Library of Congress, Geography and Map Division.*

of domestic complexity amid the physical landscape. At the low end of the building spectrum was the twenty-by-twelve-foot log dwelling house and attached kitchen on the property farmed by Edward Pearce before he sold it to Samuel Davidson. At the other end was the extensive plantation of planter Notley Young, which occupied a two-hundred-foot frontage along the Potomac River in the southwest quadrant of modern-day Washington.

Between signing their deeds of trust with the federal government and the full platting of the city into squares, the proprietors could remain on their land within the city limits or, if they preferred, could build new houses on lots returned to them as part of the deed agreement. Some remained in their houses and continued to farm their land, as tolerated by the federal city

commissioners who oversaw implementation of the city streets and public buildings. Other owners invested more heavily into the development of the urban structure, building new town houses for themselves on designated lots and squares that would conform to the plan for the city.

NOTLEY YOUNG'S PLANTATION

Maryland planter Notley Young had inherited his Potomac River property from his father in the mid-eighteenth century and was one of the largest landowners in what became the city of Washington. With seven hundred acres distributed across the city and more extensive tracts and farms extending into Washington beyond the planned city and neighboring Prince George's County, Maryland, Young's plantation most closely resembled the antebellum estates of the Tidewater region. The plantation, located on part of the tract of land called Duddington Pastures, was Notley Young's principal residence. It comprised much of the river's edge along today's southwest waterfront, up to the center of the city, and included a well-ordered domestic complex situated high on a bluff about thirty-five feet above the Potomac, where Banneker Overlook projects today. A two-story brick mansion dominated the site, with domestic outbuildings, stables and barns, an overseer's house, two graveyards and twenty-seven log quarters extending along the bluff. The overseer's house, located east of the main house, occupied a site within and overlooking the enclosed complex of log buildings identified as "Houses occupied by Negros," which would have housed some of the 265 enslaved persons recorded under Young's ownership by 1790 census takers. An extensive garden, highly valued by Young, spread out along the water's edge below the overseer's house, while the stables and barns were sited north of the domestic complex.

Documented through the Nicholas King plats, maps, newspaper advertisements and an early twentieth-century written account by a George Henning who had grown up in the house in the 1830s, the two-story gable-roofed brick house followed a standard four-room, central passage Georgian plan and was "finished in the most superb style."[6] Set on a half-height basement, the house measured forty-two feet by fifty-two feet, with its principal façade facing the river and a wide central corridor running through the interior from the river side of the house. According to Henning's account, the northern, landward side of the house featured a "pillared porch" with

Left: Notley Young's plantation house is shown in a detail of the 1790 "Map of the Eastern Branch of Potomac River," drawn by John Frederick Augustus Priggs. *The George Washington University Museum, Washington, D.C., AS 456 (detail), the Albert H. Small Washingtoniana Collection.*

Below: Augustus Kollner's 1839 watercolor sketch, "Tiber Creek, Mill Near Washington, North of Capitol," depicts Notley Young's mill, which stood in the vicinity of today's 100 block of L Street NE. *Courtesy of the B.F. Saul Company, Catalog No. BA 1217.*

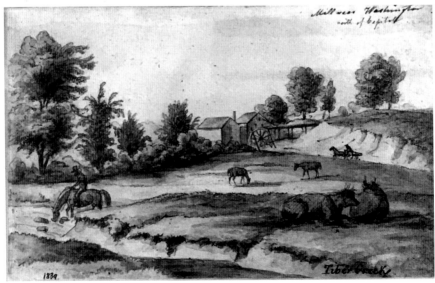

To be Sold

At Public Sale,

BY virtue of an order from the Orphan's court of Washington county, on Monday, the 26th of November next, at the Farm of the late Not. ley Young; efq. adjoining the City of Washington, a number of

Valuable Slaves,

LATE the property of the deceafed, on a credit of four and fix months, on giving notes with approved endorfers, negotiable a. the banks, and bearing intereft.

BENJAMIN YOUNG,
NICHOLAS YOUNG, } Executors
ROBERT BRENT

Octob. r 31ft, 1804.

☞ The Executors being extremely defirous to let le the affairs of the deceafed, folicit payment from thofe indebted to the eftate tdf

Left: An 1804 advertisement announces the public sale of some of Notley Young's slaves. *From the* Federalist Newspaper, *November 14, 1804.*

Below: Nonesuch, the two-story frame farmhouse of Nicholas Young, east of the Anacostia River in the vicinity of Good Hope, stood until at least 1924, when this photograph was taken. *Historical Society of Washington, D.C.*

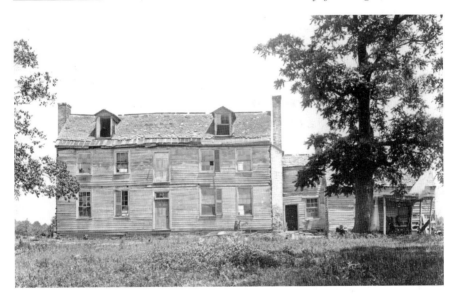

steps leading up to it; on the southern side, another porch offered wide river views that would have taken in Young's private wharf. A kitchen was located in a two-story wing that projected off of the north side of the house at its east end.

Young, whose surname was followed by "esquire" in written correspondence, appears to have been considered by the commissioners as the patriarch of the proprietors. He lived with his wife and family at his mansion house throughout the early years of the city's establishment and

continued to run his plantation, including the only mill, within its limits. Young's mill, a timber frame structure that ground wheat and other grains, stood within today's 100 block of N Street NE adjacent to Tiber Creek. The stream gathered into a pool where a millrace diverted the water to the mill.[7] To add to his holdings in the late eighteenth century, Young purchased a 150-acre tract of land on the eastern shore of the Anacostia River called Nonesuch, which he then deeded to one of his sons, Nicholas. There, Nicholas established his own plantation, building a two-story frame house and large barn and engaged the labors of his own enslaved persons for the cultivation of the land.

After Young's death in 1802 and that of his second wife and widow, Mary (Carroll), in 1815, the estate descended to Young family heirs.[8] A farm sale after Young's death advertised "a valuable stock of cattle, draft horses, hogs, sheep, farming utensils and various other articles," indicating that the family was divesting itself of the patriarch's extensive farming operations.[9] The sale of Notley's "Valuable Slaves" came two years later. Notley's son Nicholas restricted his farming to his own Nonesuch property east of the Anacostia River, where he relied on his own enslaved persons to work his fields. By the 1840s, Notley Young's mansion in Washington City had fallen into ruin and, in 1856, was demolished.

DAVID BURNES'S COTTAGE

While Notley Young's plantation house was exceptional in size and appearance, the home of David Burnes was more representative of the middling planter who occupied the upper Potomac during the eighteenth century. Described by George Washington as "the obstinate Mr. Burnes" for his hard bargaining with the president on the sale of his property to the government, Burnes had spent his adult life farming land that would make up a sizeable portion of the federal city. His land holdings, about 450 acres, extended from today's Foggy Bottom, across the White House grounds, northeast to Mount Vernon Square and south to encompass much of what would become the National Mall. Burnes's grandfather, a Scottish immigrant, had purchased this acreage in the early eighteenth century, and his father, James Burnes, had added to it. David Burnes inherited the land in 1764 and, with his wife, moved into a house on the property, erected about 1740. There Burnes began his life as a farmer, and by 1791, he had

been cultivating the land, using the labor of enslaved persons, for more than twenty-five years.

In his negotiations with the president and his emissaries, Burnes's primary goal was to reserve his right to continue his farming operations. The three city commissioners, exasperated by Burnes's persistence, described his land in fairly worthless terms, noting that six of the acres were in "timothy meadow very much grown up with sedge" and the rest was "chiefly cut down, and worn out, very much grubbed and washed. One hundred acres or more…will not bring one barrel of corn per acre."[10] But the president, fully appreciating that the worth of the land extended well beyond the value of its crops, offered Burnes additional money to sell, sealing the deal and prompting Burnes to be one of the first proprietors to sign the deed of trust with the government. This deed included an all-important clause honoring Burnes's request to continue farming: "Each proprietor shall retain the full possession and use of his land until the same shall be sold and occupied by the purchase of the lots laid out thereupon."[11]

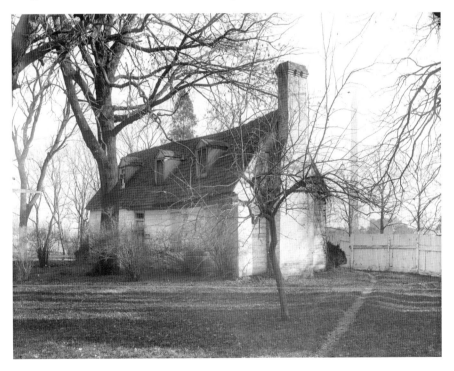

This photo of David Burnes's house taken between 1889 and 1894 with the Washington Monument in the background is one of several photos of the house. *Library of Congress, Prints and Photographs Division.*

At the time of this photograph, about 1895, the Burnes's house, which stood on the grounds just east of the Van Ness mansion at center in the photo, had been removed to make way for the Columbia Athletic Club track. *Historical Society of Washington, D.C.*

Burnes's house lot stood at the extreme western end of his landholdings, the present-day site of the Organization of American States building. His house, often referred to as a *cottage*, was less grand than Notley Young's Georgian mansion, but it was not exactly small, rather a standard dwelling form for a colonial-era middling planter. According to an 1867 account in the *Daily National Intelligencer*, the house measured eighteen feet deep and fifty-five feet long, with "three rooms below with a spacious hall running through it widthwise and three rooms above, in each of which is a dormer window looking out upon the river."[12]

In addition, agricultural and domestic outbuildings, including a kitchen, stood on the grounds. Burnes's one-and-a-half-story wood frame house, with its gable roof and dormer windows, survived long enough to be well documented by photos taken into the late nineteenth century. Burnes lived in his house as the city was growing up around his property and took advantage of the changing physical and political landscape. He continued to cultivate

his land, as allowed, by planting his crop in areas where city streets had not yet been cut through. He also embraced the opportunities that life in the city offered, most notably the education of his daughter, Marcia. Three years after Burnes's death in 1799, Marcia married John Peter Van Ness, a congressman from New York. The couple built an elegant Federal-style house designed by architect Benjamin Henry Latrobe on Marcia's inherited property, but she kept her father's cottage in place as well, purportedly seeking it out as a personal respite.

Following the death of the Van Nesses, Burnes's cottage deteriorated. With a moss-clad and sunken roof, the house attracted curiosity seekers and relic hunters who knew it as the last surviving house of one of the city's original proprietors. In 1894, despite some consideration given to moving the cottage, it was finally razed, and the land was repurposed as the site of the Columbia Athletic Club.

Duddington Manor I and II

Daniel Carroll of Duddington was the largest landowner of the original proprietors. He owned 1,400 acres of land within the city of Washington, called Duddington Manor and Duddington Pasture, extending from the future site of the Capitol south to the peninsula at Buzzard's Point. Carroll was born in 1764 on his family's lands in a house built by his father, Charles Carroll, partway down the point. From their mansion, the Carroll family had a direct view of the river traffic moving up and down the Anacostia River to the port at Bladensburg. Perhaps in an effort to capture some of this seaport trade, the elder Carroll decided, in 1770, to turn part of his estate into a seaport town, which he called Carrollsburg. The town, which never materialized beyond the paper stage, consisted of a grid of thirteen streets and 268 house lots, one of which was drawn around the Carroll family mansion, Duddington Manor (later sometimes referred to as Duddington Manor I).

Two years later, at the death of his father, young Daniel inherited his family's vast holdings, including the 160 acres of Duddington Manor that had been platted as the town of Carrollsburg. Still a minor, Carroll was sent abroad for his education and did not return to his land until it was suddenly being considered as the seat of the nation's capital. By then in his mid-twenties, Carroll had entered the world of business, recently married into

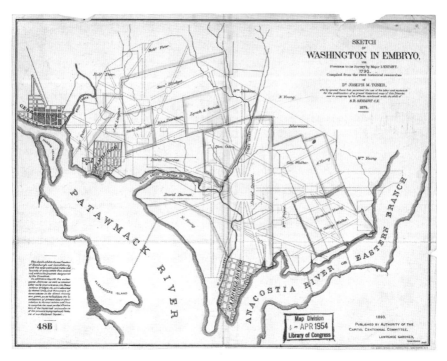

Joseph Toner's "Sketch of Washington in Embryo," 1874, clearly demarcates the platted towns of Carrollsburg in Southwest and Hamburgh in today's Foggy Bottom, both laid out in 1770. *Library of Congress, Geography and Map Division.*

the wealthy Brent family from the Virginia side of the Potomac and was living the life of a sophisticated gentleman. When he returned to his family lands, it was not only to establish himself as a gentleman planter but also as an investor in the new capital city. Although it would eventually bankrupt him, as it did others, Carroll, who became known as Daniel Carroll of Duddington to distinguish him from an uncle, Commissioner Daniel Carroll of Rock Creek, invested heavily in the city, building a new mansion house for himself, several rows of dwellings, hotels and other buildings.

Daniel Carroll's mother and her second husband, Captain Ignatius Fenwick, lived at Daniel's ancestral home, Duddington Manor I, at the center of the unrealized Carrollsburg. The estate included a brick dwelling house, measuring sixty feet by thirty-six feet, a kitchen, twenty-four by sixteen feet, frame barns and a log cabin, which, after the layout of the federal city, fell within the southwest quadrant around today's eponymous Carrollsburg Place. In the first decade of the city's existence, Carroll and Captain Fenwick continued to farm the estate together, sometimes incurring

the wrath of federal commissioners intent on marketing the government's lots to purchasers. In an April 19, 1794 letter to Fenwick, the commissioners chastised him for planting corn on his property, noting that they wanted the area "left open to disclose its attractiveness to strangers who may wish to view it" and did not want the view of visitors spoiled by cornfields.[13] In a concession to Fenwick, the commissioners expressed willingness to allow him to grow oats, which they did not feel would "produce so much inconvenience." Later, a 1799 letter from Carroll to the commissioners indicates that, despite earlier stated objections against corn to his stepfather, Carroll was still cultivating the crop on his Carrollsburg property: "I have not been able to procure a farm to my satisfaction to remove my hands and stock to, otherwise I would have relinquished the one I now occupy in the City some time ago. I purpose to cultivate a crop of corn the ensuing summer, which I hope will not be disagreeable to the Commissioners."[14]

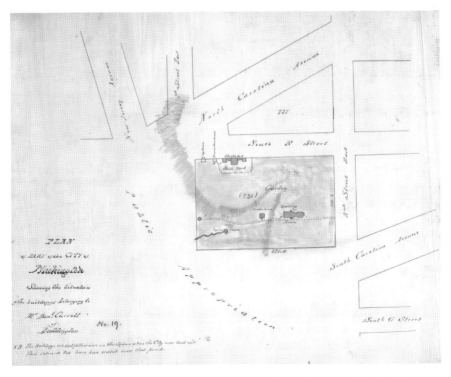

This plat of Daniel Carroll's Duddington (Duddington II) was drawn by Nicholas King in 1796 and shows Carroll's newly completed domestic complex, neatly contained within a city square and bordered by a wall. *Library of Congress, Geography and Map Division.*

As his mother and stepfather were firmly ensconced at Duddington Manor I, Daniel Carroll set about building himself a house worthy of his gentlemanly status—a second Duddington, whose story is famous in the early history of Washington. Carroll began construction of his house before L'Enfant had completed his plan for the city. After discovering that Carroll's partially constructed house was in the way of one of his avenues (today's New Jersey Avenue SE), L'Enfant simply had the house demolished by his workmen. The commissioners compensated the outraged Carroll for his loss, and he moved forward with his new mansion, Duddington (Duddington Manor II), on a nearby site. There Carroll established a well laid out domestic complex with a large house, an adjacent smokehouse, a substantial stable yard, a springhouse on the site of a "copious flowing spring" and a large garden, all of which was enclosed by a tall brick wall.

This sketch of Duddington appeared in an 1883 "Washington Rambles" article, the first in a series of articles on Washington history and historic places that appeared in the *Washington Post. From the* Washington Post, *September 2, 1883.*

To design his garden, Carroll sought help from a William Murdock in London, writing to him in June 1793, "I am in great want of a good gardiner [*sic*], a man who perfectly understands the laying off of ground, and is entire master of the art of laying out a garden in the modern taste."[15] When completed in 1797, the second Duddington was a showcase of its owner's prominent social standing: a stately, two-story brick house featuring a gable roof with large end chimneys. The house spanned nine bays, with a pediment above the center three, measured seventy feet in length and featured a one-story colonnaded porch across the three center bays of the façade. The stable yard included a carriage house that contained at least one well-appointed carriage, which Carroll ordered from a Philadelphia coachmaker, requesting that it be "painted and Japan'd any colour directed, plated mouldings lin'd with a white cloth, and Lace to Correspond with the colour the body is painted."[16]

A detail from Albert Sachse's bird's-eye view, "The National Capital, Washington, D.C." (1883–84), shows Daniel Carroll's Duddington mansion just before it was demolished in 1886 for the construction of row houses. Garfield Park appears in the foreground of the mansion. *Library of Congress, Geography and Map Division.*

Daniel Carroll of Duddington immersed himself in the affairs of the city and his own personal investments there. But poor sales of city lots led to his financial ruin. Still, Carroll lived out his days at Duddington and, at his death in 1849, was the last surviving proprietor. The house stood until 1886, when it was razed for the wholesale development of row houses. At the time of its demolition, the house stood high above surrounding streets that had been graded around it. Bounded by First, Second, E and F Streets SE, the former estate is now bisected by the east–west minor street Duddington Place SE and filled with Victorian row houses.

Cool Spring

Despite the creation of the city around them, the proprietors, especially those who owned land in the far eastern end of the city where streets were cut much later than others, continued to farm their land. Brothers Abraham and William Young, for instance, who were raised farming a large tract of land called the Nock on the eastern end of today's Capitol Hill, did not cease farming during their lifetimes. William cultivated the southern half of the tract, which was later taken over for Congressional Cemetery. He lived in a frame farmhouse surrounded by log structures, most likely slaves' quarters. There, with the labor of ten enslaved persons, he and his son planted tobacco and corn until at least 1797. Abraham, younger brother of William and owner of the northern half of the Nock, lived in his own farmhouse, a twenty-two-foot by twenty-foot frame structure, with several surrounding log buildings and an adjacent barn that stood near present-day Fourteenth and D Streets NE. While carrying on his farming operations, Abraham also shrewdly sold off some of his acreage as real estate speculation in the federal city increased. In 1795, with the proceeds, he acquired additional land just beyond the limits of the planned city along the western shores of the Anacostia River, including a tract known as Cool Spring. Benjamin Stoddert had owned the tract when the federal city was being laid out, and he did not want to relinquish it to the federal government, so he appealed to his friend, President Washington. After inspecting the site personally in the company of L'Enfant and surveyor Andrew Ellicott, Washington modified the boundaries to exclude the springs from the planned city limits, creating a distinctive and unnatural notch at the northeastern edge of the L'Enfant Plan:

Whilst the Commissioners were engaged in preparing the Deeds to be signed by the Subscribers this afternoon, I went out with the Majrs. L'Enfant and Ellicot to take a more perfect view of the ground in order to decide finally on the spots on which to place the public buildings—and to direct how a line which was to leave out a Spring (commonly known by the name of the Cool Spring) belonging to Majr Stoddert should be run.
—Washington's diary, June 28, 1791

After purchasing the Cool Spring tract, Abraham Young began construction of a new brick house to replace the existing frame farmhouse just to its west. Before Young could complete construction, however, he died, leaving a "two-story brick house unfinished," a widow and several children. Young's widow married the property manager, John Gibson, and the property, with its completed house, formal gardens, orchards, barns and numerous springs was known alternatively as Rosedale and as Gibson's Springs. The property would later be known as Isherwood for its mid-nineteenth-century owner, Robert Isherwood. Just before the home's demolition in 1912, the *Evening*

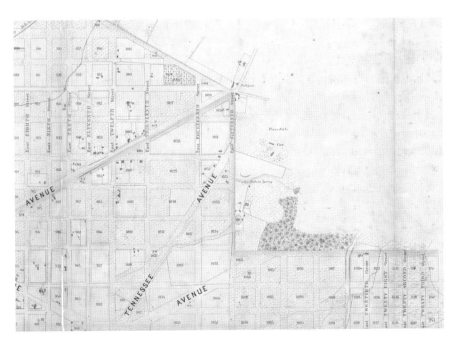

As seen in this detail of "Map of Washington City," by Albert Boschke, 1857, the boundaries of the city were drawn to exclude the Cool Spring tract, identified on this map as Gibson Spring. *Library of Congress, Geography and Map Division.*

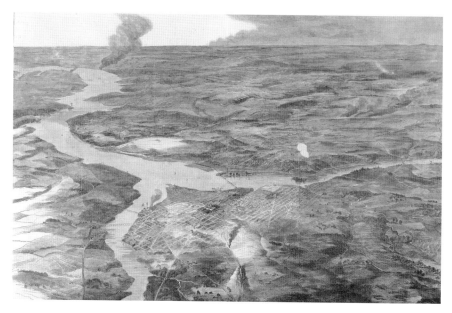

The hand-colored wood engraving "General Birds-Eye View of Washington and Vicinity, Showing the Forts, Camps, Railroads, Rivers, etc.," by Alfred J. Wells illustrates the Cool Spring tract in the immediate foreground with its two streams converging to flow into the Anacostia. *From* Harper's Weekly, *January 4, 1862.*

Star published a photograph of the substantial brick house, claiming it to be the only surviving structure "built, owned and occupied by an original proprietor" and praising its walls of brick "that are unusually thick and solid as ever."[17] Before it was demolished, the house stood at the "top of a rise of ground about 20 feet above the present street level," as the streets had been graded around it and the lots filled with row houses.[18]

BEYOND THE ORIGINAL CITY BOUNDARIES

WASHINGTON COUNTY

The 1790 act of Congress establishing a permanent seat for the federal government, known as the Residence Act, provided ten years for the city to be built and ready for the first session of Congress in December 1800. While the construction of the federal city would upend the rural character of land within its boundaries, the land beyond its limits but still within the territory of Columbia would remain relatively unaffected for the next decades.

All of the land that lay beyond Washington City and the port at Georgetown on the Maryland side of the Potomac and Anacostia Rivers was named Washington County. Established by the Organic Act of 1801 as a separate political entity governed by a levy court, the county would remain distinct from the city politically, geographically and socially throughout the nineteenth century. Initially, the levy court consisted of seven justices of the peace appointed by the president, but in 1863, the court was reorganized to include nine members: three from the city, one from Georgetown and five from the county. The levy court carried out such duties as establishing and collecting taxes and building and repairing roads. The Organic Act of 1871, implemented during the city's short-lived territorial government (1871–74), officially consolidated Washington City, Georgetown and Washington County into the single political entity of the District of Columbia. Before and after this consolidation, Washington County was a sparsely inhabited rural area of farms, country estates and villages that emanated from its seventeenth- and eighteenth-century roots.

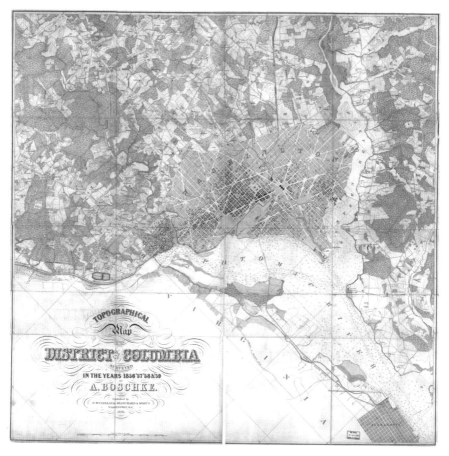

The extraordinarily detailed "Topographical Map of the District of Columbia," by Albert Boschke, 1861, shows the urbanizing city center juxtaposed to the still-rural outskirts with its tapestry of farms and woods. *Library of Congress, Geography and Map Division.*

GIESBORO

Like the original proprietors of the city, many of the owners of land in Washington County were second- and third-generation landowners, descended from the original patentees who had received land grants in the Potomac region in the latter half of the seventeenth century. One of the most extensive properties in Washington County around 1790 was Giesboro (initially spelled Gisbrough, then later Giesborough and sometimes Gisboro) Manor, a seventeenth-century tobacco plantation on the eastern shore of

the Anacostia River at its confluence with the Potomac River, the present site of the military installation, Joint Base Anacostia-Bolling.

During the eighteenth century, Giesboro would come to include two large farm complexes—Upper and Lower Giesboro—whose ownership would be separated and rejoined over the course of many decades. Giesboro traces its roots to 1663, when the second Lord Baltimore (Cecil Calvert, who received a charter from King Charles for the new colony of Maryland) made an 850-acre land grant to Thomas Dent. Dent, in the gentleman farmer tradition, operated the plantation at a distance. While Dent lived primarily near St. Mary's City, he employed an overseer and enslaved persons to run his Giesboro plantation and probably rented out part of the acreage to tenants. In 1685, Dent sold Upper Giesboro to John Addison, who, unlike the planters who preceded him, built a manor house on the property and settled on his land, becoming the first person of social standing to have made his home in what is now the District of Columbia. In 1715, the two Giesboros were again joined when John Addison's son, Thomas of Oxon Hill, who had already acquired Upper Giesboro from his father, then purchased Lower Giesboro.

By 1791, Giesboro had grown to over 1,600 acres and was then in the hands of another John Addison, a descendant of the first John Addison. He had inherited the property as a young boy sixteen years earlier, and after receiving his education abroad and waiting out the Revolutionary War, Addison returned to Giesboro to make a living raising tobacco on the land and introducing other crops as the soil became depleted. The Anacostia was navigable as far as the Northwest Branch, above Bladensburg, and was the quickest and most practical means for planters to bring their tobacco to port. As a result, storehouses and warehouses sprouted along its shores. In 1795, an English traveler, Isaac Weld, described the Anacostia: "At its mouth, it is nearly as wide as the main branch of the river, and close to the City the water is thirty feet deep. Thousands of vessels might lie here, and be sheltered from all danger."[19] Given its location on the river, Giesboro surely possessed a landing along its wide frontage, probably just above the confluence with the Potomac. Such a wharf would have facilitated the transport of the plantation's crop to the port at either Bladensburg or Georgetown.

The two plantations of Upper and Lower Giesboro each contained brick plantation houses, outbuildings and agricultural structures. The Upper Giesboro domestic complex, believed to have been built around 1808 and expanded after 1833, occupied Giesboro Point and consisted of "a brick mansion with a center building and two brick wings connected by arcades."[20]

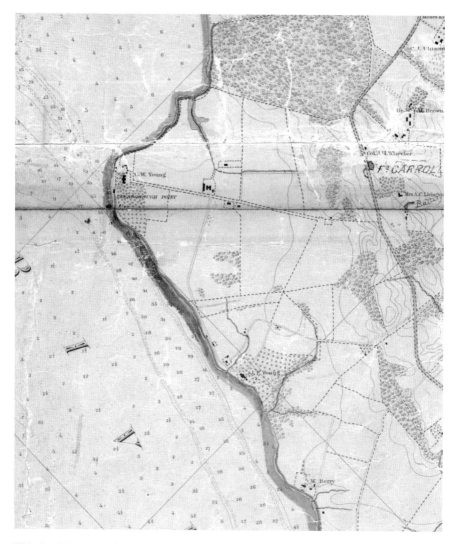

This detail from Major General J.G. Barnard's "Map of the Environs of Washington," 1865, shows the distinctive three-part building footprint of Upper Giesboro at Giesboro Point. *Library of Congress, Geography and Map Division.*

A recently discovered painting now in the Albert H. Small Washingtoniana Collection at the George Washington University Museum is the only known illustration of the five-part mansion house of Upper Giesboro. The brick house at Lower Giesboro, probably built in the last quarter of the eighteenth century, was captured in a Civil War–era photograph that reveals a four-bay configuration with recessed end wings. Lower Giesboro stood at a point just

south of Upper Giesboro and along the shore of the Potomac just below where the Anacostia merges into it.

In 1833, George Washington Young, son of Nicholas Young and grandson of original proprietor Notley Young, purchased both Upper and Lower Giesboro. He immediately moved to Upper Giesboro from the nearby Nonesuch plantation where he had grown up, while his brother, Ignatius Fenwick Young, moved to Lower Giesboro. Together they operated the Giesboro plantations until 1863, when the properties were taken over by the Union army for a camp and cavalry depot during the Civil War.

At the eve of the Civil War, Giesboro owner George Washington Young was one of the capital's wealthiest individuals, and in keeping with his family's long slaveholding tradition, he was also the largest slave owner, with ninety-one slaves listed in his ownership in the 1850 U.S. census. Young employed a white overseer to run his two plantations, both largely self-sufficient communities with carpenters, blacksmiths, bricklayers, ironworkers and

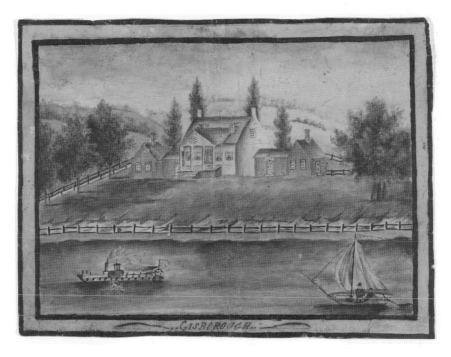

An unknown artist painted this 1830 watercolor of "Gisborough," depicting the house at Upper Giesboro with its central block and wings. Today, Giesboro Park in the military installation Joint Base Anacostia-Bolling occupies the site of Upper Giesboro. *The George Washington University Museum, the Albert H. Small Washingtoniana Collection, AS 2016.21.*

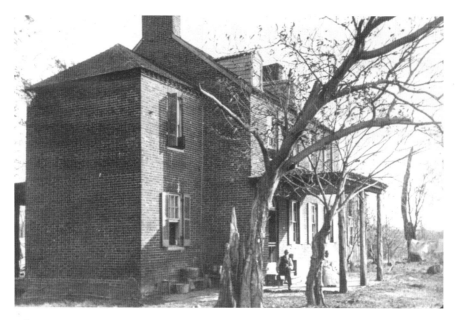

A Civil War–era photograph captures the house at Lower Giesboro, demolished in 1931 for construction of an airplane runway at today's Joint Base Anacostia-Bolling. *Historical Society of Washington, D.C.*

field hands. By 1850, Young, like most area farmers, had moved away from tobacco and instead cultivated his improved land principally with wheat, corn and oats. In 1860, George Washington Young built a house on his Nonesuch plantation for his daughter Mary—it still stands on Bangor Street SE in the Hillsdale neighborhood.

FRIENDSHIP

Friendship, an extensive 3,124-acre tract of land, extended from Tenleytown on the east beyond the western edge of the District of Columbia at Western Avenue into Montgomery County, Maryland. The land was granted by Charles Calvert to James Stoddert and Colonel Thomas Addison (the same Thomas Addison of Oxon Hill and Giesboro) in 1713, and it was purportedly dubbed Friendship for the amicable relationship that existed between the two grantees.[21] Addison controlled the southern portion of the patent, which included the larger Tenleytown area. After Colonel Addison's

death in 1727, his two youngest sons, Anthony and Henry, inherited his part of Friendship where they raised tobacco, corn and vegetables. In 1753, John Murdock, related by marriage to the Addisons, acquired jointly with his brother, Addison, over 1,200 acres of Friendship. Around 1760, John Murdock built a frame house on his part of the land, overlooking the Potomac River on a site now occupied by American University.[22]

This seemingly modest but deceptively large manor house, with its steep and broad gable roof, dormer windows and brick end chimneys, was comparable to that of David Burnes and typical for the period. Over the next two decades, Murdock raised tobacco with slave laborers who would have rolled hogsheads—wooden casks filled with tobacco—down the route that is today's Wisconsin Avenue, an old Indian trail and an eighteenth-century tobacco "rolling road," to the port at Georgetown. The 1783 personal property assessments used to raise money for the Revolution counted forty-nine slaves among Murdock's property, placing him in the

John Murdock's house, Friendship, built about 1760 and shown in this late nineteenth-century photograph, was located on the grounds of today's American University campus. *Murdock-Davis Farmhouse, American University Archives and Special Collections.*

upper echelon of wealth. In the nineteenth century, Murdock's Mill Road, a segment of which still exists west of Wisconsin Avenue, cut through the Friendship tract to Murdock Mill. The mill, a frame structure that ground wheat and oats into flour, was located on a stream west of Tenleytown known as Dogwood Branch.

BERLEITH

Just south of Murdock's Friendship, bordering the Potomac River and encompassing today's campuses of Georgetown University and Georgetown Visitation Preparatory School, stood the estate of Berleith, owned by John Threlkeld. A wealthy and active member of the community, mayor of Georgetown from 1793 to 1797 and member of the levy court of Washington County, Threlkeld had inherited the land in 1781 from his father, Henry Threlkeld, an English immigrant and farmer who came to the land through marriage. The previous owner, a Scot who had immigrated to Maryland in the early eighteenth century, named the property Berleith after a village near his birthplace. During the Threlkelds' ownership of Berleith, first father and then son acquired additional and adjacent landholdings that ultimately amounted to well over one thousand acres that stretched as far north as Tenleytown. A stone boundary marker inscribed with the Threlkeld name survives as evidence of the extent of the family's land holdings.

In 1791, John Threlkeld consolidated these landholdings under the name Alliance but kept the name Berleith for his home farm, which, according to 1785 tax records, included "a good dwelling house, a kitchen, barn, and slave quarters." The house, which would have been the second on the property after a fire destroyed the first, stood south of today's Reservoir Road on the present grounds of Georgetown Visitation Preparatory School. The house is no longer standing, but a mid-twentieth-century reconstruction of an eighteenth-century building once part of Berleith stands north of the tennis courts on the grounds of the school today. This building, referred to as "The Slave Cabin" in the mid-twentieth century, was more likely a kitchen or other type of domestic outbuilding.

In addition to his civic duties, John Threlkeld contributed to the promotion of agriculture in the county through experimental farming and by helping to found the Columbian Agricultural Society for the Promotion of Rural and Domestic Economy. Established in 1809, the society promoted farming

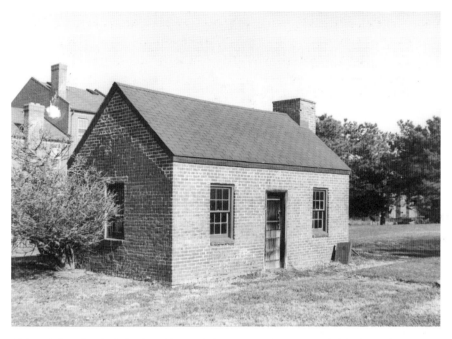

Although largely rebuilt in the mid-twentieth century, this one-story brick domestic outbuilding was historically part of the eighteenth-century Berleith property. *D.C. Historic Preservation Office.*

and agricultural pursuits by offering premiums to those who, at two annual meetings, presented the "best in their field" for both animals and textiles. The *Daily National Intelligencer* reported on the society's first meeting: "The members and visitors were numerous: the exhibition of sheep and cloths of domestic manufacture, was highly gratifying."[23] On his property, Threlkeld raised fruit trees, grazed cattle and experimented with raising merino sheep. He sold English cattle to George Washington in 1797 and provided mulberry, peach and apricot cuttings to Thomas Jefferson.

CHEIVY CHACE

Farther north and east of Berleith, the eighteenth-century land grant known as "Cheivy Chace" comprised 560 acres of land on either side of the newly defined District of Columbia border. In 1725, Lord Baltimore granted the tract to Joseph Belt. Belt was then a lieutenant colonel, soon-to-be colonel,

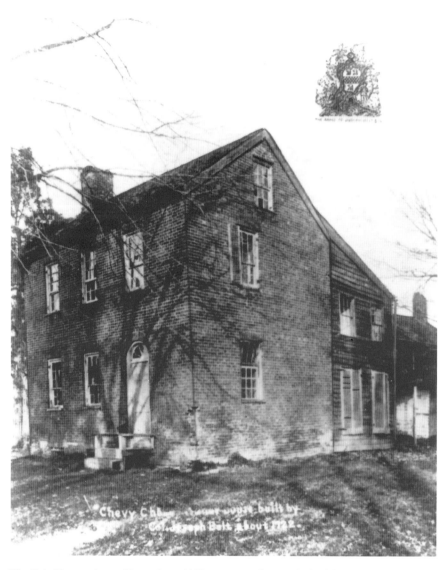

The Belt House, pictured here about 1907, was one of two principal dwellings on the Belt family's property Cheivy Chace during the eighteenth and nineteenth centuries. The Belt house was demolished for construction of a house on Oliver Street NW during the residential development of Chevy Chase, D.C. *Montgomery County Historical Society.*

and a member of the House of Burgesses from 1725 to 1737. He would go on to hold other titles, such as gentleman justice for Prince George's County, Maryland (1726–28). Belt's Cheivy Chace land, which stretched north to today's Bradley Lane on the Maryland side of the District border, was operated as a tobacco plantation by Colonel Belt. After his death in 1761, and according to his will, Belt left the Cheivy Chace tract to his grandsons, Thomas and William Belt. At the founding of the District in 1791, the property included two residential complexes, one on the District side of the border and the other on the Maryland side. The two-story brick Belt house in the District was located about five hundred yards southeast of Chevy Chase Circle near today's Oliver Street NW.

Holmead Manor

Holmead Manor was one of two principal domestic complexes of the Holmeads, a family of planters who settled in the area in 1722. The Holmead property was located on the east side of Rock Creek and stretched north to Piney Branch. At the time of the establishment of the federal city, the property was owned by Anthony Holmead, whose inheritance also included 206 acres that fell within the bounds of the federal city, making him one of the city's original proprietors. Holmead Manor, a two-story frame house with a high-pitched roof and integrated porch, was built around 1740 and stood at today's Thirteenth and Otis Streets NW until razed in the 1890s.

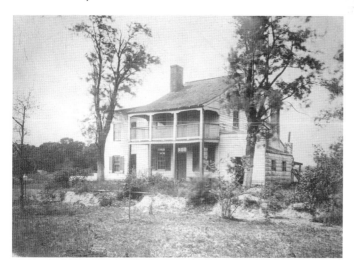

Holmead Manor, built around 1740 near today's Thirteenth and Otis Streets NW, is pictured here just a few years before it was demolished, circa 1885. *Historical Society of Washington, D.C.*

ROSEDALE COTTAGE

The eighteenth-century manor houses and those of other landowners in the county stood distant from one another, with agricultural buildings, domestic outbuildings, tenant houses and other structures scattered between them and across the land. As gleaned from the 1798 federal direct tax records, the rural dwellings beyond manor houses were primarily one- and two-room cabins. Built mostly of perishable materials such as log and wood, these early buildings are long gone, but one stone house, referred to as the Rosedale Cottage, survives with distinction as the oldest extant building in the District of Columbia. The stone structure, built around 1740, is incorporated as a rear wing to the 1794 Rosedale farmhouse.

Not much is known about the early history of this house. It stood on one of several parcels of land outside of Georgetown that merchants and business partners General Uriah Forrest and Benjamin Stoddert bought and consolidated in 1793 into a tract they called Pretty Prospects. Much of the land that the partnership purchased had been inhabited by owners or tenants, and indeed, land records of 1765 for this particular parcel list "buildings, improvements, profits, commodities, advantages and appurtenances."[24] Although not scientifically authenticated, the 1740 date traditionally attributed to the house is consistent with the building's architectural materials, type and character of construction. The Rosedale Cottage is actually two buildings constructed in phases and joined as one.

The thick walls are made of local stone, uncoursed and irregular in size and shape. The north section of the cottage, somewhat cruder in construction, appears to be the original house, and the southern section is a somewhat later addition. The two wings have different floor levels but are joined on the interior and covered by separate but abutting gable roofs. The north wing includes two small rooms and a larger room where there is a battered brick fireplace against its south wall. The southern wing has two small rooms, one of which was the kitchen and is equipped with a large fireplace and oven under a brick arch, sharing the chimney of the north wing. A curved passageway through a door and one step up connects the kitchen in the south wing to the north, making for a solid five-room house that would have been a comfortable home for any eighteenth-century farmer.

In 1793, the cozy stone cottage became a respite and summer retreat for Uriah Forrest; his wife, Rebecca Plater Forrest; and their children. The following year, Forrest bought out Stoddert's interest in Pretty Prospects and began construction of a large frame farmhouse in front of the stone cottage,

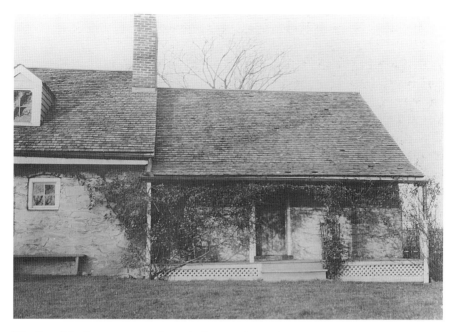

The Rosedale Cottage, a stone house built around 1740 for a tenant or yeoman farmer, was incorporated as the rear wing of the Rosedale farmhouse when it was constructed in 1794. *The Rosedale Conservancy.*

converting the former dwelling into the kitchen wing and servants' quarters. Over the decades, Forrest enhanced the property with orchards, a garden and domestic outbuildings, including a smokehouse and dairy, a large stable and a carriage house.

In 1797, financial hardship associated with Forrest's investments in the federal city forced him to sell all but 130 acres around his house. Phillip Barton Key, Forrest's brother-in-law, took over a mortgage that Forrest had taken on the property, allowing the general and his family to remain at Rosedale. Key also purchased 250 acres of Pretty Prospects and three years later built his own country house, Woodley, at the height of a hill overlooking the Potomac. Completed in 1801, Woodley was the first of many country houses that would be built on the outskirts of the city as Pretty Prospects and other large tracts were divided. After 1800, when wealthy businessmen and politicians, like Key, came to Washington to help build the city, they also sought to escape it and, in so doing, built large country estates on the outskirts, opening up a new chapter in the history of rural Washington.

4

Country Houses and
Gentlemen Farms

*For besides the attractions which I have mentioned the greatest is the relaxation
and carefree luxury of the place—there is no need for a toga, the neighbors do not
come to call, it is always quiet and peaceful—advantages as great as the healthful
situation and limpid air. I always feel energetic and fit for anything at my Tuscan
villa, both mentally and physically. I exercise my mind by study, my body by
hunting.*
—Pliny in Epistles, *V.vi.45*

Like the ancients before them, early Washingtonians of means would
soon seek out the physical, moral and emotional benefits of a home in
the country. After spending just one summer in the modest stone cottage
away from their permanent residence on M Street just above the noisy and
noxious maritime activity of Georgetown, Uriah Forrest and his family
were sold on the benefits of country living. Within the year, the Forrests
began construction on Rosedale, a more commodious, though still rustic,
farmhouse in front of the stone cottage on their Pretty Prospects land. In
so doing, the Forrests introduced Washington to the ancient tradition of the
country retreat. Of course, longtime and adjacent property owners such as
the Threlkelds and Addisons had been living in the country for generations,
but these residents were historically planters and farmers whose primary
source of income derived from the land, not businessmen and politicians who
earned their livelihood in the city. Other successful Georgetown merchants
and businessmen built their own large estates with extensive grounds and

gardens above the port of Georgetown, such as Tudor Place and Dumbarton Oaks, but unlike Rosedale, these were still essentially fashionable, in-town residences and not country retreats.

Initially, Forrest and his family maintained their principal residence in Georgetown where Forrest was active in business and politics, retreating to Rosedale for weekends and the summer months. Shortly after building Rosedale, however, the Forrests moved permanently to the country, and their retreat became a working farm and garden with fields of grain, market vegetables and fruit trees. On the hill in front of the house, the Forrests built terraces, which they planted with neat rows of fruit trees. In a small garden near the house, Rebecca Forrest planted vegetables, medicinal herbs and spices, and she maintained a greenhouse.[25] An 1817 advertisement for the sale of Rosedale after Rebecca's death highlighted the landscaped terrain, including its orchard with its "choice fruit of apples, pears, peaches, cherries, &c." along with "an elegant and beautifully situated garden well set with shrubbery, flowers &c."[26]

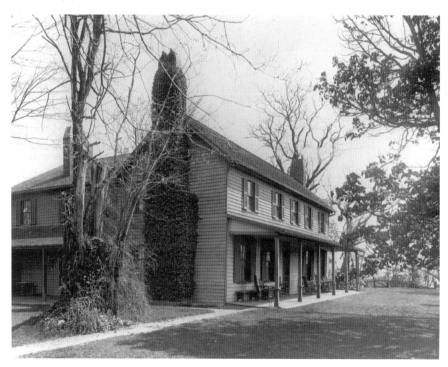

The Rosedale farmhouse in today's Cleveland Park, built in 1794 by Uriah and Rebecca Forrest, is shown in this early twentieth-century photograph. *D.C. Historic Preservation Office.*

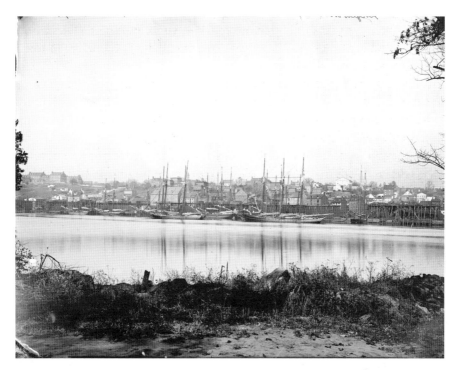

This historic view of the Georgetown waterfront illustrates the industrial character of the port town that encouraged businessmen, politicians and other persons of wealth to build houses in the country. *Library of Congress, Prints and Photographs Division.*

In 1800, the federal government moved to the new capital city, bringing with it an influx of wealthy and educated residents. For many of these individuals, the infant city with its dusty and muddy streets (depending on the season) and unfinished buildings paled in comparison to the refined urban living that they were accustomed to. In addition to the incomplete state of the city's infrastructure, the new residents suffered from the weather, especially the hot and humid summers, universally described as the "sickly" season. Within the first years of moving to the city, many of the most affluent of these early residents followed the patricians of ancient Rome and subsequent civilizations in pioneering a retreat from city to country. They purchased newly available parcels of land that came from the division of large eighteenth-century tracts following the demise in the tobacco industry and built new and architecturally assertive villas.

For their rural retreats, these persons chose sites high up on the bluffs, just beyond the original city, with extensive grounds of natural beauty as well as

cooling breezes and views to the river and nascent city below. Phillip Barton Key, Uriah Forrest's brother-in-law and chief judge of the U.S. Circuit Court, was one of the first of these newcomers to embrace this city-country lifestyle when he built Woodley in 1801, but others quickly followed. Within the first two decades of the nineteenth century, a series of country estates formed a virtual ring around Washington City on the hills above Boundary Street, today's Florida Avenue. From Kalorama on the west at Twenty-Third and S Streets NW to Brentwood on the east at Florida Avenue and Sixth Street NE and many others in between, these estates gave rise to the names of streets and places around them. Like those of antiquity, these country houses were often sophisticated, architect-designed buildings intended to showcase the social stature and wealth of their owners.

In 1817, Robert Brent, the first mayor of Washington, and his wife, Eleanor (Young), commissioned Benjamin Henry Latrobe to design a house, called Brentwood, for their only daughter. Latrobe was one of the nation's first formally trained professional architects and was then serving as superintendent of government buildings. Just before Latrobe was commissioned to design Brentwood, which he did in a graceful Neoclassical style, he had completed several other equally avant-garde houses for the city's affluent and had others underway. In a letter to his son Henry in June 1816, Latrobe wrote, "My two houses, Mr. Vanness's and Casenave's are, not to say much of them, the best in the district."[27] Later, architectural historians would consider Brentwood one of the most important houses of its day. Its two-story, square-planned central pavilion, flanked by lower one-story wings, capped by a low hipped roof with a lantern, is identified by James Goode in *Capital Losses* as a "severely elegant, early American example of Grecian architecture."[28] The house, which burned down in 1917, is remembered in name by Brentwood Park and Parkway, which runs through the former estate grounds, once a dense forest of oak, chestnut and hickory trees, just north of today's Union Market.

From their country houses, Washingtonians enjoyed the duality of a city-country life: they pursued active professional and social lives in the city but found fulfillment in the wholesome, healthful life in the country. Margaret Bayard Smith and her husband, Samuel Harrison Smith, epitomize this city and country dichotomy. Samuel Harrison Smith, a publisher from Philadelphia, came to Washington in 1800 at the urging of his friend Thomas Jefferson to establish the *Daily National Intelligencer*. The daily newspaper, which lasted for almost seventy years, was well known and highly respected in its day. Upon their arrival in the city, the Smiths were immediately embraced by

Several country houses, built in the early nineteenth century on the hills overlooking the nascent city above today's Florida Avenue, are shown in plan in this partial view of the 1892 Coast and Geodetic Survey map. The estate of Kalorama, identified on the map, was located at present-day Twenty-Third and S Streets; Oak View, farther north, stood at the southeast corner of the intersection of Florida Avenue and Columbia Road. *Library of Congress, Geography and Map Division.*

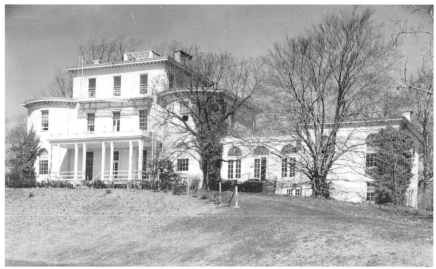

Woodley (Maret School since 1952) is the epitome of early Washington's version of a country villa. The house occupied an elevated site on the outskirts of the city, with its south elevation, shown here, affording unobstructed views over the city and to the Potomac River. *Library of Congress, Prints and Photographs Division, Historic American Buildings Survey, 1958.*

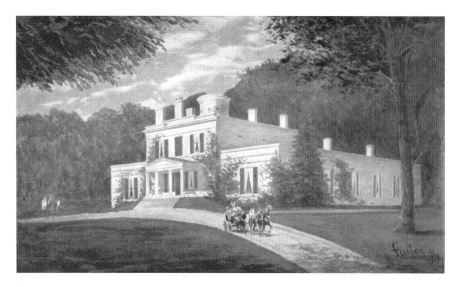

Brentwood was built in 1817 by Robert Brent, the first mayor of Washington. Brent's great-grandson Joseph Pearson Farley made this painting of the house in 1908. *From Joseph Pearson Farley*, Three Rivers: The James, The Potomac, The Hudson *(1910).*

the fledgling society and quickly immersed themselves in the city's political and social life.[29] Margaret described that early Washington scene in great detail in her many family letters, which were later compiled and published by her grandson in *The First Forty Years of Washington Society.* After a few years of living exclusively in the city and some health issues attributed to it, the Smiths purchased land in the county and built Sydney, a brick cottage and their rural retreat. Margaret, an urbanite, initially described the countryside as "a situation as rude and wild as if we settled in the western woods" but was soon taken in by the beauty of nature: "I enjoyed this stormy day, the roaring of the wind among the trees, the pelting of the rain and hail against the windows….I experienced today the sensations of tender melancholy, the wanderings of fancy, those pleasing reveries, which I used to feel in the early period of life….A residence in the country tends to preserve…this sweet glow of the soul."[30]

For most of these residents, their country houses were primarily retreats and respites from the city, where some gardening or limited farming would take place. Others were actual working farms where educated persons, or gentlemen farmers, cultivated the landscape, often while experimenting with new agricultural techniques and plant varieties. From raising merino sheep to cultivating thorn hedges and developing vineyards, these farmers

worked together to promote the science of agriculture. They established the Columbian Agricultural Society in 1809 to encourage the agricultural production of the land, published books and articles on their farming techniques, consulted with one another, sharing advice and experience, and in at least one case, they heavily lobbied Congress to support their agricultural pursuits to develop an American grape for winemaking.

ANALOSTAN

In the first decade of the nineteenth century, businessman John Mason (1766–1849) emerged as an influential farmer shortly after he established his estate, Analostan, on today's Roosevelt Island. Mason family ownership of Analostan Island began in 1717, when John Mason's grandfather acquired the island in the Potomac River, directly across from the mouth of Rock Creek. During the seventeenth and eighteenth centuries, the island was known as My Lord's Island, Anacostien Island (for the Necostin Indian tribe that inhabited the area in the seventeenth century) and Barbadoes Island. For the entirety of the nineteenth century until 1933, however, it was known as Analostan Island or Mason's Island. John Mason's father, planter and Virginia statesman George Mason (1725–1792) of Gunston Hall, who authored the Virginia Bill of Rights and also helped draft the U.S. Constitution, operated a ferry between the island and the Virginia and Maryland shores of the Potomac River. Established by his father before him, the ferry provided a vital link between Virginia and the port at Georgetown and the Ohio River Valley beyond.

John Mason grew up on his family's plantation Gunston Hall, but from an early age, he was groomed for business. He began his business career with an apprenticeship in a counting house in Alexandria and, after just two years, established the mercantile firm of Fenwick, Mason & Company in 1788. The company specialized in selling and transporting Virginia and Maryland tobacco to European agents, and in 1788, Mason moved to Bordeaux, France, where the firm's headquarters were to be. The business flourished, and by 1792, Mason had moved back to the United States and opened an office of Fenwick, Mason & Company in Georgetown. He purchased a house on M Street and quickly immersed himself in business and local community affairs. From his Georgetown house, John Mason had a view of his father's island, which he would inherit before the end of the year.

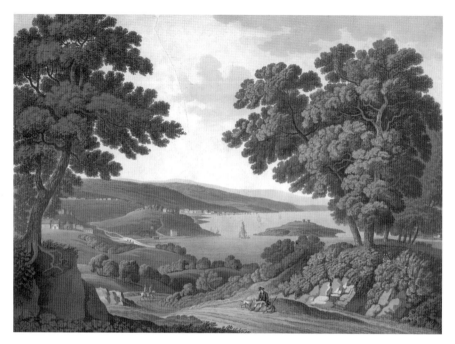

This 1801 aquatint view, "George Town and Federal City, or City of Washington," shows Analostan Island with two buildings on it, as viewed from a road above and leading to Georgetown. *Library of Congress, Prints and Photographs Division.*

Upon his father's death, John Mason lost no time in developing the island's approximately seventy-five acres as a small plantation estate, building a Neoclassical house, raising crops, grazing livestock and creating extensive gardens. At the same time, he became a prominent member of the Georgetown business community and the fledgling federal city. In 1793, Mason was one of the founding members, and later president, of the Bank of Columbia, the first bank in the District of Columbia. He was also president of the Potowmack Canal Company and served in the District of Columbia militia (1802–11). Most notably, however, Mason, who became known as "John Mason of Analostan Island," was a leader in agricultural reform, as he experimented with crops and livestock on his working farm.

Mason began constructing his house between 1793 and 1796, the year of his marriage. To get started, Mason ran an advertisement in January and February 1793 in the *Columbian Mirror* and *Alexandria Gazette* asking for "'12 to 15 stout young Negro Fellows' to apply for a year's employment in 'the neighborhood of my Ferry-House' opposite Georgetown."[31] These laborers could have been free blacks but were more likely to have been

enslaved persons who were hired out. When the federal government moved to the city, there were 3,244 slaves and 783 free blacks in Washington. It was not unusual for slave owners to hire out or allow those they held in bondage to hire themselves out. Depending on the agreement, owners could make money on their slaves, or in some cases, the enslaved were able to earn money, often working toward eventually buying their own freedom and that of their family members.

Never fully completed as conceived, the house was designed as a long, one-story, stucco-clad brick building with a main block and central entryway flanked by pedimented end wings defined by elegant arched openings. Only the main block and west end wing of the house were completed, but these were finished with all of the designed embellishments, such as stone window moldings, water table and belt coursings. Although the architect of Mason's Analostan house is not known, it has been attributed to architect George Hadfield because the sophistication of design and details recall those of Hadfield's other buildings, including Arlington House on the grounds

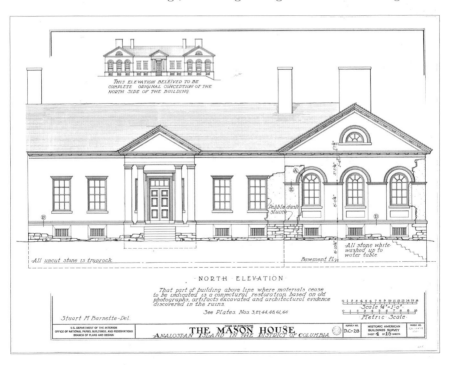

This partly conjectural elevation drawing of Analostan, prepared by the Historic American Buildings Survey in 1963, was based on surviving remnants of the house, historic photos and archaeological excavations. *Library of Congress, Prints and Photographs Division, Historic American Buildings Survey.*

of Arlington Cemetery and Old City Hall (now the District of Columbia Superior Court) in downtown Washington.

John Mason strategically sited his mansion house at the south end of the island, away from the ferry crossing at the north end. A formal, tree-lined allée led from this access point into the island, past rows of fruit trees and crops of cotton and maize to a semicircular line of trees that screened the mansion's three-part north façade. While the house itself occupied a slight promontory about fifty feet above the river's waterline, the secondary structures, including a kitchen, icehouse and quarters for the enslaved, were located behind the house at a lower position on the landscape. In 1902, a journalist reporting on the possible purchase of the island for an "isolation hospital" described the deteriorating remnants of Mason's plantation: "The first of these relics...is a small, roofless structure, picturesque in its decay, its dilapidated walls overgrown with moss and ivy. This was originally one of the slave quarters, but it has since been occupied by natives of Georgetown, the latest of whom, Charles Burroughs, a well-known waterside character, is still living at an advanced age."[32] Although John Mason was a slave owner, it is not clear how many he owned and how many of those held in bondage lived on the island. An inventory of Mason's property in 1850, a year after his death and years after he lost the island to bankruptcy, recorded nine slaves in his ownership, including three children under the age of fifteen.[33]

Primarily a businessman, John Mason was an enthusiast for scientific agriculture and operated his island as a functional and largely self-sufficient plantation where he engaged in fruit culture, the breeding of livestock and gardening. He started to develop his island's seventy-five acres shortly after beginning his house. Mason's experiments, largely known to us through author D.B. Warden, who devoted a chapter to Analostan Island in his publication *A Chorographical and Statistical Description of the District of Columbia* (1816), involved the cultivation of cotton and maize and the raising of merino sheep. Warden informs the reader that "General Mason cultivates, for the use of his family, a species of cotton the colour of nankeen, which is spun and woven with facility, and wears well without losing its natural hue."[34] As for Mason's species of maize, whose leaves are "a deep purple color and are employed as a dye," Warden boasts that he had the "honour of presenting some of the seeds to the Empress Josephine, who sowed them with her own hand in the gardens of Malmaison, where they gave a luxuriant produce."[35]

According to Warden, Mason's interest in agriculture extended to irrigation: "By means of an hydraulic machine, water may be easily raised

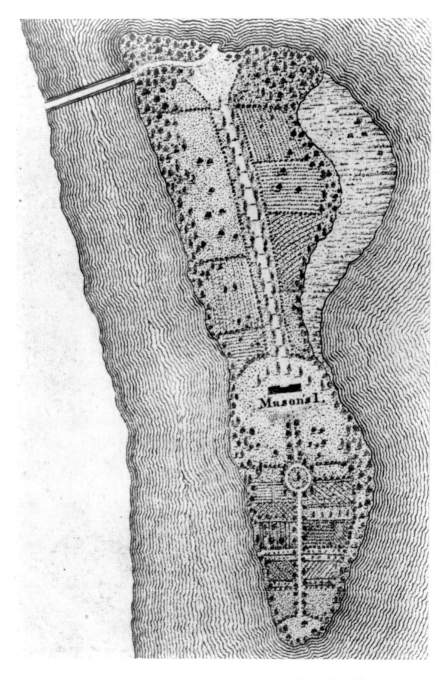

A detail from "A Map of the City of Washington," by Robert King, 1818, illustrates the Analostan plantation with its formal allée leading from the north end of the island past cultivated fields to the mansion house and gardens at the south end. *Library of Congress, Prints and Photographs Division, Historic American Buildings Survey.*

from the river, and conducted by pipes to every part of the surface."[36] While Mason appears to have cultivated cotton and maize principally for his own domestic use, he raised Spanish merino sheep as a commercial venture and in an effort to improve the primitive American woolen industry through the introduction of the sheep with their "long, fine wool." The British embargo on wool and wool clothing exports to the United States before the War of 1812 led to the "Merino Craze" embraced by gentlemen farmers in the District such as John Mason and John Threlkeld, both of whom bought and raised herds of their own. Mason's interest in sheep was encouraged through his involvement in the Columbian Agricultural Society, and he played an active role in its founding and participated in its semiannual exhibitions and fairs. In 1811 and 1812, he earned first-place honors for his entries in the fine wool lamb category, and in 1810, Mason's wife, Anna, won three times for her entries in the cotton cloth, hempen or flaxen table linen entries—all likely the product of the nankeen cotton variety grown on the island. In Jeffersonian fashion, Mason recorded statistics on his farm, including a chart published by Warden comparing the weight "in carcass and wool" of the different breeds of imported merino sheep bred on Analostan Island.

With the income generated by the ferry and his business ventures, including the purchase of Henry Foxall's foundry, John Mason was not financially dependent on farming. He experimented in farming for its contribution to the science and knowledge of agriculture and as a hobby and diversion from his Georgetown business activities. Analostan Island was a working farm, but it was also a rural retreat for his family and friends to relax and socialize. In keeping with this role, Mason developed a series of pleasure grounds, orchards, gardens, lawns and ornamental structures. Mason's interest in his island as a picturesque retreat was likely inspired by his time abroad when he traveled extensively in France and England, where the tradition of designed, picturesque landscapes figured large.[37] Mason must have been pleased when Anne Newport Royall, regarded today as the first professional woman journalist, visited Analostan in 1828 and declared it to be "the most enchanting spot I ever beheld."[38] Despite Mason's efforts, Analostan's location at low ground made it untenable during the hottest summer months, due to the humid and "sickly" weather that plagued the city's residents.

John Mason's Fenwick, Mason & Company dissolved due to falling tobacco prices, and a subsequent series of poor business investments and ventures eventually led to the demise of his plantation. In 1825, Mason was forced to mortgage the island to a bank, and in 1829, he took out another

loan on his property. Unable to pay back his debts, Mason lost Analostan Island to foreclosure in 1832. Former Washington mayor William Bradley purchased the island, built a "dancing saloon" and developed it as a resort destination. Bradley let out the property for short-term recreational activities including company picnics, a jousting competition, feasts, dances and athletic competition. During the Civil War, the island was the camp of the First U.S. Colored Troops, an African American infantry regiment composed of freemen and contraband, organized in 1863. At this secluded island site, away from hostile whites who harassed and assaulted them, the black troops learned the basics of army life. They lived in barracks that ranged on either side of the road, across the northern end of the island. Mason's house was occupied by the camp superintendent and was also used as a school. At the end of the Civil War, a temporary pontoon bridge was built across the river from Georgetown to the northern end of the island to provide easy access for departing soldiers.

After the war, the island was again used for recreational purposes, and people came to hunt, fish, swim and picnic. By 1902, the journalist reporting on Analostan Island for the *Washington Times* described the island

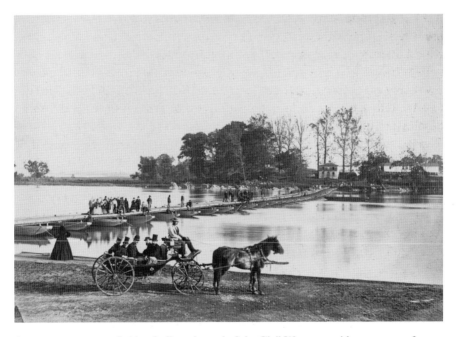

A temporary pontoon bridge, built at the end of the Civil War to provide easy access for departing soldiers, crosses the Potomac from Georgetown to the northern end of Analostan Island where a guardhouse stood. *Library of Congress, Prints and Photographs Division.*

as "desolate in the extreme," with the ruins of the Mason house "hidden in the dense growth of trees which has overrun the island."[39] In 1931, after decades of various uses and decay, the Theodore Roosevelt Memorial Association purchased the island, taking the first step in what would be the redevelopment of the island as a memorial to the conservationist and former president, giving it the name we know today.

WHITEHAVEN

Just northwest from Analostan Island where John Mason was establishing his plantation, fellow agriculturalist Thomas Main was cultivating the property known as Whitehaven on the banks of the Potomac. The property had been part of the extensive landholdings of John Threlkeld, but in 1794, Threlkeld sold the Whitehaven tract to Abner Cloud, who rented the property to Thomas Main. A recent Scottish immigrant to Washington, Main learned about gardening "on the banks of the Tweed," and though he lacked the social stature of John Mason, he shared his enthusiasm for agriculture. At Whitehaven, Main lived in a frame farmhouse—which still stands on its hill on the south side of Reservoir Road overlooking the Potomac—and experimented with cultivating a variety of plants and shrubs, beginning with the grapevine. Main tried to grow vines on the east side of his hill, but after a frost destroyed his crop four years into the venture, he turned his attention to raising an indigenous thorn bush similar to that used extensively in his native Scotland as hedging to divide agricultural fields. The American hawthorn, which Main promoted equally for dividing farm fields or enclosing estate grounds, became his specialty. Main imparted the knowledge he gained from his experimental farming in his writings, including *Directions for the Transplantation and Management of Young Thorn*, providing step-by-step instructions on the cultivation of the plant from seeds. In his book, Main extoled the environmental and economic benefits of live fencing over post-and-rail wood fencing, emphasizing that wood fencing contributed to the scarcity of wood, which in turn increased the cost of fuel and the cost of cultivated land:

> *Practical directions on an important agricultural subject, are detailed in this small though valuable publication. The increasing scarcity of wood in many parts of the country, not only adds to the price of fuel, but of fencing*

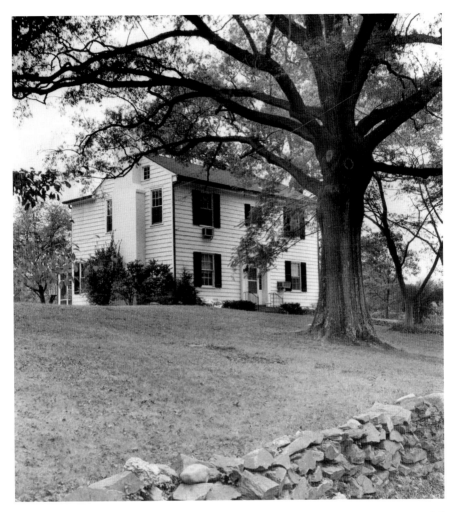

Whitehaven, shown in this 1959 photo, was the home of Thomas Main and his commercial nursery in the early nineteenth century. Whitehaven still stands on its site on Reservoir Road above Canal Road. *D.C. Public Library.*

stuff. Through the latter it adds considerably to the dearness of cultivated land. Every attempt, therefore, to substitute live-fences instead of posts and rails is worthy of notice. The rearing of hedges is one of the most important improvements remaining to be made in rural economy.
—excerpt from Thomas Main's Directions for the Transplantation and Management of Young Thorn, *1807*

THORN HEDGES.

FOR sale by the subscriber, and will
be ready for delivery in the course of the
season, at his nursery near the Little-Falls
of Potomac, upwards of fifty thousand
Seedling plants of the American HEDGE
THORN, from five dollars, to two and
an half per thousand.—Also a few thou-
sand of the EVERGREEN THORN, and
HONEY LOCUST, at different prices.

THOMAS MAIN.

Feb'y 20, 1808. 8t11

Thomas Main regularly advertised his thorn plants in local newspapers until his death in 1814. *Advertisement,* Washington Expositor, *February 20, 1808.*

Main was as much a businessman as an agriculturist, raising and selling his seedlings through regular newspaper advertisements, often encouraging those interested to visit his nursery "near the Little Falls of the Potomak [*sic*]" to be "informed of the advantageous method of hedging used by the subscriber." Main also implored those interested in buying his plants to pay in advance, in order that he "may be able to support an establishment which many gentlemen of the highest respectability have marked as a public benefit."[40]

Thomas Main's experimentation caught the interest of Thomas Jefferson, who became a regular customer and friend. Margaret Bayard Smith wrote that Jefferson took particular delight in two nursery gardens, including that of Thomas Main, "partly on account of their romantic and picturesque location and the beautiful rides that led to them, but chiefly because he discovered in their proprietors, an uncommon degree of scientific information, united with an enthusiastic love of their occupation."[41] Of Main, Smith informs us, "It was he who introduced into this section of our country, the use of the American Thorn for hedges. This was the favorite, though not exclusive object of his zealous industry. Rare fruits and flowers were his pride and delight: this similarity of tastes made Mr. Jefferson find peculiar pleasure in furnishing him with foreign plants and seeds, and in visiting his plantation on the high banks of the Potomac."[42] As president, Jefferson made at least five substantial purchases from Thomas Main between June 1806 and December 1807. One order for "10,000 transplanted plants of the American Hedge thorn" may have been either for Jefferson's beautification of the grounds of the Executive Mansion or for his own estate at Monticello.[43] Following Main's death in 1814, his executor, William Bunyie, continued to advertise his seeds and plants for sale at Main's nursery.

THE VINEYARD

In the early 1800s, John Adlum, a Pennsylvania surveyor who had earned the rank of major in the Revolutionary War and known today as the Father of American Viticulture, purchased two hundred acres of land north of present-day Cleveland Park. Adlum came to the outskirts of the federal city from Havre de Grace, Maryland, where, in 1798, he first took up farming after a lucrative career as a surveyor that included such commissions as surveying the navigability of the Schuylkill River. At his property in the county, known as the Vineyard, Adlum immersed himself in the cultivation of wine grapes. As one of a small group of pioneers in viticulture in the country, Adlum initially tried growing vines imported from Europe. But, as these succumbed to disease and insects, he turned his attention to domestic grapevines and, in the process, received the encouragement of Thomas Jefferson. In a letter to Adlum in 1809, Jefferson reported that he had served a wine made by Adlum from a native Maryland grape alongside that of an imported wine and his "company could not distinguish the one from the other," leading Jefferson to opine, "I think it would be well to push the

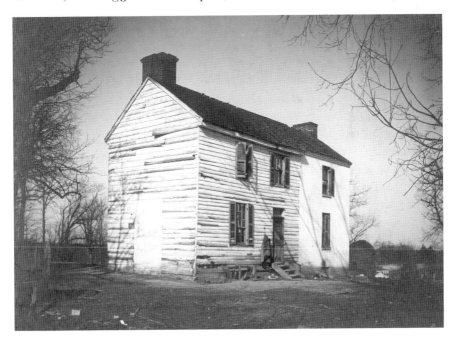

John Adlum's house, built around 1810 on his property, the Vineyard, stood near the intersection of present-day Reno Road and Tilden Street NW. *Historical Society of Washington, D.C.*

culture of the grape without losing our time and effort in search of foreign vines which it will take centuries to adapt to our soil and climate."[44]

Adlum's interest in growing native vines led him to lobby the government to set aside a "portion of the public ground in the City for the purpose of forming a Vineyard, and of cultivating an experimental farm."[45] As he describes it in his memoirs, Adlum wanted to collect cuttings from different species of native grapes, study and grow them on federal land that he proposed be set aside for that purpose and exhibit "a new source of wealth," but Congress rejected his proposal. Concerned that native vines would become extinct, if "not attended to," Adlum undertook the experimentation on his own with "limited means" at the Vineyard.

In 1822, Adlum described his property as a "small Vineyard," which he had planted with cuttings two years earlier. According to Adlum, he had a total of one acre "bearing vines" in 1820 and four more acres under cultivation in 1822, but he anticipated having five additional acres under cultivation by the spring of 1823, for a total vineyard size of ten acres.[46] In early 1823, Adlum advertised the sale of several thousand cuttings "of native and Foreign Grape Vines" at his vineyard, listing a number of varieties, "all of which are good Wine Grapes, very great bearers, and some of them food for the table."

By March 1824, as Adlum's reputation extended beyond the region, his vineyard was featured in the *New England Farmer*:

His vineyard is in a sequestered and lonely situation, surrounded by hills and woods, on the banks of Rock Creek, a small branch of the Potomack. It is planted on a steep declivity, looking to the south, and covering several acres....At the lower verge passes a small brook planted with willows from which a black vine-dresser was very busy in plucking twigs to be used in tying up the tendrils.[47]

Although Adlum was not the only person cultivating vines in the region, he was one of the most successful. He is known as the father of viticulture largely for his cultivation of the Catawba grape. He advertised the variety throughout the 1820s and 1830s, and it is still cultivated by winegrowers today. In 1825, Nicholas Longworth of Ohio visited the Vineyard and obtained slips from Adlum's Catawba vines, which he later cultivated on a vast scale along the Ohio Valley. By the 1850s, Longworth was producing 100,000 bottles of sparkling Catawba annually and advertising it nationally. From Longworth, the Catawba grape was passed to the Hudson

Above: In this 1833 advertisement, John Adlum offers for sale vine cuttings and bottles of wine at his vineyard in Washington. *From the* United States Telegraph, *April 3, 1833.*

Left: The cover of John Adlum's 1823 publication, *A Memoir of the Cultivation of the Vine in America, and the Best Mode of Making Wine. Public domain.*

Springland, built around 1845 on land originally part of Adlum's Vineyard, still stands on Tilden Street NW. *National Register of Historic Places.*

River Valley and spread along the East Coast, becoming a leading grape for winemaking and inspiring Henry Wadsworth Longfellow's "Ode to Catawba Wine":[48]

> *Very Good in its way is the Verzenay*
> *Or the Sillery, soft and creamy,*
> *But Catawba wine has a taste more divine,*
> *More dulcet, delicious and dreamy.*
> *There grows no vine, by the haunted Rhine,*
> *By the Danube or Guadalquiver,*
> *Nor on island or cape, that bears such a grape*
> *As grows by the beautiful River.*

Following Adlum's death, his youngest daughter, Ann Maria, purchased 139 acres of the property where her mother continued to live. Ann Maria and her husband, Henry Hatch Dent, constructed their own house around 1845 on the property, which they called Springland. For the next five years, the Dents lived at Springland with their five children before Ann Maria's death in 1849 compelled her husband to move his family back to his home in Pennsylvania.

LINNAEAN HILL

Linnaean Hill, the headquarters of the National Park Service–Rock Creek Park and now known as the Peirce-Klingle mansion, occupies a terraced bluff above a bow in Rock Creek on Williamsburg Lane south of Peirce Mill. Beginning in 1823, Joshua Peirce (1795–1869), a rising horticulturist, built a house on the property and established a commercial nursery on its then eighty-two-acre grounds. His house, a unique, Federal-style stone building with later Gothic Revival–style additions, was constructed of randomly coursed and locally quarried granite. While the two-story mansion was the centerpiece of Peirce's Linnaean Hill, the property included several other buildings, namely a gatehouse, greenhouses, a barn and two surviving potting sheds that were directly associated with the nursery enterprise.

Joshua Peirce's interest in horticulture came through his father, Isaac Peirce (1756–1841), whose plantation included the flour mill on Rock Creek as well as a sizeable orchard and a nursery that, based on ads Isaac

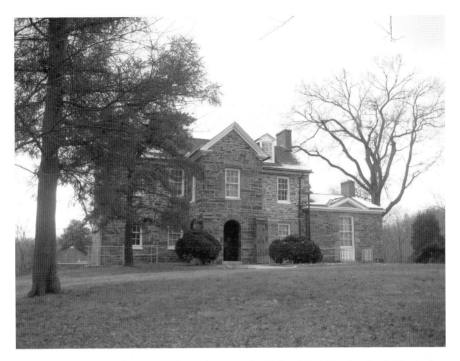

Joshua Peirce's house, Linnaean Hill, now home to the National Park Service–Rock Creek Park, was the center of his commercial nursery on the property. *National Register of Historic Places.*

Peirce placed in the local papers, were a significant component of Peirce's agricultural undertakings:

> *For Sale: On moderate terms, at the Nursery of the subscriber on Rock Creek, three miles from Georgetown, 20,000 ENGRAFTED APPLE trees of different sizes, consisting of nearly one hundred kinds, selected from some of the best orchards in Pennsylvania, Maryland and Virginia.*[49]

In October 1823, Isaac Peirce deeded eighty-two acres of his property along Rock Creek to his youngest son, Joshua, who had been engaged for some time in his father's nursery business and was showing a depth of interest and knowledge in horticulture. Joshua Peirce named his acquired property Linnaean Hill in honor of the famous Swedish botanist Carl Linnaeus. Peirce set about collecting native plants and acquired seeds from respected wholesalers by swapping plants for seeds, and he employed innovative propagating and grafting techniques. In 1824, just one year after

establishing Linnaean Hill, Peirce published a catalogue that advertised a large selection of plants for sale, including evergreens such as pines, spruce trees, firs and hemlocks; deciduous trees; ornamental flowering shrubs; rose bushes; and other trees and plants.[50] The catalogue also provided essays on planting and cultivation, along with horticultural advice that encouraged the sale of his inventory. Louis P. Shoemaker, Peirce's nephew, notes that Peirce cultivated the camellia in great quantity and even described how his stone greenhouse was "crowded with bushes densely covered with the bloom of this conspicuously beautiful flower."[51] In *Peirce Mill: Two Hundred Years in the Nation's Capital*, author Steve Dryden reveals that Peirce "also sold two of North America's more noxious imports," English ivy and multiflora rose, then an ornamental vine and a useful hedging plant. Peirce was a founding member of the Columbia Horticultural Society, an organization established in 1848 to foster the science and practice of fruit growing, and he corresponded with notable nurserymen outside of the District.[52]

In 1825, Peirce placed an advertisement in the *National Intelligencer* listing a huge variety of plants for sale at his nursery, many of which he noted were suitable for "streets and lawns," illustrating that Peirce's business was catering to residents as well as the city and federal governments for the beautification of the developing city. Peirce is believed to have provided botanical specimens for the White House grounds and those of the Capitol, as well as other city parks and public reservations. In addition to his principal nursery at Linnaean Hill, he also owned several other plots of land within the city limits where he raised and sold plants and where customers could more readily make their purchases. By fulfilling a demand for trees, shrubs and flowers, Peirce became a financial success. At his death in 1869, following the post–Civil War building boom, Peirce's total estate holdings were valued at more than $150,000 and his inventory at $23,000, significant sums for the period.

But Peirce's successful commercial enterprise at Linnaean Hill was exceptional. Joshua Peirce, John Mason, Thomas Main, John Adlum and gentleman farmers engaged in experimental farming and animal husbandry represented only a small segment of rural Washington. As the city grew, a more complex rural economy on its outskirts evolved where hundreds of farmsteads, ranging in size and scale, developed to help feed and fuel the city's growing population.

Farms and Farmsteads

While the city of Washington was growing into the nation's capital in the first half of the nineteenth century, Washington County remained sparsely populated and rural. In 1820, there were 2,729 county residents (1,514 white, 168 free black, and 1,047 enslaved) representing just 8 percent of the District's total population of 33,039. By 1850, the number of residents had increased to 3,320, but the county population as a percent of the total District actually decreased slightly. As in earlier decades, the vast majority of the county residents were engaged in farming, including Washington's gentleman farmers. However, major shifts in both the nature of farming and the built environment were underway. Tobacco had essentially disappeared from the rural landscape, and the once-extensive eighteenth-century tracts of land were becoming progressively smaller. The median size of farms was down to about forty acres of land from one hundred or more acres in the previous century. And as farm size decreased, the number of farmsteads increased. Tight clusters of domestic and agricultural complexes surrounded by cultivated fields filled the rural landscape.

As in the previous decades, an uneven distribution of wealth in the form of land, buildings and residents persisted throughout the first half of the nineteenth century. Gentlemen's farms and country estates were one small part of a tapestry of more modest working farms and farmhouses. About 67 percent of county residents were considered yeoman farmers—that is, farmers with modest acreage who worked their own land, in some cases

By the early nineteenth century, District farmers had moved almost entirely away from the cultivation of tobacco toward greater diversity of crops. Two principal developments encouraged this shift. One was the exhaustion of soils due to years of production of the nutrient-depleting tobacco crop, and the other was a growing demand for flour overseas. To accommodate this market, large flour mills were established in the Piedmont region along the Potomac River and later along the Chesapeake and Ohio Canal, convenient to the port at Georgetown. With this demand for flour, millers flocked to the area, cementing the transition in farming away from tobacco to wheat as a primary crop. While the larger commercial mills along the Potomac River catered to this export market, smaller mills such as Peirce Mill emerged along Rock Creek, serving the local community. As the capital's population grew, local farmers further diversified their crop production to accommodate local food needs. In addition to wheat and corn, they planted rye, oats and potatoes (both Irish and sweet); raised cattle for dairying purposes; and were engaged in butter production, meat slaughtering and vegetable gardening. Orchards, which had been a requirement for tenancy of the land in the eighteenth century, were still popular in the mid-nineteenth century but by the end of the century had largely faded from the county's rural lands.

with one or more hired workers or slaves. Yeoman farmers, along with those of fewer means, including free blacks, lived next to one another and to the wealthy landowners alike.[53]

PRE–CIVIL WAR FARMHOUSES

The appearance of the county's mid-nineteenth-century farmsteads is known from the few remaining farmhouses and outbuildings and gleaned from historic photographs, as well as maps, such as the 1861 *Topographical Map of the District of Columbia* by Albert Boschke, along with assessment records and other archival sources. A Civil War circular, recently brought to light, provides additional insight into the character of mid-nineteenth-century rural Washington. After the July 1864 Battle of Fort Stevens, Union officers decided they needed "to acquaint themselves as soon as practicable

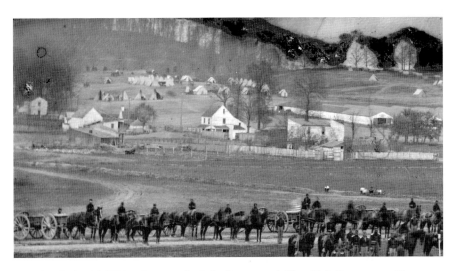

This detail of a Civil War photograph of the Seventeenth New York Battery near Fort Lincoln, around present-day Bladensburg Road and Eastern Avenue NE, offers a glimpse of the types of farmhouses that occupied the District's then-rural landscape. *Library of Congress, Geography and Map Division.*

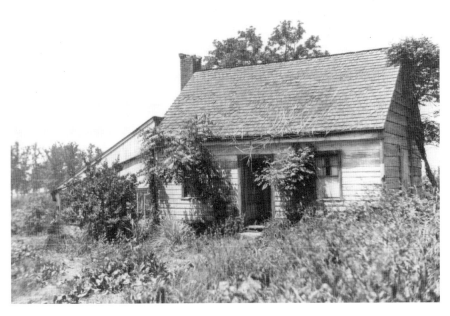

This one-story frame house, identified as being on Rock Creek Church Road when it was photographed in the early twentieth century, was typical of the modest dwelling forms of rural Washington in the first half of the nineteenth century. *Powderly Collection, Catholic University of America.*

with the names condition character &c. of neighboring citizens and to enter all such information in a book to be kept at Brigade Head Quarters for reference." To that end, Union provost marshals went out door-to-door gathering intelligence on the local citizenry in the vicinity of the line of forts and other defenses, including detailed descriptions of the area's farmhouses. Their report, analyzed by historian Timothy Dennée in "A Civil War–Era Dictionary of Washington County, D.C. and Nearby Maryland," offers broad observations on the physical characteristics of rural homesteads.

According to Dennée's analysis, about 80 percent of the houses recorded were of wood frame construction. One-tenth of the residences were of log construction, and only 8 percent of the dwellings were identified as brick or stone. The houses were regularly listed as being painted, whether frame, brick or stone, with white being most common. Nearly all of the frame houses were sided with weather boards, but the records specifically called some "board" houses, many of which were further described as old or shanties. These mid-nineteenth-century farmhouses, once ubiquitous, survive only in limited numbers today, with many in much-altered states and settings. Nonetheless, they offer tangible reminders of the District's rural past.

Wetzel-Archbold Cabin

Identified under the name of "Witzell" as a "one-story brown house" near Battery Cameron in the 1864 Civil War report, the Wetzel-Archbold cabin on today's Reservoir Road is the District's only surviving log farmhouse. It is a one-and-one-half-story building whose initial construction in 1843 consisted of a V-notched single-pen log structure measuring eighteen feet by fourteen feet. In 1850, an addition, also of log, was built to abut the east end of the original building, extending the length of the house by sixteen feet. A string of twentieth-century frame wings was constructed at the rear of the house, including an addition from the 1990s that greatly expanded the modest living quarters. Named for its original nineteenth- and later twentieth-century owners, Lazarus Wetzel and Anne Archbold, the Wetzel-Archbold cabin sits on a one-acre wooded hill above Reservoir Road, a remnant of its historic sixteen-acre tract. Lazarus Wetzel, listed in the 1850 U.S. census as "laborer" and ten years later as "farmer," is a perfect illustration of a yeoman farmer—one who owned his modest tract of land, which he and his family worked themselves. Wetzel purchased the sixteen acres from William Murdock in 1843, planted it with fruit trees and vegetables and

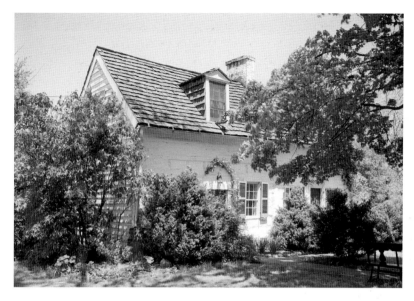

The log core of the Wetzel-Archbold Cabin, shown in this 1937 Historic American Buildings Survey photo, was built in two stages in 1843 and 1850. Greatly enlarged at its rear, the house still stands on Reservoir Road adjacent to Glover-Archbold Park. *Library of Congress, Prints and Photographs Division, Historic American Buildings Survey.*

provided grazing land for his home-use horses and cattle. Wetzel's log cabin, perhaps predating his purchase of the land or built by him, became the nucleus of his small farming operation and home to his family for the next four decades. In 1931, Anne Archbold, heiress to the Standard Oil fortune, purchased the cabin and its surrounding acreage, which remained occupied and undeveloped by the Archbold family until its sale in 1998.

Samuel and Harriet Burrows Farmhouse

Identified under the name of Mrs. Burrows in the Civil War report and described as a "two-story wood colored house in [a] field [in] front of the fort," the Burrows House is a remarkable survivor, largely due to a 1928 move that saved the 1850s house from demolition. In 1857, Samuel and Harriet Burrows purchased an approximately eighty-acre farm near River Road in the Tenleytown area, adjacent to lands where his family had been farming for years. The property, identified as the Phillips farm on the 1861 Boschke Map, may have already included the two-story, three-bay wood frame house into which Burrows and his wife, Harriet, moved with their children, or it

might have been built or rebuilt by them at that time. At the start of the Civil War, shortly after the Burrows family settled down there, the Union army seized fifty acres of their land then under cultivation to provide for barracks, campgrounds and parade grounds associated with the newly constructed and nearby Fort Bayard but left the house and its occupants in place. Although the Burrowses sympathized with the South, they sold milk, vegetables and cattle to the Union quartermaster. For several decades after the war, Samuel and Harriet Burrows resumed farming on their recovered land, raising a herd of milk cows and cultivating winter wheat, corn and oats. Following Samuel's death, Harriet remained in the house until her death in 1923. Five years later, just before the surrounding acreage was developed with houses, a Charles Limerick purchased the house from the developers and moved it from its site below River Road near today's Ellicott Street almost one mile south to Verplanck Place in American University Park. Oral history holds that during the move, the house sat at Forty-Sixth and Davenport Streets for some time, and when it reached Verplanck Place, it rested on its side before eventually being raised to the upright position it holds today.

The Samuel and Harriet Burrows Farmhouse in its current location on Verplanck Place NW, where it was moved in 1928. *Photograph by the author.*

Scheele-Brown Farmhouse

In 1864, butcher Augustus Scheele was living in a two-story house on the west side of today's Wisconsin Avenue in the heights above Georgetown. Described as "drab" in the Civil War report, the frame house was likely painted a dull green or tannish color. Within the year, Scheele had purchased a larger farm property along present-day Foxhall Road and began construction of a new two-story wood frame farmhouse. In 1865, Civil War photographer William Morris Smith captured an image of the house in the mid-ground of his photograph "A View from Georgetown Heights." The new farmhouse, then under construction and shown with its roof unsheathed in the photo, is sited in front of the more modest house that already stood on the propwerty when purchased by the Scheeles.

Scheele, who had worked as a butcher throughout the 1850s and early 1860s, purchased the larger property with his wife so they could have their own farm and establish their own cattle butchery. For ten years, the Scheeles ran the slaughterhouse on the property, a venture that butcher and farmer Walter Brown took over from the Scheeles and continued to operate for the next forty years. The Scheele-Brown slaughterhouse farm was one of many in the District during the nineteenth century. An 1873 newspaper article claimed

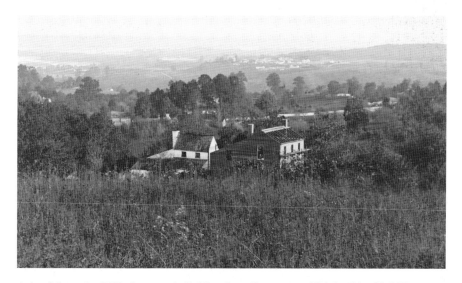

A detail from the 1865 photograph "A View from Georgetown Heights," by Civil War photographer William Morris Smith, shows the farmhouse of butcher Augustus Scheele. The house, under construction in the photo, still stands on Foxhall Road. *Library of Congress, Prints and Photographs Division.*

A MENACE TO T

Slaughter Yards Contaminate the
Water in the Reservoir,

BUT THEY ARE TO BE REMOVED

Colonel Elliott Has Been Investigating
the Matter and Says that "Drovers'
Rest" Must Become a Thing of the
Past—Congress to be Asked for Aid.

"Drovers' Rest" is the name given to a
piece of ground containing about five acres
and situated just above the lower reser-
voir. Here are situated a number of cat-
tle pens, in which cattle are confined by
drovers pending their sale to the butchers
of the city and their subsequent removal
to the slaughter yards, which are in the
vicinity of the reservoir.
Col. George H. Elliott, who is in charge
of the Washington Aqueduct, has for
some time past been observing this place,
and has come to the conclusion that it is a
serious menace to the health of the city of
Washington, and, as a result, has written
a letter to the Secretary of War on the
subject.

THE CATTLE YARDS AND RESERVOIR.
In this letter he recommends that Con-
gress be asked to appropriate $3,500 for the
purpose of purchasing the property already
mentioned. The letter has been indorsed

Left: Drovers' Rest, close to the Georgetown Reservoir, near the intersection of today's MacArthur Boulevard and Reservoir Road, contained a number of cattle pens where cattle awaited their sale and subsequent slaughter at nearby slaughter yards. *"A Menace to the City, Slaughter Yards Contaminate the Water in the Reservoir,"* the Washington Post, *January 8, 1890.*

Below: The Tucker-Means farmhouse at today's Twelfth Place and Upshur Street NE, built about 1854, is shown in this current photo. *Photograph by the author.*

that the District contained ninety-five slaughterhouses, "all around the outskirts of the city, from the Eastern branch to Rock Creek, and even to the Potomac river."[54] The heights above Georgetown on the western part of the county was a particularly popular locale for butchers and their slaughterhouse farms, largely because an 1820 ordinance banned new slaughterhouses south and east of today's Thirty-Sixth Street and Whitehaven Parkway, but also because it was convenient to Drovers' Rest. The rest was established in the 1830s at the intersection of today's Reservoir Road and MacArthur Boulevard, where cattle corrals and slaughter yards, as well as a hotel and tavern for drovers and buyers, grew up around it. Drovers from distant Maryland and Virginia farms herded their livestock there to be rested and fattened for slaughter. Area butchers would then have their purchases herded to their farms, where the animals were slaughtered and the meat readied for sale at local markets. Livestock auctions were held weekly there, and Drovers' Rest eventually became the city's primary wholesale cattle depot.[55]

Although Drovers' Rest, the Scheele-Brown butchery and the land associated with it are long gone, the modest wood frame farmhouse still stands on Foxhall Road, providing a reminder of the area's rural roots and its local dwelling forms.

Tucker-Means Farmhouse

The Tucker-Means farmhouse on Upshur Street NE in the Brookland area is one of the more substantial of the city's surviving pre–Civil War farmhouses. In the early 1850s, after Enoch Tucker sold a 240-acre truck farm east of the Anacostia River to the Union Land Association for its subdivision called Uniontown (today's old Anacostia), he purchased a 50-acre tract in the northeast section of the county and built the still-standing two-story frame farmhouse amid a fruit orchard. Tucker cultivated the fruit trees, which he regularly advertised as being "of the first quality," and sold them both on the property and at his downtown business, E. Tucker & Company, which contained a "full stock of Housekeeping and Builders' Hardware, Mechanics Tools, Guns, Pistols, Fishing Tackle, etc." Later, Lewis Means, a well-to-do Tenleytown farmer and cattle dealer, purchased the property, transferring his cattle operation to the property, which was adjacent to the newly laid Metropolitan Branch line of the B&O Railroad. There, along the tracks, Means established a new drove yard and auction yard, known as the Washington Cattle Market at Queenstown.

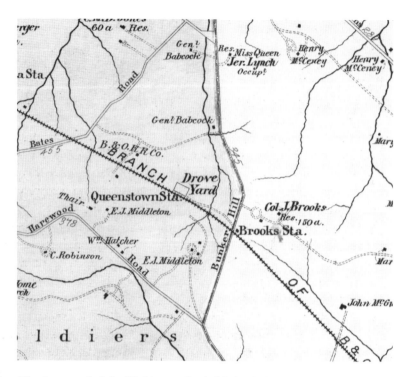

Above: The drove yard of the Washington Cattle Market is shown on this 1879 G.M. Hopkins Map across the railroad tracks from the Queenstown Station. *Library of Congress, Geography and Map Division.*

Below: During the 1880s, the Washington Cattle Market held regular weekly auctions, as advertised in the local *Evening Star*. Advertisement, *the* Evening Star, *April 15, 1885.*

r. connection, and
lst connection, were
ce.
ceeded to the exam-
he members of the
opening service will
: Elder John E. Price,
vard Day. The regu-
0.a. m. and continue
'erence will continue
.t, when the appoint-
announced.
NING OF CHILDREN.
: arose while passing
ood remarked upon
ting children in the
" he said, "in a great
:n are not' in our
f some of our minis-
iurches. There was
some people that the
for 10 or 15 years of
life—and then after
o work to get them

st Chief Cronin.
ENT FIRE COMPANY
:S VIGOROUSLY. i
t of the Independent
iaticipation celebra-

Henry F. Brown and Rose F. McElfresh; Jacob
Talliaferro and Maggie Willis.

BASE BALL.—The game of base ball yester-
day between the Athletics and Nationals re-
sulted in a victory for the visitors by a score of
four to three. At the beginning of the game
both sides pounded the ball, but it soon turned
to a pitchers' game and proved very tame to
the spectators. Poor judgment in running,
bases and costly errors lost the game for the
home club. The Providence and National clubs
will play to-morrow.

WASHINGTON CATTLE MARKET.—Held every
Monday at Queenstown, on the Metropolitan
branch B. & O. R.R., three miles from the city,
Lewis D. Means, proprietor. 101 head of
cattle on the market and sold; best, 5¾ to 5⅜;
good, 5¾ to 5⅝; fair, 5 to 5¼; medium, 4½ to
4⅛; ordinary, 3½ to 4¼c. 488 sheep and
lambs up and sold. Wool sheep brought 5 to
5.40; clipped sheep, 3½ to 4½; spring lambs,
8 to 11c. Cows and calves selling from $30 to
$55 per head. State of the market brisk.

THE NEWSBOYS' AID SOCIETY.—The News-
boys' Aid Society held its regular monthly
meeting in the red parlor of the Riggs house
yesterday afternoon, a large number of ladies
being in attendance. The first vice president,
Mrs. Bishop Andrews, presided. The corres-
ponding secretary read a letter from the presi-
dent, Mrs. Darwin R. James, expressing re-
gret at her unavoidable absence and suggest-

drew into the sta
cheers. An addre
and much enthus

Mexican Clai
A LONG LIST OF (
RATION
CITY OF MEXIC
comes the arbiter
other Central Am
probably be sent
rangement. Mex
tion of her own
These claims dat
grow out of a long
Guatemalans whe
and on Mexicans f
cans have been for
army, and many l
with his own hand
terests in Guatem
fered with. In or
bought a large qua
on which the expe
special order of th
ice had to be se
small portion only
secure evidence to
receipt for these e:
possession of the N
therefore, has a cl
but will obtain rec

Genera

Free Black Farms

In rare but increasing instances, free persons of color owned the land on which they worked, often in sight of farms that were supported by enslaved residents. The 1820 census enumerated 168 free blacks in Washington County, along with 1,047 enslaved persons. The number of free blacks gradually increased before the Civil War, but in 1840, when Mary Ann and Thomas Harris, both black, purchased a 2-acre lot of land just east of Broad Branch Road in today's Chevy Chase, it was rare for African Americans to own their property. The Harrises lived and raised chickens on their property adjacent to the 560-acre eighteenth-century plantation Cheivy Chace, owned by Charles Belt and home to thirteen persons held in bondage. In a recent article, "Free Black People of Washington County," authors Barbara Torrey and Clara Green note that for free black people such as the Harris family to live next to white farmers and their slaves was "an uncomfortable reminder of how tenuous freedom was."[56]

During the 1850s and 1860s, John Payne, a free black carpenter and cultivator, lived with his family among a number of white families, including members of the slaveholding Sheriffs. Payne purchased eighteen acres in 1852 on the north side of Benning Road from white landowner Selby B. Scaggs. Valued at $2,000 in the 1860 U.S. census, his property would later increase to thirty-one acres and included Payne's Cemetery. Payne's Cemetery began as a family burial plot but came to be the second most active African American cemetery in Washington.[57] Other instances of free blacks owning and farming land in rural Washington before emancipation are well documented, such as Basil Guttridge, a freed "gardener" who in 1860 owned ten acres of land near Turkey Thicket in present-day Brookland where he cultivated corn along with Irish and sweet potatoes, and Elizabeth (Betty) Thomas, whose farm property near the free black community of Vinegar Hill in Brightwood was requisitioned during the Civil War by the U.S. Army for the construction of Fort Stevens.

Agricultural and Domestic Outbuildings

Regardless of the size of the farm, farmhouses were just one part of a larger complex of domestic and agricultural buildings. Domestic buildings such as kitchen dependencies, icehouses, meathouses and smokehouses,

springhouses, privies, wells and sheds clustered close to the main house, while barns, stables and other agricultural buildings were constructed away from the house in the fields and more convenient to farming operations. Farm complexes would also have included quarters for enslaved workers. A large percentage of Washington's enslaved lived within the main house or in attached wings under close watch of the owner, but others occupied separate quarters removed from the main residence. These structures, generally built of log or wood, were most likely sited within a fenced compound along with the overseer's house, such as the arrangement at the mansion lot on Notley Young's Potomac River plantation. East of the Anacostia River on Levi Sheriff's plantation, quarters were described as being "distant from each other as well as from the main house," with "gardens, fruit trees, chickens and pigs."[58]

With the exception of Peirce Mill, where several of the buildings associated with the family's farm and milling operation survive, farm complexes as entities are known to us only through the archival record. Historic maps clearly identify clusters of buildings forming area farmsteads, and historic photographs provide evidence of the types of buildings that may have been part of such farmsteads. Period drawings, paintings and descriptions evoke the picturesque character of these farmsteads on the landscape, including watercolors of rural Washington by artist Augustus Kollner in the 1830s and

This 1917 photo shows the Fenwick barn that was part of the nineteenth-century farm of Philip Fenwick, set at a distance north and east of where his domestic complex stood. *National Park Service, Frederick Law Olmsted Historic Site.*

drawings made by Civil War soldiers and officers manning the Union forts and other defenses. In the mid-nineteenth century, Peirce Mill, in particular, with its mill building on the banks of Rock Creek, a miller's house, Isaac Peirce's own house and a tight collection of farm buildings arranged along the surrounding hillside leading up from the creek, appealed to writers and painters. In 1830, an unknown artist painted the mill building and its agricultural setting, and in 1858, photographer Titian Peale captured an image of the mill in one of the earliest photographs of Washington, D.C. In the 1880s, owner Peirce Shoemaker made his own quaint drawing depicting his rural homestead.

Peirce Mill Farm

It struck me as one of the most comfortable and poetical nooks that I have ever beheld. It seemed to have everything about it calculated to win the heart of a lover of nature and rural life. Though situated on the side of a hill and embowered in trees, it [Peirce farmhouse] *commands a pleasing landscape; and it was built upwards of one hundred years ago.... Surmounted as it is with a pointed roof, green with moss of years, and*

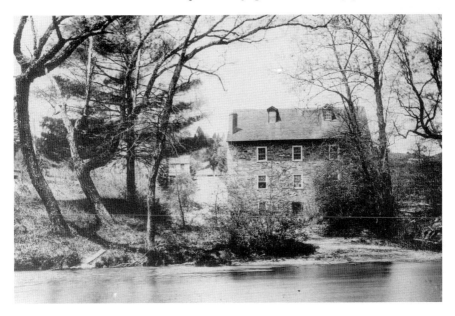

This view of Peirce Mill was taken about 1900 from the east side of Rock Creek. *Library of Congress, Prints and Photographs Division, Historic American Buildings Survey.*

flanked by a vine-covered porch, the vegetation which clusters around it so abundant that one could hardly discover its real proportions. And all the outbuildings were within keeping of the cottage itself. It is, upon the whole, one of the most interesting nooks to be found anywhere within an hour's ride of the Capitol.
—*the* National Intelligencer, *October 20, 1848*

At the time that this 1848 description was written, Peirce Mill had been in operation for almost fifty years. Isaac Peirce, a Pennsylvania Quaker, farmer and millwright, came to the Potomac Valley in the 1780s and married fellow Quaker Elizabeth Cloud. Elizabeth's father, Abner Cloud, operated a mill at the eastern terminus of a canal built to bypass Little Falls on the Potomac River and constructed by the Potomac Company, created in 1785 to improve the navigability of the Potomac River for commerce. In 1794, Peirce purchased his own property, 150 acres of land along Rock Creek that included a preexisting frame house described in the excerpt and a two-story gristmill. The house and mill would grow into a significantly larger working farm and milling complex and remain in Peirce family hands for several generations. Before Peirce built the large stone mill in 1829 that would become the center of his agricultural enterprise, he began by improving the house on the property, planting an orchard and nursery and constructing a series of buildings that would support his farming activities. These included a sawmill, located downstream from the gristmill; a springhouse, in the median strip of Tilden Street; a potato house; and a cow barn, located on the western slope above Rock Creek. Closer to the mill site on the creek, Peirce built two still-extant barns: a stone wagon barn/stable, once known as the Art Barn and now called the Peirce Barn, and a larger stone barn, converted to a residence and known today as the Peirce Still House. The Peirce Still House, part of the Peirce agricultural and mill complex, was originally built in 1811 as a barn but was later converted into a whiskey distillery and then, in 1924, completely remodeled and expanded to become a private residence. In 1876, Peirce Shoemaker, who had taken over the farming operations, added to the complex when he built his own house, Cloverdale, west of the distillery, on the site of his grandfather Isaac Peirce's first residence.

In its first decades of operation in the early nineteenth century, Isaac Peirce operated the grist- and sawmills, ran a nursery and raised and hauled hay, barley, flaxseed and other grains to local customers. He grew fruit trees by the thousands, including twenty thousand engrafted apple trees he advertised for sale in 1814. In 1829, Peirce constructed the substantial stone

mill that would ultimately become the center of operations, run by members of the family, indentured servants and enslaved laborers.[59] By the 1840s, milling had become one of Washington's most dominant industries. Rock Creek had eight mills, including Peirce Mill, up and down its banks, catering to an exclusively local market. They served area farmers whose lands lay within just a few miles of the mills, grinding wheat, corn, rye and other grains for home use and for sale at the local market.

Following Isaac Peirce's death in 1841, his eldest son, Abner, inherited the milling operation and continued the diverse operations of the farm, exclusive of Joshua Peirce's Linnaean Hill nursery, which his father had given him in 1823. In addition to the mill, Abner established a distillery; raised sheep, pigs and cows; and grew large quantities of wheat and corn and smaller amounts of rye and oats. The 1850 census shows that Abner Peirce had 80 acres of improved land and 880 acres of unimproved land that included pasture and woodland. A stonemason by trade, he owned eighteen slaves, five horses, three mules, five "milch" cows, four working oxen and other cattle, as well as fifty sheep and nineteen swine. Abner also raised bees, cultivated potatoes and made 156 pounds of butter that year. For the rest of the nineteenth century until 1890, when the Peirce Mill site was incorporated into the newly established Rock Creek Park, Peirce family heirs continued to operate the mill.

While Peirce Mill is the only agricultural complex within the city that is architecturally intact, other complexes known to us through historic photos reveal the nature and type of agricultural and domestic buildings that occupied the rural landscape. Almost every farm, no matter how small, would have had a barn for livestock, grain and/or equipment. Other buildings, such as detached kitchens, smokehouses, meathouses and springhouses, also known as cool houses or milk houses, were common appurtenances of almost every rural property. Because these outbuildings were part of the domestic, rather than agricultural, functioning of the farms, they tended to be clustered close to the main house or at least incorporated into a domestic lot or yard.

William Hickey's Greenvale estate and working farm, on land now occupied by the National Arboretum, included an impressive Greek Revival–style brick mansion and, in juxtaposition around it, a tight collection of frame agricultural and domestic outbuildings. These buildings and outbuildings supported a sizeable farming operation that consisted of 120 acres of improved land planted with corn, oats, rye, potatoes and market garden produce that housed numerous livestock, including horses, mules, seven milk cows, twelve other cattle and eleven swine. A frame barn banked into the

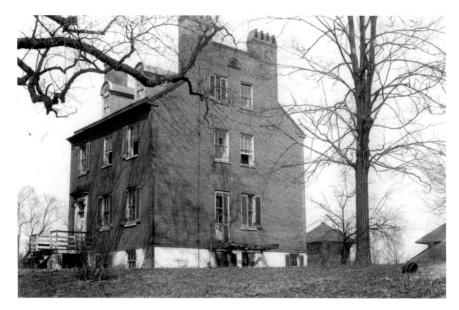

The Greenvale estate and working farm of William Hickey showing the main house with outbuildings at its rear. *Historical Society of Washington, D.C.*

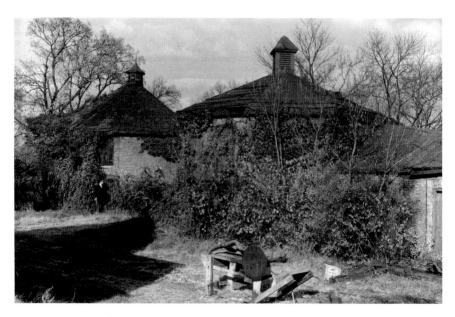

Icehouses, shown in a 1936 Historic American Buildings Survey photograph of the former Ruppert farm, were critical to the nineteenth-century slaughterhouse operations of Anton Ruppert. *Library of Congress, Prints and Photographs Division, Historic American Buildings Survey.*

hillside likely would have housed Hickey's livestock and provided for the storage of grain. The barn stood adjacent to what appear in photographs to be a corncrib and either a smokehouse or meathouse immediately behind the main house.

While many of the agricultural buildings and outbuildings served general farm purposes, others were specific to the particular activities of the farm they served. The farm of Anton Ruppert, which once stood at the intersection of today's New York Avenue and Bladensburg Road NE, contained an important collection of agricultural buildings associated with Ruppert's slaughterhouse business. A German-born butcher who came to Washington in 1852, Ruppert established his first slaughterhouse on Seventh Street NW, just north of the city's limits at today's Florida Avenue, but in 1865, he moved his business farther east. He purchased a thirty-three-acre tract of land along the new Washington branch of the B&O Railroad line and expanded his slaughterhouse operation. In a tight cluster around an eighteenth-century farmhouse on site, Ruppert built stables for horses and cattle, long sheds for curing and smoking meats, corncribs, two icehouses for keeping meat cold and other farm buildings.

Barns

A variety of barn types would have served both the general and particular agricultural needs of area farms. Dairy barns, bank barns, wagon barns and, at one time, tobacco barns dotted the rural countryside. Today, the wagon barn adjacent to Peirce Mill, two barns at the former St. Elizabeths Hospital and two barns at the Franciscan Monastery are the only known surviving barns in the District.

A variety of barns that served both general and specific farm needs were once a common feature of the rural landscape. The barn/wagon shed at Peirce Mill, shown here in a 1936 photograph, is one of only a few surviving barns in the District. *Library of Congress, Prints and Photographs Division, Historic American Buildings Survey.*

The smokehouse and corncrib at Greenvale. *Historical Society of Washington, D.C.*

Corncribs

Corncribs were generally long and narrow wood frame structures that were designed to provide maximum air circulation in order to dry corn. Corn cribs typically had at least two openings—one near the top for loading and one near the bottom for unloading. The corncrib at Greenvale was raised on a stone foundation and featured slatted wood walls for air circulation. As would be expected, the building had separate openings—one in the upper wooden section for the loading of corn and two in the lower foundation for unloading the corn. A wide-eaved, hipped roof protected the corn from rain.

Icehouses

Icehouses were built to store large quantities of ice over the spring and summer seasons. Typically, large pits were dug into the ground, and brick or stone walls, capped with roofs, were built above them. Ice, gathered from frozen ponds or waterways, was loaded into the house and stacked

on top of layers of sawdust. The ice melted together to form a mass and would then be chipped away for use. The two icehouses at the Ruppert farm photographed by the Historic American Buildings Survey before their demolition were sizeable two-story brick buildings, capped by pyramidal roofs and housing two separate chambers. Frozen and cut on the property, the ice would be packed into the upper chamber, while the lower chamber would be filled with the racks and barrels of meat to be kept fresh while awaiting transport to market.

Smokehouses and Meathouses

The smokehouse or meathouse was typically a square-plan structure covered with a hipped roof and featuring a door in one wall and vented opening in another. Smokehouses, used to shelter meat in the curing process, were typically constructed of brick or stone since a fire would be built on the floor of the building to smoke the meat, which hung from S-hooks near

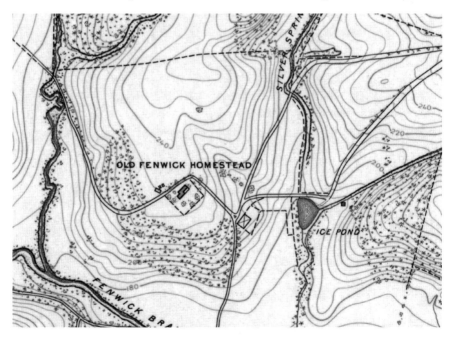

A detail from the 1892 Coast and Geodetic Survey, District of Columbia, shows the ice pond on the "Old Fenwick Homestead," created by damming the stream. In winter, it would have provided ice for the farm's icehouse. *Library of Congress, Geography and Map Division.*

the center of the structure.[60] Ventilation slits were cut into the masonry walls to provide oxygen for the fire. In some regions, however, where wood frame smokehouses were also common, the fire would have ventilated readily without slits. Unlike smokehouses that required fire to cure the meat, meathouses simply held vats in which meats could be pickled or brined. One District meathouse, built around 1836 to cure and store meat for the residents at the Georgetown Visitation Convent and Preparatory Schools, still survives on the site.

Springhouses

Springhouses, generally low-slung buildings constructed of log, stone or brick, were erected directly over springs and often banked into the terrain. The walls of the structure created a shallow pool of water in which vessels such as pans, tubs and jars for milk, cream and other perishables could be placed on slightly submerged stone or brick shelves to remain cool in an era before refrigeration. Springhouses were covered with sloped, gabled or pyramidal roofs with interior ceilings open to the roof structure, or fitted with a loft level for storage. In rural Washington, where butter making was common, springhouses were prevalent, and several springhouses survive: the stone Peirce springhouse above Peirce Mill, the Springland springhouse on Springland Lane NW and the Fenwick Farm springhouse.

The Peirce springhouse, built in 1801, is the oldest surviving example. Located in a triangular shaped hollow now part of a median strip between the two lanes of Tilden Street NW, it is a one-and-a-half-story stone structure, covered with a pitched gable roof, sheathed in shingles. The building, banked into its site, features the springhouse on the first floor and, atypically, a finished room on the second, heated by a fireplace, as evidenced by the stone chimney on the building's western elevation.

The springhouse at Springland was historically part of the Springland estate, built around 1845 on a portion of John Adlum's Vineyard by his daughter and her husband. The springhouse is a fieldstone structure banked into its sloping site with two sources of water that are channeled into the building beneath the sill of a door on the building's west elevation. The water collected in a trough where vessels of milk would have rested.

The stone and brick Fenwick Farm springhouse, located on the Lowell School property on Kalmia Street off upper Sixteenth Street NW, is the only remnant of the Fenwick farm, which occupied the site. The 124-

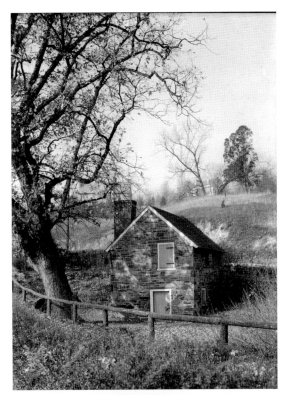

Right: The Peirce springhouse, built around 1801 and pictured here in 1936, is the oldest of three known surviving springhouses in the city. It stands in the median strip on Tilden Street just above Rock Creek and Peirce Mill. *Library of Congress, Prints and Photographs Division, Historic American Buildings Survey*.

Below: This photograph of a since-demolished domestic springhouse at Greenvale shows the low-slung building nestled into its terrain. Its brick walls, built around the spring, and covered with a shed roof, provided a cool storage place for milk and other perishables. *Historical Society of Washington, D.C.*

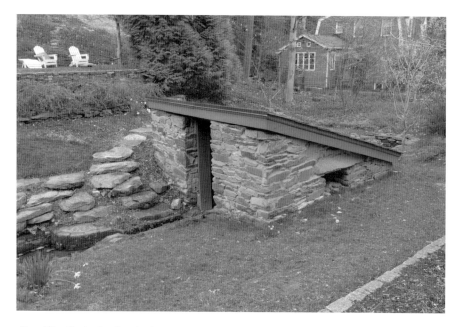

Above: The Springland springhouse on Tilden Street, west of Reno Road, was built around 1845. *Photograph by the author*.

Below: The Fenwick farm springhouse, on today's Lowell School campus, was a critical component of Philip Fenwick's farming operation, which in 1850 included the production of 312 pounds of butter. *Photograph by the author*.

acre property, described as "well wooded and watered," was owned in the pre–Civil War years by longtime area farmer Philip Fenwick and included a farmhouse, agricultural buildings and the surviving springhouse. Fenwick cultivated wheat, oats, rye and other grains on his farm and, in 1850, produced 312 pounds of butter, putting his springhouse to good use. Although no longer necessary, the presence of these few surviving agricultural and domestic outbuildings serve to remind us of the cultural landscape of a rural Washington whose owners lived a largely self-sufficient existence.

6

Shifting Landscapes

In the decades before the Civil War, the Washington County landscape remained intensely rural and dominated by agriculture. At the same time, new land uses, progressively introduced onto county lands, contributed to a shifting cultural landscape. Educational and institutional complexes, recreational facilities, cemeteries and the city's first residential subdivisions found new homes on the open land, repurposing the former farms and fields for their own, new uses that catered to the desires and demands of a growing city.

As early as 1821, Columbian College, belatedly founded to fulfill George Washington's desire for a national university in the District of Columbia, was built on rural county land that would eventually give rise to the name of today's Columbia Heights neighborhood. In 1852, the U.S. Congress selected the farm of Thomas Blagden on a wooded bluff overlooking the Anacostia River in southeast for the location of St. Elizabeths Hospital, the country's first large-scale mental hospital. Also in 1852, after purchasing the 200-plus-acre estate of George Washington Riggs, the government opened the U.S. Military Asylum (called the Soldiers' Home, now officially the Armed Forces Retirement Home) to its first cadre of veterans on the site. In 1854, farmer Enoch Tucker sold his 240-acre farm to the Union Land Association for its development of Uniontown, the city's first suburb. That same year, an act of Congress established Glenwood Cemetery—the District's first private cemetery—on what had been Clover Hill farm. And in 1856, two years

after unsuccessfully subdividing his own land for suburban residential purposes, the noted philanthropist Amos Kendall donated 2 acres of his property for the establishment of the Columbian Institution for the Deaf, Dumb and Blind, the precursor to today's Gallaudet University, one of many farms that would be taken over for educational purposes.

INSTITUTIONAL FARMING

While new land uses such as those described above would ultimately alter the county's rural landscape, they also helped to preserve much of its open space and even its agricultural character. Many of the institutions that moved to the county pursued agriculture more aggressively than the farms they had replaced, and many of the former farmhouses and country estates were repurposed as administrative buildings or living quarters, just as new agricultural buildings were constructed. In some instances, the institutions continued farming well into the twentieth century, beyond when traditional farming had disappeared. The Soldiers' Home, Gallaudet University and St. Elizabeths Hospital, for instance, all had extensive farming operations that were critical to their existence.

When the U.S. government purchased the farm of George Washington Riggs for use as a home for soldiers, Captain Robert Anderson had already conceived the institution as a working farm: "The use of the lands for agricultural purposes, the sale (if near a good market) of surplus vegetables, &c., the raising of cattle, hogs, poultry, &c., will render the purchase of commissary stores nearly or entirely unnecessary."[61] The Riggs–Soldiers' Home property was a 197-acre working farm north of the city limits that banker George Washington Riggs had purchased ten years earlier, at the age of twenty-nine. Drawn to the property's "commanding site overlooking the city," its cornfields and its "thriving orchards of well selected fruit," Riggs contracted with Washington carpenter and builder William H. Degges to design and build a country house on his new property, which he called Corn Rigs. The name has been attributed to a popular early-nineteenth-century tune, "Corn Rigs Are Bonie," based on a poem by Scottish poet Robert Burns.[62] In this case, "rigs" would have had pertinent double meaning, not only referring to the Scottish word *rig*, for ridge or a furrow, but also to the name of the owner. The house is now known as the Lincoln Cottage for its later association with President Abraham

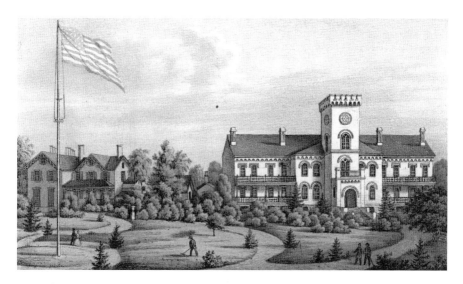

The U.S. Military Asylum (today's Armed Forces Retirement Home) was established in 1852 on the country estate and working farm of George Washington Riggs. Riggs's country house, now known as the Lincoln Cottage and still standing on the grounds of the Home, is shown at left in this nineteenth-century color rendering. *D.C. Public Library, Washingtoniana Division.*

Lincoln, who used the home as a seasonal retreat. He worked on drafts of the Emancipation Proclamation there.

Degges's plans for the house reflected a Gothic Revival style of architecture that was then sweeping across England and America, fostered in part by the Neogothic imagery in the novels of Sir Walter Scott. The building style is characterized by its asymmetrical forms and features, including wraparound porches, tall and projecting gables with carved wood cornice boards and clustered brick chimneys with decorative brick detailing, picturesque qualities that lent themselves to the rural landscape. To enhance the setting further, the designers refined the landscape to contain winding walking paths, plantings and garden ornamentation that added to the picturesque character of the country retreat. In designing Corn Rigs, Degges would have been aware of the work of architect Alexander Jackson Davis and landscape designer Alexander Jackson Downing, who were chief promoters of the Gothic Revival and other Romantic styles, primarily through their respective publications, *Rural Residences* (1837) and *Treatise on the Theory and Practice of Landscape Gardening, Adapted to North America: With a View to the Improvement of Country Residences* (1841). Downing's *Rural Residences*, with its heavily illustrated drawings of country cottages, was widely disseminated,

garnering widespread acceptance for a variety of Romantic styles, from Gothic Revival to Italianate villa.

For ten years, Riggs found solace at his rural retreat, which he referred to as his "little farm." In 1850, he wrote a friend that he was living quietly in the country. Yet before the end of 1851, Riggs announced the sale of his property to the U.S. government for a military asylum. As the Soldiers' Home grew to accommodate hundreds of residents over the next decades, it also expanded the cultivation of the land to include extensive orchards, vegetable gardens, horses and cows. The institution hired a farmer and gardener and paid the residents to work in the fields. In 1862, the resident gardener, an Irish immigrant, was given a "house rent free and the privilege of keeping one cow—without fuel from the farm or any other allowance whatsoever."[63]

Although the Soldiers' Home never achieved self-sufficiency, farming remained a critical component of the institution well into the twentieth century. In 1909, the annual report for the Soldiers' Home noted that over 120 acres were under cultivation, 25 acres of which were used for "ensilage"—the storage of fodder such as hay or corn for livestock feed. A sizeable dairy, which at one point counted 150 Holstein cows in its herd, was critical to the economy of the Soldiers' Home, as well as a big attraction for visitors and students. Local schools participated in educational programs at the dairy, and federal agencies worked with veterinarians at the home to develop experimental breeding. As the dairy operation expanded, so did farming. Fields were cultivated to provide feed for cattle, and new barns were erected, specifically designed and built for dairy cattle.

After the Civil War, while the Soldiers' Home continued to grow its agricultural operations, it also began an ambitious program to beautify the grounds and open them up for the public's enjoyment of rural Washington. Ten miles of roads for horseback riding and for driving horse-drawn carriages and marked by architecturally designed entrance gates were built to welcome the public. The Soldiers' Home and its pastoral setting quickly became a popular destination: "The grounds now consist of 502 acres, beautifully laid out in walks and drives, interspersed with lawn and woodland so attractive that it has become the favorite park for driving to the residents of the city."[64] In 1870, an article on the environs of Washington in the *New York Times* admired the pleasure grounds and working farm of the Soldiers' Home: "They are laid out in pleasant drives over well graveled roads, shaded avenues, with now and then a small fish pond, and every other possible attraction for either the sentimental or

Farming at the Soldiers' Home, which included a sizeable dairy herd, was critical to the existence of the institution and also a big attraction for visitors. *D.C. Public Library, Washingtoniana Division, Dig DC Collection.*

practical visitor. To the latter, the vegetable garden and fine fields of grain are objects of unfailing admiration."[65]

In the early 1870s, the Soldiers' Home acquired additional surrounding acreage, including Harewood, the abutting 191-acre country retreat and farm of William Wilson Corcoran. Corcoran had purchased the property—a working farm—in 1852, just after his former business partner, G.W. Riggs, had sold his own property to the government for the Soldiers' Home. The cultivated but hilly and wooded land was said to have been named by Corcoran for its large population of rabbits. Upon his purchase of the property, Corcoran remodeled an existing farmhouse, added numerous outbuildings and hired horticulturist John Saul to enhance the grounds with orchards, allées of ornamental trees and picturesque and winding paths that led from the main entry at the eastern edge of the property at Harewood Road through the woods to the farmstead:

> *In advancing over the fine, firm road which leads from the gate toward the dwelling house and its surroundings, one is instantly reminded by the careful cultivation, skillful laying out of the grounds and extreme neatness of everything, of the country residences of the English gentry. As you approach the family mansion…the impression is by no means diminished, and the*

various buildings might be taken for a tasteful little village, harmonious though varying in style. The imagination has to be quite active to devise uses for all these tenements, for after enumerating farmhouse, gardener's lodge, stable, barn, dairy and corncrib, there would still be room to spare.[66]

Among the many outbuildings was a stone lodge house, the only surviving building of Harewood, located at the original entrance to the property on Harewood Road NE. Designed by architect James Renwick and built in 1856–57, the lodge, with its rustic stone walls and steep mansard roof, is an early example of the Second Empire style in America and the first use of the style in the District. Having experimented with it at Harewood, James Renwick would fully embrace the style for his design of three buildings that played an important role in promoting the prolific use of the style nationwide: the Corcoran Gallery of Art (now the Renwick Gallery) in Washington (1859), the Charity Hospital of New York (1858–60) and Old Main, Vassar College, in Poughkeepsie, New York (1861–64).

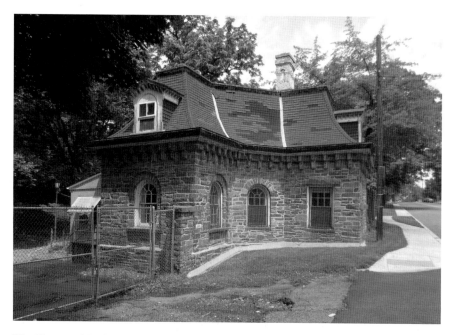

The Harewood Lodge on Harewood Road in Brookland, built in 1856–57, historically served as the entry gate to William Wilson Corcoran's Harewood estate. Designed by James Renwick, architect of the Smithsonian Castle and Corcoran Gallery of Art (now the Renwick Gallery), the lodge, with its distinctive mansard roof, survives as an early example of the Second Empire style in America. *D.C. Historic Preservation Office.*

At the start of the Civil War, as William Wilson Corcoran, a well-known Southern sympathizer, sat the war out in Europe, his property was confiscated to serve as a military hospital. Harewood Hospital was erected in the field east of Corcoran's house, while the house became the quarters for the surgeon in charge, the outbuildings the nurses' quarters and the stables a sutler's store. After the war, Corcoran reclaimed his rural retreat and its fields, which though trampled were recovered. In 1870, Corcoran again had his acreage under cultivation primarily with Irish and sweet potatoes and market produce, along with about a dozen livestock. At the time of its sale to the government for expansion of the Soldiers' Home grounds two years later, the property was described as a "neat and well cultivated farm." Once acquired, Harewood became the center of the Home's vegetable farming and dairy operations, with the dairy barns and horse stable clustered east of Corcoran's house. Unlike Riggs's house (Lincoln Cottage), which still stands at the north end of the Soldiers' Home, Corcoran's house was later demolished, along with its outbuildings and the later farm buildings, leaving only the Harewood Lodge from Corcoran's period of ownership.

As at the Soldiers' Home, agriculture was a critical component of St. Elizabeths Hospital, not only to the self-sufficiency of the institution but also

The Cow Barn at St. Elizabeths Hospital, built in 1884 and pictured here in 2004–5, survives from the institution's agricultural days. *Library of Congress, Prints and Photographs Division, Historic American Buildings Survey.*

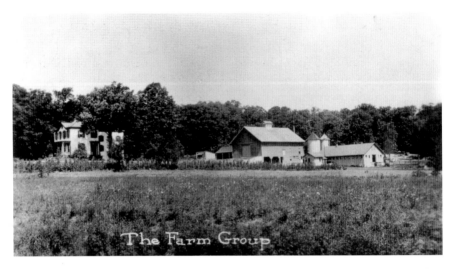

This 1930s photograph of the "Farm Group" at Gallaudet shows expanded farming operations of the university on the site of Amos Kendall's Kendall Green farm. *Gallaudet University.*

to the therapeutic treatment of the patients who were employed to work the farm. In 1869, the hospital purchased the present East Campus for the expansion of its agricultural operations and began the construction of barns for livestock and feed and houses for the farm staff. Upon completion of a cow barn in 1884, the annual report for St. Elizabeths Hospital noted that the new building would "afford ample room for the hay and other forage crops cut from the farm as well as commodious quarters for our growing herd of milch cows."[67] The cow barn, still standing on the East Campus, accommodated the hospital's herd of about one hundred dairy cattle and the associated dairying operations.

In 1856, when Amos Kendall first established what would become Gallaudet University on his property known as Kendall Green, he retained his house and associated farm complex, separated from the new school buildings by an open field. Upon his death in 1869, the school gained ownership of the compound, and farming became an integral part of the institution. The college converted the main residence at Kendall Green into a home for the school's farm manager and expanded the school's farming operations. During the twentieth century, new agricultural buildings were constructed to accommodate the increased farming activity, including a sizeable thirty-stall dairy barn, built in 1911.

Recreational and Suburban Villas

While the pleasure grounds at the Soldiers' Home provided Washingtonians with a much-desired recreational venue in the country, they were not the only such locations in rural Washington. Almost immediately after the establishment of the capital, Washingtonians were quick to find sources of leisure at its outskirts. As early as 1802, a mile-long circular racetrack, best known as the National Course but also called the Washington Course, was located in the area around present-day Fourteenth Street, north of Euclid Street and south of Park Road. The extravagant horse racing events there, held over three to five days in May and October, attracted thousands of city residents to the country and included a wide range of spectators:

> *There were about 200 carriages and between 3,000 and 4,000 people—black, white and yellow; of all conditions, from the President of the United States to the beggar in his rags; of all ages and of both sexes, for I should judge one-third were female.*[68]

Several other race courses were located outside the city, including in Congress Heights, Bennings, Ivy City and Brightwood. The small crossroads community of Brightwood, at the juncture of today's Georgia and Missouri Avenues, developed into a resort destination, with horse racing just one of its attractions. The half-mile Brightwood course, first known as the Crystal Springs Course (later as the Piney Branch Race Course or the Brightwood Driving Park), was located southwest of the crossroads, closer to present-day Sixteenth Street and Colorado Avenue. Opened by 1857, the site had betting and its own hotel, the Piney Branch Hotel, drawing regular crowds and overnight visitors. Stagecoaches operated twice daily trips and "three on Sundays" from various points downtown to the racetrack, and a grandstand "capable of seating one thousand persons" was erected for the "comfort of visitors."[69] The Crystal Springs resort, established on the site of an abundant spring just west of today's Sixteenth and Kennedy Streets, further enticed residents to Brightwood. The springs apparently provided a popular picnic spot in the mid-1800s, and by 1863, the resort complex, consisting of several pavilions and a hotel, had been built on the site.

These recreational attractions, the surrounding countryside and cooling breezes during the hot summer months enticed many city dwellers to build houses in the country. Like those erected fifty years earlier on the bluffs above the original city boundary, these country houses represented a return to

A detail from the "Topographical sketch of the environs of Washington, D.C.," 1867, shows the Crystal Springs resort, the Piney Branch Race Course, and its adjacent Piney Branch Hotel near Brightwood. *Library of Congress, Geography and Map Division.*

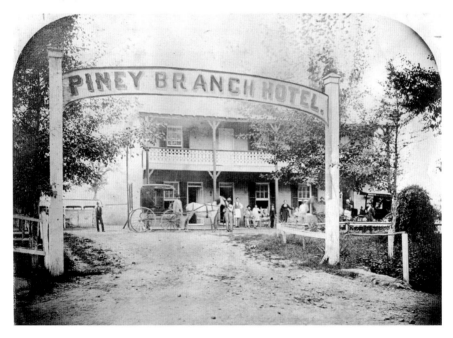

The Piney Branch Hotel at Brightwood, shown in this late nineteenth-century photograph, provided accommodations to guests attending the popular horse racing and other events at the resort destination. *Historical Society of Washington, D.C.*

nature and a retreat from the rigors of the urban world. As in the past, these country houses might include large farming operations, small garden plots or even formal gardens. While wealthy Washingtonians such as Corcoran and Riggs lived the life of country gentlemen, members of the city's rising merchant class began to enter the country house market. These new buyers, seeking the same healthful benefits as the wealthy, did not necessarily limit their experience to summers or weekends, however, but began instead to build suburban villas for permanent living. Traveling to and from their jobs in the city, they became Washington's first commuters. Similarly, these new property owners also maintained orchards, cultivated fields or garden plots for produce for their own consumption.

One such buyer, Benedict Jost, a merchant who worked and lived in downtown Washington, saw a development opportunity for suburban living on the outskirts of Brightwood, with its rural land and adjacent resort attractions. Born in Switzerland in 1807, Jost immigrated to America and settled in Washington in the late 1840s, where he went from being a hotel keeper to a merchant. According to his obituary in 1869, Jost operated a saddle and harness business in his early years in Washington but later ran a wholesale liquor store where he specialized in imported wines. This trade—confirmed through regular advertisements for Jost's imported liquors in the *Daily National Intelligencer*—was clearly good to him, since by 1859, he had amassed enough money to purchase a twenty-four-acre farm property in Brightwood and build the still-extant Italianate-style brick country villa on the site. Jost originally built the house for rental income, advertising it as a "residence for a fashionable family" and touting its convenience "within half an hour's drive from the President's Mansion":[70]

> *For Rent: A new first-class Brick House, built in the best and most convenient manner, containing a large parlor, nine rooms, one bath-room, and two capacious dry cellars. There is a back building attached, containing a kitchen and two bed-rooms for servants; also a pump of pure water and a carriage house and stable. The house is well adapted as a residence for a fashionable family. It is situated in the most healthful part of the District of Columbia, a short distance from the residence of Major Blagden on the Piney Branch road, and within half an hour's drive from the President's Mansion. Possession can be given the early part of July next week. For terms, apply to B. JOST, Wine and Liquor Merchant, no. 131 Pennsylvania Avenue, near Seventeenth Street.*
>
> —*advertisement,* Daily National Intelligencer, *June 2, 1859*

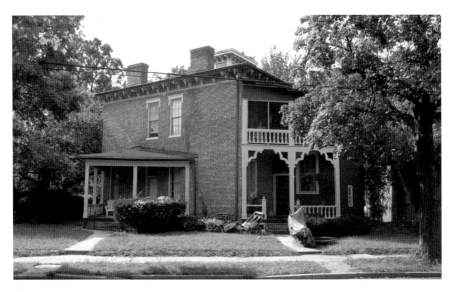

The Jost-Kuhn house, built in 1859 by Benedict Jost, stands in the 1300 block of Madison Street NW. The street façade, shown here, was historically the rear of the house. The front faced south to the city. *Photograph by the author.*

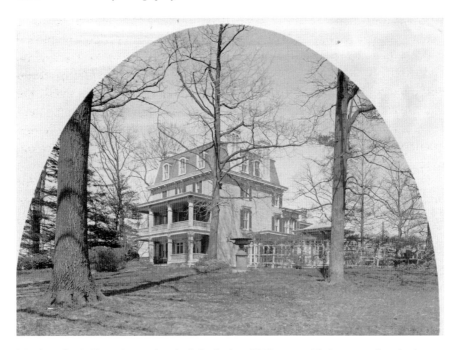

Matthew Gault Emery's mansion, built in the late 1850s, was sold almost one hundred years later to the city by his heirs. The house was demolished sometime after 1946, and a playground was built on the land. *Historical Society of Washington, D.C.*

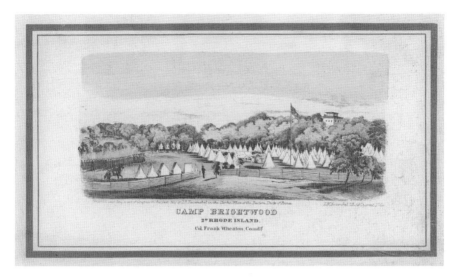

CAMP BRIGHTWOOD
2ND RHODE ISLAND
Col. Frank Wheaton, Comdr

This Civil War drawing shows the Emery mansion on the height of a hill overlooking Camp Brightwood. *Courtesy of the Library Company of Philadelphia.*

At the time of his death ten years later, Jost no longer rented the house out but lived there with his family. In the 1880s, after Jost's widow remarried and lost the property according to the terms of her husband's will, the house and its twenty-four acres were purchased by piano dealer Gustav Kuhn and his wife, Louisa. In addition to maintaining their piano business, the Kuhns farmed their newly purchased land, at least until a fire disrupted their agricultural endeavors: "Gustave Kuhn's barn, carriage house, grain-house, grain, carriage, dog-cart, horse, and a cow, on his farm out near Brightwood, were burned. The origin of the fire is unknown and the loss $1,500."[71]

In the late 1850s, around the same time that Benedict Jost was building his house, local builder, stonemason and later mayor of Washington Matthew Gault Emery purchased twelve acres of land just east of the Brightwood crossroads and did the same. On a rise of land overlooking the city, Emery built a robust, Second Empire–style house that featured a double-story porch facing south to the city. During the Civil War, Captain Emery led the local militia, and his hilltop property became home to Camp Brightwood, a signal station where soldiers used flags and torches to communicate with nearby Fort DeRussy.

7

THE CIVIL WAR

We are buzy in building a battery.... [I]t holts about too thousand mens...yet we
cut down orchards with fine apple and peach trees and also some large cornfields
we have destroyed too houses that were in our way to build the battery.
—letter from Adam S. Bray of the Third Pennsylvania Reserve stationed at
Camp Tenally to his brother, August 1861

I f the agricultural use of land in Washington County was already showing signs of transition in the mid-nineteenth century, the Civil War would further compound it and prove to be an important turning point in the transformation of rural Washington. In *Reveille in Washington 1860–1865*, historian Margaret Leech put it more emphatically: "The farmers were ruined. Not only were their orchards and vegetable gardens trampled and their fields filled with tents, but the very face of their land was changed, as its soil was shifted into high mounds, and deep ditches."[72]

THE NECESSITIES OF WAR: MILITARY TAKINGS

The District of Columbia has no natural topographic or geographic features to aid in its self-defense. As a low-lying city along the banks of the Potomac River across from Virginia, the heart of the Confederacy, it was vulnerable to attack by land and water.[73] Sobered by defeat at the First Battle of

Manassas in July 1861 and fearing that Southern leaders were intent upon capturing Washington, the Union army began construction of a system of forts and batteries and mounting guns around the city. By the end of 1861, the defenses of Washington would consist of a thirty-seven-mile ring of 48 military posts and battlements along the city's ridges, complete with trenches, rifle pits and military roads.[74] At war's end, Washington's defensive system totaled 164 forts and batteries, including 68 major enclosed forts. The main forts, placed at half-mile intervals, were constructed of timber felled on the land and surrounded with *abatis*—a field fortification of cut trees laid with the sharpened tops directed toward the enemy. The ground in front of the forts was cleared of standing timber for a distance of two miles, and the land between them was similarly cut for a clear line of sight and communication. The forts and batteries, the massive earthworks, lines of rifle pits and military roads, including those laid to link the forts, were all built on and cut into cultivated fields, orchards and farmsteads.

Farmers whose lands were seized were given no choice or recourse. John Gross Barnard of the U.S. Army Corps of Engineers, in charge of the construction of the defenses, summarized the effort in a report at the end of the war:

> *The sites of the several works being determined upon, possession was at once taken, with little or no reference to the rights of the owners or the occupants of the lands—the stern law of "military necessity" and the magnitude of the public interests involved in the security of the nation's capital being paramount to every other consideration. In one case a church, and in several instances dwellings and other buildings were demolished, that the sites might be occupied by forts. Long lines of rifle trenches and military roads were located and constructed where the principal of defense or the convenience of communication required them without regard to the cultivated fields or orchards through which they might pass.*[75]

To add to the hardship, the government did not compensate property owners for the use of their land until after the war, and even then, the amount of money paid out did not begin to cover the landowners' losses. Some property owners attempted to file claims for compensation before the end of the war but were invariably rejected. Local farmer and Washington County road supervisor B.T. Swart, who owned the two-hundred-acre farm on which Fort DeRussy was built, filed his first claim in December 1862, arguing that the army occupation not only prevented him from cultivating his land to

support his family but also felled his timber for buildings, removing the only other source of income that his land provided. Swart asked for rent on his land and the ability either to use his own wood or to "receive recompense for it." Swart's request was rejected.[76] After the war, the government paid Swart $3,156 for rent for his farm during the hostilities. Swart, whose land was ruined, filed an additional claim detailing his losses that illustrates the challenges he faced trying to rebuild his farm: the destruction of three hundred peach trees and fifty apple trees; the loss of 1,530 cords of firewood used by the troops; the removal of 1,900 panels of fencing torn down; and a host of other losses, including thirty bushels of wheat and thirty-seven acres of corn. This claim, held up in congressional committee for years, was not settled until 1890, when the court recommended that Swart be awarded an additional sum of $6,013.[77]

After the war, in an effort to avoid claims from rural property owners like Swart, the army approved Special Orders No. 315, which essentially stated that once the forts were dismantled, the land would be returned to the property owners, along with the "fixtures of timber on the bombproofs, magazines, and stockades erected thereon."[78] If owners refused the offer of such materials in lieu of money, the government removed all of its buildings and materials, leaving the owners the unpromising alternative of getting their claims for compensation through Congress.

Regardless of their circumstances or wealth, many area farmers lost their land and property to the war. Colonel Jehiel Brooks, a large landowner and farmer of some social standing, put up a fight challenging the army's seizure of his Bellair property. The property included 246 acres of land under cultivation owned by Brooks's wife, Ann Margaret (Queen); the Brooks's Greek Revival–style country house, built circa 1840; its associated outbuildings; and an orchard and formal gardens. The land had been part of Beall's Enclosure, a larger tract of land that had been owned throughout the eighteenth and nineteenth centuries by the Queen family, wealthy planters whose name still figures prominently in northeast Washington, as in Queen's Chapel Road. Despite the social stature of the Queen family and Colonel Jehiel Brooks, the army nevertheless claimed Bellair for construction of Fort Bunker Hill. The fort was positioned atop the highest point on Brooks's property, between Fort Saratoga (to the east) and Fort Slemmer (to the west). To construct the earthworks, the Boston Volunteers cleared the heavily wooded hill on the property and dug the entrenchments at its summit. In the process, they clear-cut the fruit trees, orchards and wild growth on the surrounding acreage to improve visibility and the fields of

A detail from an 1863 Civil War topographical map shows the mansion, formal garden, orchards and farmland of Bellair, the Queen-Brooks property near Fort Bunker Hill that was requisitioned by the U.S. Army for the war effort. "Topographical map, 1st Brigade, Defense north of Potomac, Washington, D.C.," by R.A. Hodasevich. *Library of Congress, Geography and Map Division.*

fire.[79] The army left the mansion house in place—still standing in today's Brookland neighborhood—along with its formal garden, southwest of the earthworks.

One of the most significant military takings in the county was that of Giesboro (both Upper and Lower), the plantation on the eastern shore of the Anacostia River then owned by George Washington Young, a grandson of Notley Young, original proprietor of lands making up the federal city. In 1863, the Union army took over the property to establish a camp and cavalry depot, one of six major depots to be established by the Union Cavalry Bureau. The bureau selected the plantation at Giesboro Point for its flat terrain and easy access to the river—the same qualities that made the riverside property attractive to its original owners, who raised tobacco on the land and shipped it upstream to the tobacco port at Bladensburg or over to Georgetown. Under continuous cultivation since the late seventeenth century, the plantation was still a major farming operation that contributed significantly to the capital's food supply. In 1860, the farm, run by an overseer and heavily dependent on slave labor, had an assessed cash value of $70,000 and was the most prosperous of the District's farms. In addition to its livestock, the farm produced wheat, corn, rye and oats along with potatoes, beans and a large volume of market produce.

Local residents objected to the selection of Giesboro as the site for the cavalry depot, arguing that the harvest from the farm was crucial to the city's food supply and too valuable to be taken over for military purposes. With no apparent consideration given to the landowner or local citizenry, the military seized the site, taking possession in August 1863 and refusing Young's offer to sell his property to the government for $100,000. Instead, the government paid Young annual rent of $6,000 from 1863 to 1866. The army quickly built wharves along the Potomac shoreline and stables on the flat land set back from the water. The brick manor house became the depot's administrative headquarters, while barracks, mess houses and storage buildings were constructed across the farm fields. The cavalry depot was designed to hold up to 30,000 horses; over the course of the war, more than 200,000 were received, issued, sold or died at Giesboro.

Following Young's 1867 death, his estate received $2,640 from the government for compensation for damages, far less than the $41,488.75 that his widow had requested. In rejecting her request, the government highlighted the benefits of its occupation of the farmland: "The land has

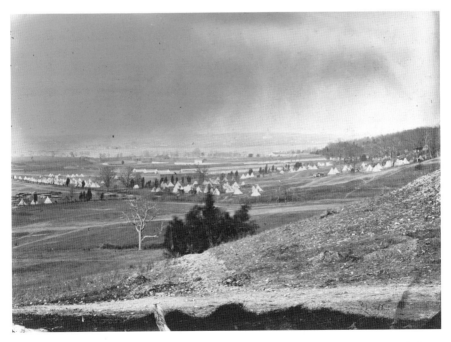

This Civil War photograph of the Cavalry Depot at Giesboro shows the soldiers' barracks in the farm fields in the foreground, the extensive horse stables along the shoreline and the Capitol dome across the river in the background. *Library of Congress, Prints and Photographs Division.*

Elizabeth Proctor Thomas, identified as Aunt Betty in this photograph, fought for decades to receive just compensation for the government's requisitioning of her family's house and land for the construction of Fort Stevens. *Historical Society of Washington, D.C.*

been greatly enriched by the thousands of animals kept upon it; miles of drainage pipes have been laid…a large amount of new fencing constructed; valuable costly wharfage built; the mansion house, barns and outbuildings repaired and remodeled; new buildings erected left on the premises."[80] After the war, Giesboro never did resume its role as a productive farm, becoming instead a recreational resort and industrial manufacturing site.

The military's seizures of land took a heavy toll on the area's poorest residents. In one especially poignant example, for its construction of Fort Stevens in 1861, the army took possession of the eleven-acre property of free black Elizabeth Butler. In 1840, Butler had purchased the land, with a house and outbuildings, adjacent to Vinegar Hill, an emerging free black community along Milk House Ford Road in Brightwood. The day the Union army came to take possession of her land, animals, outbuildings and stored foodstuffs, Butler was overcome with grief and is said to have sat down and died. Her granddaughter Elizabeth Proctor Thomas also lived on the property with her husband and children and earned her livelihood there raising chickens and growing fruit trees and crops. She inherited the property and fought for just compensation for decades after the war. The findings of fact in Thomas's compensation claim describe the extent of her loss:

> *Troops belonging to the Army of the United States occupied said land, and during such occupancy it became a military necessity for them to, and they did, tear down a 2-1/2-story frame house, a stable with barn over it, a cow shed, a corn house, a hen house, a post and rail fence that enclosed the land, and a paling fence around a one-acre garden. They also cut down a small apple and peach orchard, damson trees, and many kinds of cherry trees, together with a lot of shrubbery, to build a fort.…A rifle pit was dug across the farm…and Fort Stevens occupied about 3 acres of said land; said rifle pits and fortifications greatly decreased the value of said land for farming or any other purpose.*[81]

For all of her losses, including being without her land and the income it generated for the duration of the war, Elizabeth Thomas was awarded just $6,930. This award, by an act of Congress, came in 1904, more than three decades after the end of the war. Thomas lived on her Vinegar Hill property for the rest of her life, watching the community grow around her, as formerly enslaved persons who had sought work and shelter at the fort during the war built houses and established a school, churches and businesses in the community.

HEADQUARTERS AND HOSPITALS

If the farms were not destroyed to make way for the defenses, they were just as likely to have been seized for army headquarters or hospitals. The county's farms and country estates, readily accessible by farm roads and on prime sites with views and cooler air, proved attractive for such uses. Joel Barlow's early nineteenth-century Kalorama estate became Kalorama General Hospital; Joseph Gales's Eckington estate was converted into Eckington General Hospital; William Wilson Corcoran's Harewood estate and farm became home to Harewood General Hospital; Columbian Hospital occupied Meridian House on Meridian Hill; and Mason's Hospital was located at John Mason's former farm on Analostan Island (Roosevelt Island).

These houses taken for hospitals and/or headquarters did not fare well under such heavy use. In *Meridian Hill: A History*, author Steven McKevitt recounts that open fires were lit in the rooms of Meridian Hill house by convalescing soldiers trying to stay warm. Surprisingly, the house survived the war, only to succumb to fire in 1866 shortly after its wartime use as a hospital ended. Similarly, a hospital party at the close of the war in 1865 caused a fire that gutted the former Kalorama mansion. The army's abuse of area buildings was not lost on its soldiers and officers. In a letter home to his mother, George E. Chamberlin, a young officer whose regiment was stationed at Fort Lincoln in 1862 and again in 1864, wrote:

> *You remember Fort Lincoln, where I was stationed in the fall of 1862, when I was taken sick. Do you remember the large house? It is Post Headquarters, and we live in it. It is nearly as large as your house, was a nice residence once, but is now old and somewhat used up and dirty, by having been occupied by officers since the war commenced.*[82]

For the rural property owners whose land was not taken, their fields and farmyards were ripe for looting by soldiers who requisitioned building materials such as wood and bricks and raided chicken coops and gardens: "Our team has just come in, loaded with bed-sacks, so that we must buy or steal (or else in camp language 'forage'), some straw to put in them or go without. Some of the boys have recently managed to 'find' some new potatoes, cabbages, cucumbers and other good things, so that the straw will probably soon be found."[83] While such looting strained relations between the soldiers and the locals, good will also existed between the two. Samuel

Civil War photographer James B. Gardner caught this general view of Harewood Hospital, established on the farm and estate of William Wilson Corcoran during the Civil War. Harewood's barns and springhouse are visible to the left in the photo. *Library of Congress, Prints and Photographs Division.*

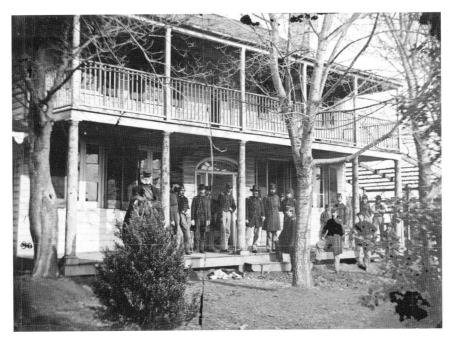

The Union army headquarters at Fort Lincoln, formerly the country residence of a John C. Rives, is shown in this Civil War photograph. *Library of Congress, Prints and Photographs Division.*

and Harriet Burrows, who lived with their family on a part of their farm that was not taken for the construction of Fort Bayard, sold milk, vegetables and cattle regularly to the quartermaster. Although Southern sympathizers, the couple, whose farmhouse stood adjacent to the fort's barracks and parade grounds, opened their hearts and arms to the young soldiers camped nearby. A testimonial from seventy-five members of Company M, Ninth New York Volunteer Artillery who were encamped there expressed their "thanks for the many kindnesses and hospitalities we have received from Mr. Samuel [Burrows] and wife near Fort Bayard—since our first arrival at that place (January 4, 1863) and removal to Fort Simmons [May 4] and which they were always willing to bestow."[84] In another instance in what was surely just one of many similar to it, the Honorable John C. Rives opened his residence, later the Fort Lincoln headquarters, to a young officer during his long illness and to his mother, who came to care for him.

The only battle of the war fought within the District's boundaries—the Battle of Fort Stevens—took a heavy toll on the land. After a day and night of fighting, the Confederates under the command of Lieutenant General Jubal Early retreated north toward the Maryland line, looting as they went. The Confederate soldiers took livestock, stored food stuffs, clothing and other

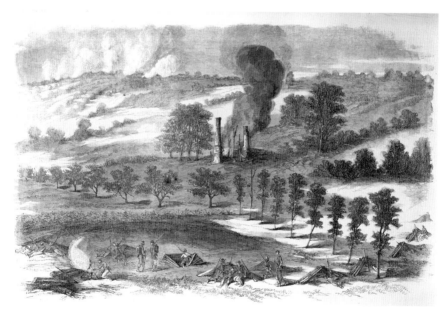

This sketch, "Aftermath of the Battle of Fort Stevens," with a burning house in the midground, illustrates the general devastation that the war wrought on the cultural landscape of the county. *Library of Congress, Prints and Photographs Division.*

goods. The Union army then compounded the damage by burning down residences and other structures that would provide coverage for Confederate soldiers, in case they should attempt to return.

As part of this aftermath of battle, longtime property owner and farmer Abner Shoemaker lost his house, as did his neighbor, former Washington mayor Thomas Carbery. Yet the loss of material culture paled in comparison to the devastation of lost lives as reported by an onlooker: "On the floors [of the civilian homes], on the roofs, in the yards, within reach of the heat, were many bodies of the dead and dying, who could not be moved, and had been left behind by their comrades."[85]

WARTIME FARMING OPPORTUNITIES

It was not all devastation for rural Washington, however. The war also provided opportunities for local farmers and communities. The city's population, swollen by the necessities of war, increased the demand for food and goods, which sent prices up. From its prewar population of just under 63,000, Washington exploded to a population that at times exceeded 200,000. Civilians, including escaped slaves called contrabands seeking refuge with the Union army, flocked to the capital to take advantage of service and business opportunities that the war offered. The number of Union soldiers in the city and county increased from 17,000 at the start of the war to 310,000 three months later to 2 million by the end of the war. Each army unit was responsible for local procurement of materials, which in addition to clothing, equipment and military and hospital supplies included enormous volumes of food for men and animals.

For some farmers, the war's food and material needs proved to be excellent business. Farmers, butchers and dairymen responded by increasing production and selling their produce both at market and at military camps. Others sold timber for buildings, for the construction of abatis and for firewood. Washington-born butcher, farmer and slave owner John Little realized both financial and personal gain through the military presence in the city. Little not only sold meat and produce to the U.S. quartermaster, but by virtue of his loyalty to the Union, earned the protection of his enslaved property as well. Little had owned his 56.5-acre farm on the site of present-day Kalorama Park since 1836 and, by 1840, was the recorded owner of twelve enslaved persons. With his slave labor, Little ran a cattle farm, had 40

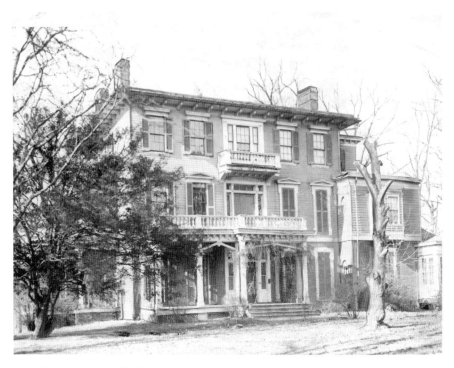

Some District farmers like John Little, whose house is shown here in an early twentieth-century photograph, benefitted from the war by selling meat and produce to the U.S. quartermaster. *Historical Society of Washington, D.C.*

acres under cultivation and had acquired enough wealth in 1850 to begin construction of a new, three-story house.

Over the next ten years, the assessed cash value of Little's property continued to rise, from $12,000 in 1850 to $40,000 in 1860. At a time when slaves were increasingly able to purchase their freedom from their owners, there is no evidence that John Little was wont to give up his chattel. So, at the start of the Civil War in the spring of 1861 and with no apparent hope for manumission, twenty-year-old enslaved Hortense Prout fled from Little's farm. As thousands of newly organized Union troops were pouring into the city, creating mass confusion, Prout disguised herself as a man and made her way from the Little farm, past Union camps at nearby Kalorama and Meridian Hill, two miles east to a camp on a farm in Bloomingdale filled with 1,270 young troops from Ohio. There she was discovered and returned to John Little because of his loyalty to the Union:

A FUGITIVE—A slave woman belonging to Mr. John Little having eloped, Mr. Little made diligent search and ascertained that she was in one of the Ohio camps. He made visit to the camp and told the colonel commanding what he wanted, and the reply was, "You shall have her, if she is here." Search was made and the fugitive was found, completely rigged out in male attire. She was immediately turned over to the custody of Mr. Little, and was taken to jail. Every opportunity is afforded loyal citizens of loyal States to recover their fugitive slaves.[86]

POST–CIVIL WAR SETTLEMENTS: MERIDIAN HILL AND RENO CITY

After the Civil War, when the government returned seized lands, many of the original owners or their heirs did not return to their farms. Some had settled in the city and decided to remain there, others had left the region altogether and others had aged out of farming or died. Still others were not able financially to sustain their farming operations without enslaved labor. In cases where property owners or their heirs did not resettle on their rural lands, the property was put up for sale, becoming ripe for development. Many of the forts and camps had become havens for African Americans (both free and escaped slaves) who came to the capital during the war seeking employment and safety. African American communities emerged all around the District in proximity to the former forts, just as the population of already established free black communities, such as Vinegar Hill in Brightwood, swelled.

All the forts around or overlooking the city are dismantled, the guns taken out of them, the land resigned to its owners. Needy negro squatters, living around the forts, have built themselves shanties of the officers' quarters, pulled out the abattis for firewood, made cord-wood or joists out of the log platforms for the guns, and sawed up the great flag-staffs into quilting poles or bedstead posts.... The strolls out to the old forts are seedily picturesque. Freedmen, who exist by selling old horseshoes and iron spikes, live with their squatter families where, of old, the Army sutler kept the canteen.[87]

In two instances—that of Meridian Hill and Fort Reno—when the army returned the lands it had taken to the pre–Civil War property owners or

their heirs, these owners sold the former farms to real estate developers and the makeshift freed black communities that had grown up around the forts were formalized into residential subdivisions. African Americans purchased lots, built houses, started businesses and places of worship and organized schools in what became thriving communities.

Meridian Hill was an early nineteenth-century estate that stood just beyond the city's limit at today's Florida Avenue on Sixteenth Street, and during the war it was the site of Camp Cameron. Like at other Civil War sites around the city, African Americans sought jobs and security within its confines and settled nearby, building rough housing of scraps of wood, metal and other found materials. At war's end, the prewar occupant of the 110-acre Meridian Hill property, Gilbert Thompson, was then in his seventies and financially unable to return to his land.[88] The Meridian Hill mansion had been destroyed by an 1866 fire just after the home's wartime use as a hospital ended, and the former farmland and its orchards were ruined. Colonel Isaac E. Messmore, a lawyer and Civil War commander who moved to Washington after the war, saw the potential for development of the area and purchased the Meridian Hill property. In 1867, Messmore collaborated with businessmen and real estate developers Richard M. Hall and John R. Elvans to develop the Hall & Elvans' Subdivision of Meridian Hill. Elvans, the owner of a downtown hardware business, J.R. Elvans' Hardware, was civic-minded and a strong supporter of equal rights for former slaves. He and Hall had assisted the Freedmen's Bureau in its purchase of Barry's Farm in Southeast, which the federal government subdivided into 1-acre plots of

This Civil War photo captures a group of Union soldiers at Camp Cameron on the site of Meridian Hill with an African American boy shining a shoe in the foreground. Many of the Civil War forts and camps became havens for African Americans. *Library of Congress, Prints and Photographs Division.*

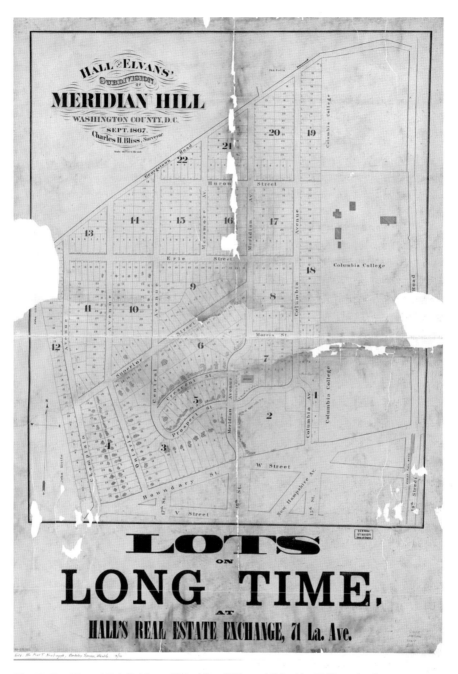

The Hall & Elvans' Subdivision of Meridian Hill, established in 1867 on the former
Meridian Hill farm, became a thriving African American community. *Library of Congress,
Prints and Photographs Division.*

land for purchase by newly freed slaves. The Hall & Elvans' Subdivision of Meridian Hill included twenty-two squares divided into a series of urban-sized building lots.

Within the first decade of development, Meridian Hill attracted a majority of African American residents, many of whom had likely not left the site since settling there during the war. Wayland Seminary, organized in 1865–66 to train African American clergy and teachers, established itself on Meridian Hill in 1873, encouraging further settlement. By the 1880s, Meridian Hill had grown into a true community, with modest, two-story frame houses clustered along the two-block stretch of Fifteenth Street between Chapin and Euclid Streets, occupied exclusively by working-class African Americans, many of whom owned the lot and house where they lived.

In Tenleytown, the Union army selected the highest point in Washington for construction of Fort Reno, with unobstructed views north and south and overlooking three major routes leading to and from the city: River Road, today's Wisconsin Avenue and Belt Road. The land seized for the fort was owned by brothers Giles and Miles Dyer, who lived on and farmed

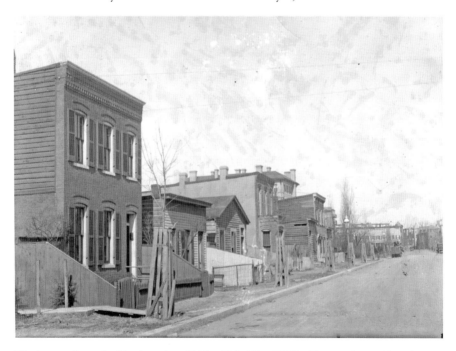

The houses shown in this view, circa 1915, of Meridian Hill looking north on Fifteenth Street were located on what would become the upper esplanade of Meridian Hill Park. *Historical Society of Washington, D.C.*

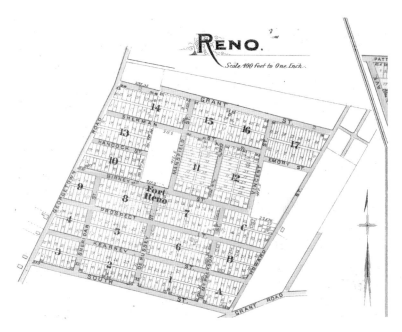

This plat from the G.M. Hopkins Atlas, 1887, shows Reno City, a residential subdivision established just after the Civil War on the site of Fort Reno. *G.M. Hopkins Atlas 1887, D.C. Office of the Surveyor.*

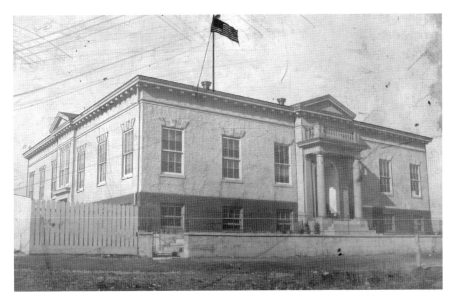

Reno School, built in 1904 for the African American schoolchildren of Reno City, is shown in this photo shortly after construction. Reno School, now part of Alice Deal Middle School, is the only remaining building of Reno City. *D.C. Historic Preservation Office/Office of Planning.*

the property. After the war, the army returned the property to Giles's descendants, who in turn sold the land to real estate developers Newall Onion and Alexander Butts in 1869. Called Reno City, the land was arranged into twenty-one one-acre blocks, which were further divided into urban-sized building lots and put up for sale at low prices. Many African Americans who had come to the fort during the war and had built houses there remained afterward, eventually managing to make down payments and purchase the lots where their houses stood. Not all of the lots were purchased by blacks, however, and Reno City, replete with churches, schools and stores, developed into a mixed-race but segregated community. Reno City was later razed, but Reno School, built for black students by the District of Columbia government in 1904, survives adjacent to the Alice Deal School as a reminder of post–Civil War Reno City.

Although immediately adjacent to Tenleytown, Reno City remained distinct from it. After the war, and despite the increased population in the area, Tenleytown resumed its rural village existence. This remote and outlying area of Washington County, though war-torn, was still devoted to the cultivation of crops and the grazing of cattle. Period trade magazines touted the cheap land to attract the small-scale and immigrant farmer to the region. Germans flocked to Tenleytown, operating dairies and opening businesses as butchers, tailors and shoemakers. As the economy grew, more people came, including Irish and Italian immigrants, and established themselves by building houses, stores and businesses. The 1880 census for Tenleytown identifies a wide variety of agricultural occupations ranging from dairyman, farmer, farm laborer and butcher to gardener and blacksmith. By the last decade of the nineteenth century, though still a rural community, Tenleytown was thriving and changing. For the most part, the residents worked in Tenleytown; however, a growing number of merchants, policemen, bankers and schoolteachers who worked outside the area indicate that Tenleytown was beginning to expand beyond its agricultural roots.[89]

8

THE PERMANENT HIGHWAY PLAN

THE CITY'S FIRST SUBURBS

In the decades following the Civil War, Washington's population increased substantially, from approximately 75,000 before the war to 130,000 in 1870 and to 230,000 by 1890. As the already developed areas of the city were filling to capacity, speculative development, fueled by a robust public works program and the need to house the growing population, began to push residential growth up to and eventually beyond the boundaries of the original city limits, blurring the line between urbanized city and rural county. Politically, the Organic Act of 1871 further eroded the differentiation when Washington City, Georgetown and Washington County were consolidated into a single entity as the District of Columbia. As part of this act, Congress abolished the Washington County Levy Court, which had governed the county from its inception in 1801, bringing the county under control of the District's Territorial Government.

The residential development that was pushing beyond the city limits was enabled largely by new modes of transportation that made moving around in and beyond the urban city possible. In 1862, to help move troops and materials through the city, Congress granted a charter to the city's first streetcar company, the Washington and Georgetown Railway Company. The railway company opened three horse-drawn streetcar lines, two of which ran north–south along Seventh and Fourteenth Streets NW and one

extending east–west from Georgetown to the Navy Yard, making new areas of the city accessible to the expanding population and encouraging the growth of the city's first suburbs.

In the years before and just after the war, Uniontown, Mount Pleasant, Le Droit Park, Ivy City, Trinidad and other subdivisions were developed as residential suburbs on the immediate outskirts of the city, in proximity to the job centers of downtown and the Navy Yard. Like the Reno City and Meridian Hill subdivisions that were platted within the confines of former farm properties that had been taken over as Civil War forts and camps, these first suburbs were laid to conform to existing property lines and the often hilly topography. The layout of the subdivisions bore no physical relationship to L'Enfant's Plan of the City of Washington in terms of street alignments, dimensions and naming patterns. Uniontown was the first of these suburbs, planned in 1854 when the Union Land Association purchased a 240-acre farm east of the river, across from the Navy Yard, and on 100 of its acres laid out a residential subdivision. Convenient to and within walking distance of the Navy Yard via the Navy Yard Bridge (site of today's Eleventh Street Bridge), Uniontown was meant to be a whites-only subdivision that would attract workers from the Yard. The subdivision followed a compact seventeen-block grid pattern enclosing seven hundred small lots. With no reason to continue the grid of the city, the developers ran the streets parallel to the former farm's property lines on level terrain below the steep and hilly banks of the Anacostia.[90]

In 1862, shipbuilder and businessman Samuel P. Brown bought the former estate of William Seldon, developing the first subdivision in the present-day neighborhood of Mount Pleasant. Seldon had served as treasurer of the United States from 1839 to 1850 and as treasurer of the Agricultural Society, and in 1850, he built a large house on seventy-three acres of land that had historically been part of the large tract owned by Anthony Holmead, one of the city's original proprietors. The property stood east of and above Rock Creek and immediately north of Peirce Mill Road (now Park Road), which connected Peirce Mill on Rock Creek with the Fourteenth Street Road, north of the city. A Southern sympathizer, Seldon sold his property in 1862 to Brown at a low price to return to his native Richmond, Virginia.

During the war, Seldon's former estate was occupied by the Union army and the house used as a hospital. But after the war, Brown moved into the house (now demolished) while he subdivided and improved the surrounding acreage into Mount Pleasant. The suburban village was laid out with Fourteenth Street Road as its eastern boundary and the old Peirce

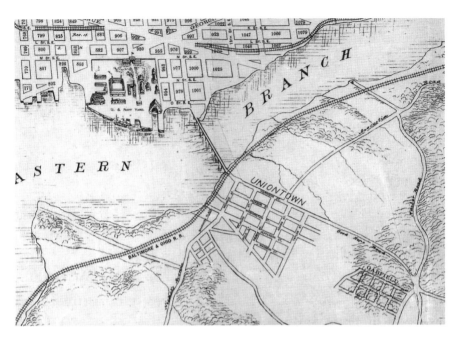

Detail of B.H. Warner & Company's "Bird's-Eye View of the City of Washington and Suburbs," 1886, showing Uniontown (old Anacostia), the city's first suburb. *Library of Congress, Geography and Map Division.*

Mill Road at its southern end. New streets, laid without any right angles or any relationship to the city streets, took advantage of the flattest terrain and were improved with frame cottages. Just west of Seldon's former property and abutting Rock Creek stood another country estate, known as Ingleside. That estate included an Italianate-style villa built in 1852 as the country home for a Philadelphia businessman, T.B.A. Hewlings, and designed by architect Thomas U. Walter, who was at the same time designing the U.S. Capitol dome and side wings. Several decades later, in 1891, the Ingleside estate grounds were also subdivided for residential development, becoming part of the expanding Mount Pleasant neighborhood, where the Ingleside mansion still stands at 1811 Newton Street.

Like Uniontown and Mount Pleasant, other suburbs like Le Droit Park, Ivy City and Trinidad each followed their own street plans distinct from the city's grid. Le Droit Park, built in 1873 just beyond the old Washington City boundary (Florida Avenue) between Second and Sixth Streets NW, was designed after the popular rural landscape ideal set forth by Andrew Jackson Downing and improved with detached and picturesque dwellings designed

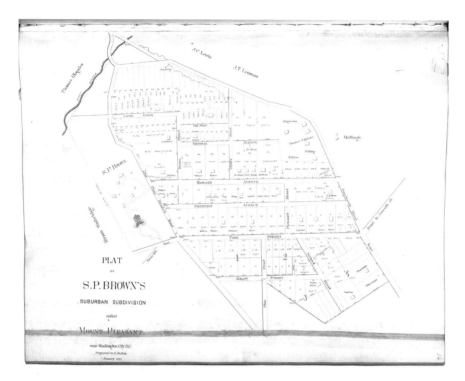

This map, "S.P. Brown's Suburban Subdivision called Mount Pleasant Near Washington, D.C.," 1872, includes a rendering of his house (demolished), adjacent to which he laid out the residential development. *D.C. Office of the Surveyor, Levy Court, Liber CS 01 Folio 56.*

in a variety of Romantic styles for the wealthy buyers. Ivy City and Trinidad, laid out in 1873 and 1888 to either side of the B&O Railroad line north of Florida Avenue, were multi-block subdivisions whose street alignments were similarly skewed to those of the city. When the Washington Machine Brick Company purchased Trinidad, one of W.W. Corcoran's farm properties, it kept sixty-five of its acres for its brickworks business and subdivided the other one hundred for speculative residential development. At the center of Trinidad's street grid was a two-block-long U-shaped street called Holbrooke Terrace. Named for the president of the company, the terrace followed a natural knoll with scenic views, creating Trinidad's largest and priciest lots.[91] During the 1880s, the Ivy City Brickworks and the Washington Brick Machine Company became major employment centers, encouraging the residential growth of the Ivy City and Trinidad subdivisions.

During the 1870s, Congress granted several additional streetcar charters, providing the city with a comprehensive network of horse-drawn lines.

140

Initially, because none of these first streetcar lines extended beyond the original city limits, new development was generally restricted to within its bounds or its immediate outskirts. Two branches of the steam-powered B&O Railroad, the Metropolitan Branch and the Washington Branch, provided an alternative to the strictly intra-urban horse-drawn streetcar service, with local stations serving both industry and passengers. The Metropolitan Branch, completed in 1873, ran forty-three miles from Washington to Point of Rocks, Maryland, leading to the emergence of suburban communities along its route. Although most of this development occurred in Montgomery County, Maryland, the line inspired the platting of Takoma Park (1883) and Brookland (1887) in the District and attracted other types of development around the stations along its route. In place of former farms, some commercial and industrial concerns such as brickworks and terra-cotta factories arose on either side of the rail lines. While the railroad had a significant impact on the rise of suburban communities, it was the introduction of the electric streetcar that would more profoundly affect growth within the District itself.

Washington saw its first electric-powered, overhead trolley system in 1888, the same year the service was introduced in Richmond, Virginia. Faster and cheaper to build than railroads, the electric streetcar provided easier access to developments at a distance from the city center.[92] As the population continued to grow, the former Washington County experienced a significant real estate boom. Workers of all kinds no longer had to live close to where they worked, and many Washingtonians chose to move to the new suburbs growing up beyond the old city boundaries. Throughout the 1880s and 1890s, land speculators and developers bought up the farms and estates to either side of the newly chartered streetcar routes and platted the former farm fields for residential development. Subdivisions leap-frogged over fields, creating a patchwork of residential streets and cultivated farms. Like the first subdivisions on the city's outskirts, these new neighborhoods were nonconforming—that is, they developed independent of one another, their streets laid out according to their own plans, with no relation to those nearby or to the federal city.

As they proliferated, these unregulated subdivisions concerned residents, city planners and politicians, who began to advocate for government intervention. According to Michael Harrison in "The 'Evil of the Misfit Subdivisions': Creating the Permanent System of Highways in the District of Columbia," the House and Senate District Committees would hear at least ten bills related to comprehensive street planning between 1886 and 1889. In 1888, Congress approved the Act to Regulate the Subdivision of Land

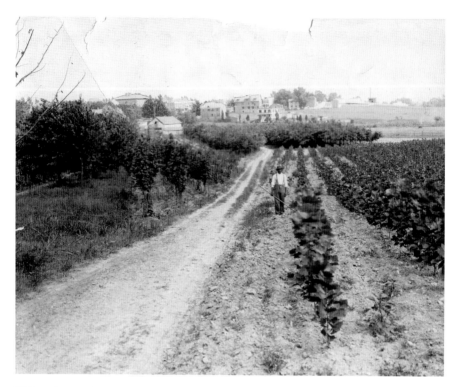

This early twentieth-century view of a farmhand in a cultivated field that was part of the forty-five-acre Ruppert farm in today's Petworth neighborhood illustrates the encroachment of development on the countryside. Petworth Elementary School, at 801 Shepherd Street and built in 1902, is visible in the left background. *Historical Society of Washington, D.C.*

within the District of Columbia, commonly referred to as the Subdivision Act, which required that new subdivisions beyond the old city limits conform to L'Enfant's General Plan of the City of Washington. To that end, the board of commissioners published orders for platting and subdividing, spelling out the precise widths for all thoroughfares and requiring that avenues and streets correspond to the directions and dimensions of those in the city.

The city government then approved sixteen subdivisions designed in conformance with the Subdivision Act. The largest and most notable of these was Petworth. Named for and laid out over a 536-acre estate of the same name, Petworth was in essence a true extension of the L'Enfant Plan. The two circles and three diagonal avenues bisecting them were integrated with a grid of streets lined with urban building lots. The streets followed the nomenclature of streets in the city, and Sherman and Grant Circles were

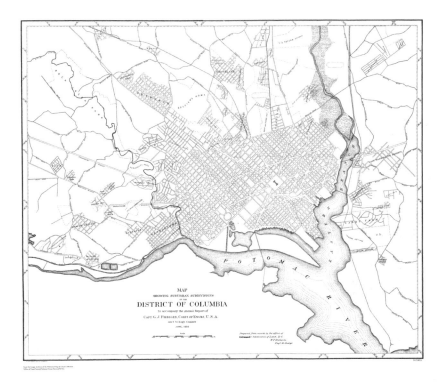

The U.S. Army Corps of Engineers' 1892 "Map Showing Suburban Subdivisions of the District of Columbia" illustrates the extent of unregulated residential subdivisions outside the boundaries of the L'Enfant Plan. *Library of Congress, Geography and Map Collection.*

named for Civil War generals. However, problems associated with the 1888 Subdivision Act were quick to arise. The topographic conditions of the former county differed drastically from the flatter character of the historic federal city, making an extension of the L'Enfant Plan an engineering challenge in places. For the developers, continuing the wide streets of L'Enfant's plan in the newly subdivided land was difficult and expensive, plus it reduced the amount of land that could be sold as private lots. Also, nonconforming subdivisions already covered approximately 4,000 acres of land, prompting years of debates over how and whether to bring them into compliance. To deal with this reality, Congress passed new legislation, the Permanent Highway Act in 1893; as revised in 1898, the law authorized the creation of a permanent system of roads beyond the L'Enfant city.

The resulting road maps, prepared in sections and finalized in 1900, established a comprehensive street plan for the old Washington County

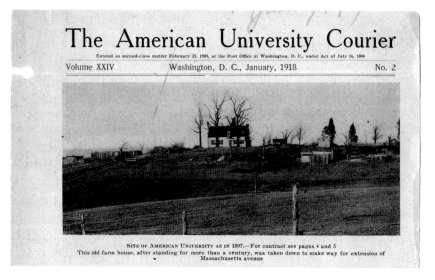

The American University Courier

Entered as second-class matter February 27, 1909, at the Post Office at Washington, D. C., under Act of July 16, 1894

Volume XXIV Washington, D. C., January, 1918 No. 2

SITE OF AMERICAN UNIVERSITY AS IN 1897.—For contrast see pages 4 and 5
This old farm house, after standing for more than a century, was taken down to make way for extension of Massachusetts avenue

In 1918, the *American University Courier* highlighted the loss of the Friendship house (circa 1760), which was endangered by the extension of Massachusetts Avenue. *American University Archives and Special Collections.*

that assumed the eventual eradication of farmland and farmsteads. When new subdivisions were created, landowners had to lay out their streets as the plan dictated. In those areas where no subdivisions existed, the commissioners could condemn property and open thoroughfares through farms and estates.[93] The new street plan was more progressive than the 1888 Subdivision Act that preceded it, in that it incorporated existing subdivisions and certain old roads and recognized the complications posed by some topographic conditions. Still, it made no accommodations for existing farms, farmsteads or other aspects of rural Washington's built environment. Fully recognizing that the future value of the land was in residential subdivisions, property owners and private real estate developers gradually subdivided the farmland into blocks of suburban-sized residential lots. In preparation for building suburban homes and putting in planned streets, the preexisting farmhouses, country houses, agricultural buildings and associated structures were often left abandoned and destined for removal.

RAZING FARMHOUSES

Newspaper reports documenting the demolition of the former farmhouses either lamented their loss and the way of life that they represented or hailed their razing as "progress." Such was the case in 1886 when the *Washington Post* announced the sale and impending demolition of Duddington, the estate house of original proprietor Daniel Carroll: "The building of this square which has lain untouched for such a number of years, will be a vast improvement to this section of the city and will probably be but the commencement of a series of improvements which are likely to follow."[94]

Few efforts were mounted to prevent the loss of historic farmhouses, even when the quality of construction and materials were prized. An account of the Burnes's Cottage at the time of its razing in 1894 noted that, despite its dilapidated state, "it required the most forcible handling to demolish and seemed to defy the wreckers down to its brick foundation." Similarly, a newspaper article on the demolition of the Abraham Young mansion that occupied the Cool Spring site noted that the building's walls "are unusually thick and solid as ever," and the "old fashioned locks, which are opened by an enormous key, are still in place and look good for another century."[95] Still, a number of farmhouses and even more country houses survived destruction, either by design or circumstances. Many farmhouses and farm buildings were incorporated into large institutional complexes, namely school and religious campuses, while others were retained as part of the residential subdivision process.

In 1889, after losing the presidential election following his first term, Grover Cleveland sold his twenty-six-acre Oak View estate to Francis Newlands, then a U.S. congressman and later U.S. senator and developer of Chevy Chase, Maryland. In 1890, Cleveland's former estate was subdivided, preserving the house and approximately two acres surrounding it, while the rest was platted as residential lots forming part of what would eventually become today's Cleveland Park neighborhood. The house lot,

BUILDERS' MATERIAL FOR SALE.

Sealed Proposals will be received for the Old Carroll Mansion, situated on square 736, until THURSDAY, April 22d;.

The building contains a large quantity of Brick, Slate, Stone, Sash, Doors, Blinds, &c.

Proposals will also be received for all the Sward, Soil and Wood on the place.

Gravel and Sand also for sale.

Address AUSTIN P. BROWN, Trustee, 1426 F st. n.w. ap16-td

Several months before the demolition of Daniel Carroll's Duddington in 1894, the developers of the site placed an advertisement in the local paper seeking proposals from builders to salvage materials. *From the Evening Star, April 19, 1886.*

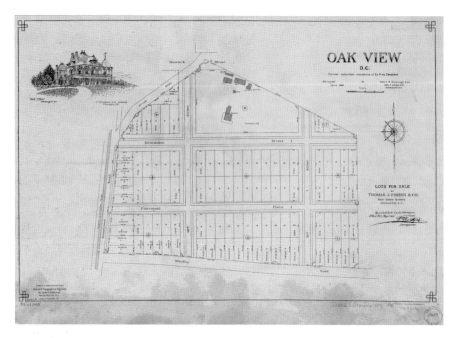

Above: When developer Francis Newlands laid out a residential subdivision on the twenty-six-acre estate of Grover Cleveland, he left the former president's house and outbuildings intact on a two-acre lot at the north end of the Oak View subdivision, named after the estate. *Library of Congress Prints and Photographs Divisions.*

Opposite: The fanciful Oak View house, shown in this 1887 photograph, stood on its two-acre lot in today's Cleveland Park neighborhood until 1928, when it was demolished. The stone from Oak View was reportedly used to build the stone retaining wall surrounding the 1928 house built on its site, at the corner of Newark and Thirty-Sixth Streets. *Library of Congress, Prints and Photographs Division.*

located at the northern end of the subdivision, occupied a full block within the established plan, preserving not just the house but servants' quarters, a barn, a carriage house and associated buildings as well. After 1928, however, Oak View was sold and demolished, while the stone from its walls was reputedly incorporated into the retaining walls, entrance gates and steps of the Georgian Revival house built on the site.

Francis Newlands's Chevy Chase Land Company purportedly sought to keep the old Belt mansion that was once the manor house associated with Cheivy Chace, the eighteenth-century land grant and the suburb's namesake. But the house, which stood below Chevy Chase Circle in the middle of the company's Chevy Chase, D.C. subdivision, was instead demolished and the present house at 3734 Oliver Street constructed in its place. Conversely, the

Land Company did retain the farmhouse at present-day 3039 Davenport Street by carving a lot around the house as part of its development of that property at the turn of the twentieth century.

Initially, at least, similar efforts were made to save Bleak House, the post–Civil War country home of Alexander Shepherd, vice president of the Board of Public Works during part of the city's four years as a territorial government (1871–74). During its brief tenure, the board, created to improve the city's infrastructure, graded and paved miles of streets, laid gas and sewer lines and water mains and planted thousands of trees along the city's streets and in its parks and reservations. In the process, however, Shepherd significantly outspent the government's budget and was charged with corruption, and the entire territorial government experiment was abolished. In 1880, Shepherd and his family moved to Mexico, where he ran a silver mine for the next twenty years. But throughout their Mexican residency, the Shepherds maintained their 260-acre country home in Washington. Bleak House, built in 1867 in today's Shepherd Park neighborhood, was an exuberant Second Empire–style frame house, with a stone porter's lodge marking the entrance to the estate and a stone carriage house at its rear. The estate also contained a bowling alley, a gymnasium, a barn and an overseer's house, as well as trout ponds and a cherry orchard.[96]

By 1900, developers were pursuing the subdivision of land in a northerly push, purchasing farms and country estates as far as the District line. After

In 1911, when the country estate of Alexander Shepherd was carved into a residential subdivision, his exuberant home, Bleak House, was retained on a large lot in the center of the development. By 1919, however, the house had been demolished for the construction of more suburban houses making up today's Shepherd Park neighborhood. *Historical Society of Washington, D.C.*

Shepherd's death in 1902, the Lynchburg Investment Corporation entered the scene in 1909, making "the largest transaction in suburban real estate in recent years."[97] Armed with a plan to "bring the city limits as far north as the District line," the Virginia syndicate purchased three separate tracts of land, including one hundred acres of the Bleak House property. The subdivision, named Sixteenth Street Heights and later Shepherd Park, was approved by the Office of the Surveyor in 1911, with Bleak House preserved in the center on a four-acre house lot bounded by Alaska Avenue, Fourteenth, Holly and Geranium Streets NW. The good intentions were short-lived, however, and between 1916 and 1919, the four-acre site was sold, Bleak House demolished and new houses were being constructed on the site. A site plan for a new house at 1332 Holly Street, filed in 1929 as part of its D.C. building permit, called for the retention of the "old stone carriage house to be used as garage on premises." The stone carriage house/garage remains on site, a physical reminder of Alexander Shepherd and his family's country home.

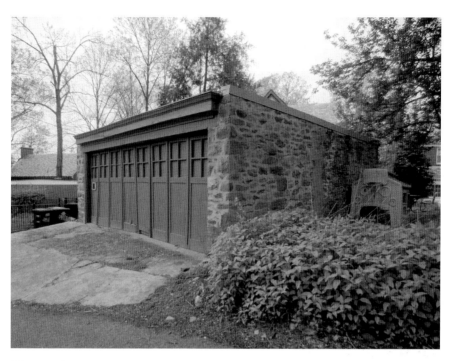

The stone building shown in this photo and located in an alleyway near Fourteenth and Holly Streets NW was once the carriage house on the Bleak House estate. In 1929, it was converted into a garage and is, today, the sole remnant of Alexander Shepherd's country property. *Photograph by the author.*

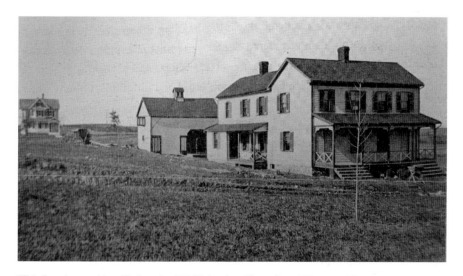

This farmhouse, identified as the "Old Mansion House" and illustrated in this 1897 promotional brochure for American University Park, was moved to its present site at 4716 Forty-Eighth Street NW. *American University Archives.*

When developers retained historic houses in their development plans, it was invariably to capitalize on the rural aspect of their proposed subdivisions, which they often touted in promotional brochures as "bucolic" and "picturesque." In 1897, the developers of American University Park, John D. Croissant and David D. Stone, published a promotional booklet illustrating the new houses under construction and including a photograph showing an existing farmhouse and its barn in the background. Identified as the "Old Mansion House" in the publication, the farmhouse was later moved and survives today at 4716 Forty-Eighth Street NW.

Moving Farmhouses

Like the "Old Mansion House," many of the city's farmhouses that stood in the way of the streets and the residential subdivisions were regularly moved out of the way and reoriented on the newly subdivided suburban lots. Although seemingly extraordinary, the phenomenon of moving houses was quite common in centuries past. People have preserved structures for many reasons, particularly the quality of their raw materials and the craftsmanship of their construction. Due to the high cost of construction, moving buildings was often less expensive than building anew. The Samuel and Harriet Burrows farmhouse, which stood near the site of Fort Bayard during the Civil War, escaped later demolition due to the efforts of a purchaser, who simply saw value in the quality of construction and picked the house up and moved it. After lifelong Washingtonian Harriet Burrows died at ninety-five, leaving behind the family farmhouse where she and her family had lived since before the Civil War, Allen E. Walker purchased the farmhouse and its surrounding land in 1925 to develop it as part of the American University Park residential subdivision. Before the farmhouse could be demolished, however, Charles Limerick bought it from the developer and moved it to a new site for use as his own residence. Once located south of River Road near present-day Ellicott Street, the house now sits nearly one mile away at 4624 Verplanck Place NW.

Many other farmhouses in the old county were also moved, either out of the way of new developments like the Burrows farmhouse, out of the path of new roads or streets or simply re-positioned on their lots to align with newly laid streets. As dictated by the Permanent Highway Plan map, Upshur Street NE ran not only through the middle of the former fifty-acre Tucker-Means

In this 1928 "Application for Permit to Move," owner Charles Limerick seeks permission to move a "dwelling house" from Forty-Fifth and Ellicott Streets several blocks south to Verplanck Place, where the farmhouse sits today. *National Archives, RG 351, Permit to Move #116186.*

This page: This detail of the 1907 Baist Real Estate Map shows the trajectory of Upshur Street passing directly through the pre–Civil War Tucker-Means farmhouse. Rather than being razed, the farmhouse was moved immediately north to a corner lot at Twelfth Place and Upshur Street NE, as shown on the 1927 Sanborn Map, where it remains today. *Library of Congress, Geography and Map Division.*

farm, but also directly through where the farmhouse stood, prompting the developers of the Turkey Thicket Subdivision to pick the house up and move it in 1910, neatly siting it at the corner of Upshur Street and Twelfth Place NE, where it rests today in perfect alignment with the new streets.

The Conrad Sherrier house at 5066 MacArthur Boulevard is considered by local historians to be the original 1820s farmhouse of the Sherrier family,

who owned extensive land in the Palisades and farmed it for generations. The farmhouse, with a Victorian façade added to its front, was moved from its original site north of MacArthur Boulevard to its present site south of the road sometime before 1881, perhaps as early as the late 1850s when Conduit Road (today's MacArthur Boulevard) was built. As the Palisades was being developed in the late nineteenth century, the Amberger farmhouse and its barn/stable, also owned by longtime farmers, remained on a one-and-one-half-acre plot adjacent to the newly subdivided lots. Sometime after 1916, as the lots filled with houses, the barn was razed, but the farmhouse was moved and reoriented to align with the street and neighboring houses.

For property owners who developed their own lands, farmhouses were more likely to survive the subdivision process. Such is the case of two still-standing farmhouses on First and Harlan Streets in Takoma, built and later developed by the same family. In 1881, Mary E. Harlan built a sizeable frame farmhouse on a seventeen-acre farm that she and her husband, Woodford, owned and worked, while Woodford also earned an income working for the federal government. The following year, the Harlans constructed a tenant

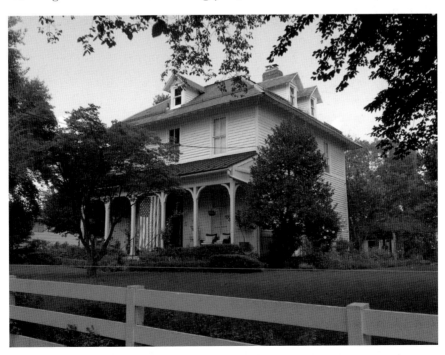

In 1909, when the Harlan farmhouse found itself in the path of First Street NW in Takoma, its owner moved the house two hundred feet east to face the new-cut street. *Photograph by the author.*

house on the property, east of their own. In 1909, about ten years after Mary's death, Woodford subdivided the family's farm into Harlan's Subdivision between today's Van Buren and Whitter Streets NW, on either side of First Street. The alignment of First Street, according to the Permanent Highway Plan, ran right through the farmhouse, so Woodford simply moved the house so it would sit neatly on its lot and face First Street when it would be cut and laid. The permit issued for moving the house noted that it would be moved "two hundred feet east" with "no improvement or change in house contemplated."[98] Later, the tenant house was rotated on its lot to face Harlan Place, which was laid according to the subdivision plat. For the next decade, Woodford Harlan remained in his farmhouse, on its reduced lot, and actively advertised the sale of lots around it, which he touted as being "two blocks from Capital Traction cars" and having "water, sewer and electric lights."[99]

THE PERSISTENCE OF AGRICULTURE

Despite the economic and urban planning pressures, agricultural use of the land persisted in the old county throughout the nineteenth and into the twentieth centuries. In 1882, a reporter visiting northeast Washington around the former Fort Bunker Hill described the agrarian landscape:

> *The road led through a slightly hilly and fairly well-wooded country, chiefly along the line of the Baltimore and Ohio Railroad....Broad fields, most of them in a perfect state of cultivation, which upon a closer approach, proved to be planted chiefly with sweet potatoes....Wheat is already bearded out, and on one farm a lot of men were engaged in bunching hay....The farm houses as a rule were well built and nicely painted.[100]*

Agricultural census records reveal that farmers continued to plant wheat, corn, oats and other grains, while increasingly moving toward the cultivation of vegetables for sale at market. Cash was in short supply and labor costs were high due to competition from employment opportunities in the city, putting added pressure on farmers to diversify their crops, reduce the amount of land under cultivation or abandon the cultivation of their fields altogether. Archaeologist Laura Henley's extensive research into land use patterns in historic Washington County reveals just how small the profit margins for area farmers could be.

One extreme example is that of Cuckold's Delight, a productive pre–Civil War farm property of two hundred acres owned in the mid-nineteenth century by George and Harriett McCeney and largely occupied today by the Franciscan Monastery, the adjacent Holy Name College (Howard University Divinity School) and parts of Brookland. Agricultural census records in 1860 estimate the cash value of the McCeney farm at $20,000. In that year, with his fourteen enslaved workers, George McCeney and his sons cultivated four hundred bushels of Irish potatoes, four hundred bushels of sweet potatoes and $2,000 worth of market produce, among other crops. After the war, neither of McCeney's sons, who carried on the family farm after their father's death in 1867, could make enough of a profit to continue the agricultural business for long. On Edgar McCeney's forty-eight-acre parcel of the farm, the 1870 agricultural census valued his crop yield at $1,000 and the cost of his farm labor at $800, leaving a meager $200 in profit. Given such minimal return on his labors and the promise of easier money in real estate development, it is not surprising that in 1875 Edgar sold his acreage to real estate developers Brainard Warner and Thomas Wilson. Edgar's brother, Henry, continued to farm his ninety-three-acre parcel for another few years. But in 1881, he, too, jumped on the real estate bandwagon, subdividing his own property into seven unequal lots as Henry McCeney's Subdivision.

The subdivision of the former McCeney farm into large-sized lots that could be further subdivided for residential purposes, however, did not spell the end of farming on the former Cuckold's Delight. One buyer, James Sherwood, purchased several of the lots in the Warner and Wilson subdivision and consolidated them into a fifteen-acre parcel, which he then cultivated with crops into the 1910s. At the center of his land, Sherwood built a two-story Queen Anne frame farmhouse, along with a two-story stable. While Sherwood lived at the house with his family and farmed his land, he was simultaneously engaged with his brother Jesse in the development of Brookland as a residential subdivision. In 1910, James Sherwood was still listed as a produce merchant in the U.S. census, as was his twenty-one-year-old son, but by 1919, Sherwood had sold thirty-five acres of his farm to Holy Name College. To accommodate classrooms and dormitories, the college built a large institutional building on the site but retained the former Sherwood farmhouse, which still stands today, as a convent for the Missionary Sisters of the Immaculate Conception, who came "in charge of the culinary department of the new clericate."[101]

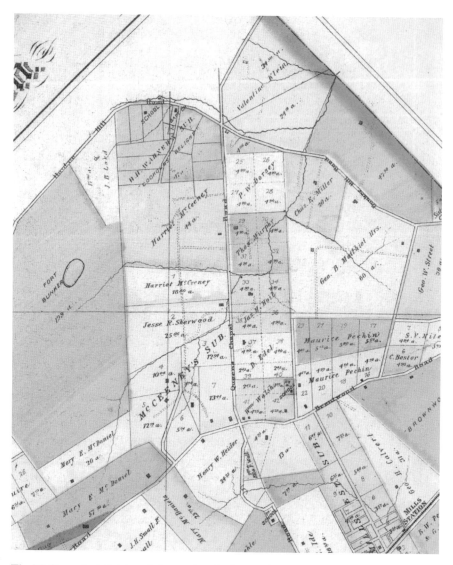

The McCeneys' subdivision of the two-hundred-acre "Cuckold's Delight," as shown in detail on the 1887 G.M. Hopkins map, makes up part of the Brookland neighborhood today. *Library of Congress, Geography and Map Division.*

Despite the intentions of well-to-do, longtime Washington County farmer Philip Fenwick to divest his future estate of his farming operations, his heirs continued to farm his land into the twentieth century. In 1863, being of "sound mind and memory," Fenwick filed his will, specifying that his property be subdivided and sold and the proceeds equally distributed among his ten

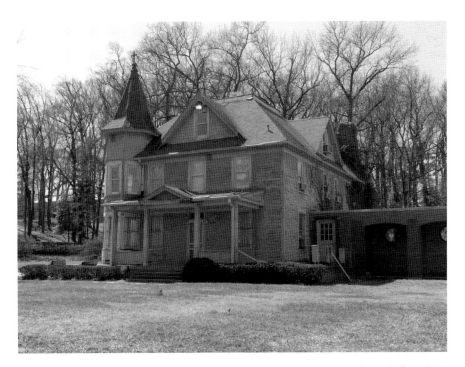

The Sherwood Farmhouse, built in 1886, is located on the former Holy Name College site in Brookland. *Photograph by the author.*

children. However, rather than liquidate the property as directed by the will, Fenwick's daughter Mary and her husband, John Van Riswick, who was a successful businessman in the city, acquired a significant portion of the land, maintaining its agricultural use under the management of an overseer for several decades, while building themselves a country house, Van View, on the eastern edge of the farm holdings at present-day Thirteenth and Jonquil Streets NW.

The farm remained active until the deaths of first John Van Riswick and later Mary. In 1896, following Mary's death, the *Evening Star* advertised the sale of livestock from her property: "Latimer & Co. will sell tomorrow at 11:30 o'clock nine head of cattle, most of them Jerseys; a bay horse, one mule, chicken, etc. on the farm lately owned by Mary Van Riswick, on 7th Street road, at terminus of Brightwood electric railway."[102] The Van Riswicks' son, Lambert, retained ownership of the farm property after his mother's death, but in 1909, he sold part of it to the Lynchburg Investment Corporation. The corporation proposed an extensive residential development that encompassed Van View and other adjoining properties,

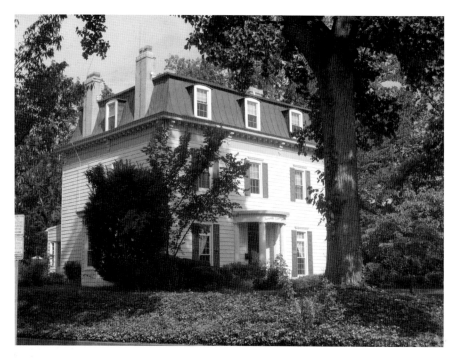

Van View, at Thirteenth and Jonquil Streets today, was the country home of Mary (Fenwick) and John Van Riswick, who built the house between 1868 and 1871 and oversaw the cultivation of the surrounding acreage. *Photograph by the author.*

including Bleak House, the one-hundred-acre country home of Alexander Robey Shepherd.

Similarly, despite the subdivision of the Greenvale estate following the death of William Hickey after the Civil War, the land remained in agricultural use for decades. Hickey was born and raised in Washington, where he pursued a career in the city, but he lived at and actively cultivated his Greenvale estate, the present site of the National Arboretum. There Hickey raised cattle and planted corn, potatoes and garden vegetables. Following Hickey's death, his descendants retained the Greenvale mansion on its "eminence in a grove of forest oaks," its outbuildings and the surrounding thirty acres.[103] But they partitioned the rest of the farm into fifteen large lots ranging in size from five to twenty acres and promoted them at auction as "being especially adapted for market gardens, both as to soil and location."[104] Illustrating the postwar transition away from large farms that required now-expensive labor, to smaller garden farms, the advertisement also left the door open for other options, noting, "It could be conveniently divided up into villa sites

that would form attractive places of residence for persons doing business in Washington." Leopold Luchs, who lived in the city and ran a cigar store on Seventh Street NW, had just such plans when, in 1879, he purchased two of the lots, further subdividing them into smaller lots clearly destined for residential development. But on one of these lots, designated as Lot 9 and crossed by a freshwater stream (Hickey's Run), Luchs neither farmed the land nor developed it for residential uses. He instead established a commercial water bottling operation on the site, which he named Red Oak Spring Company for the large oaks that stood nearby. Luchs built two brick structures—a springhouse and bottling house—both striking brick buildings with conical roofs. In one, he captured the spring water straight from its source, and in the other, he bottled the water in large "carboy" containers he then transported to his warehouse in northeast Capitol Hill for distribution to businesses and residences.

During the first decade of the twentieth century, the Red Oak Spring Company regularly advertised its water in local papers, touting it as a way

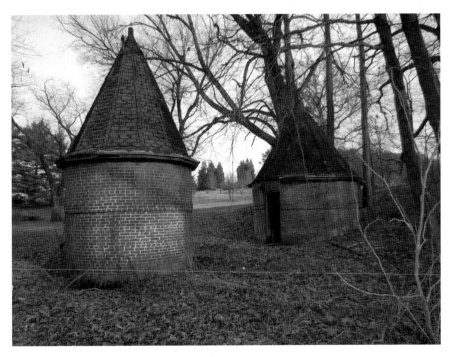

These two brick springhouses on the grounds of the National Arboretum were part of the Red Oak Spring Company, a commercial water bottling company in Washington during the early twentieth century. *Photograph by the author.*

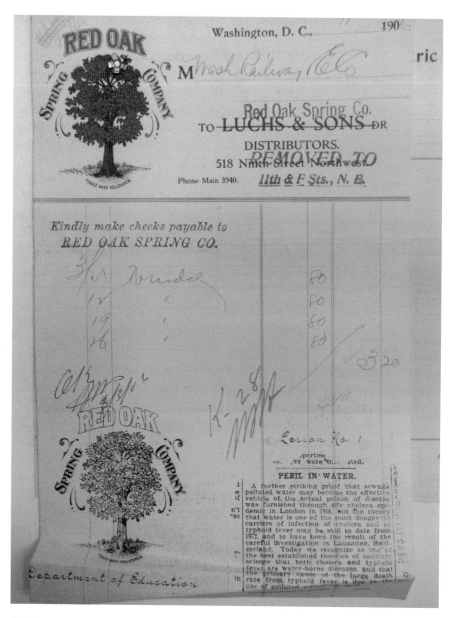

This invoice from the Red Oak Spring Company illustrates the company's red oak tree logo, inspired by the large oak trees that surrounded the Greenvale house site. *Historical Society of Washington, D.C.*

How to Avoid Typhoid.

Drink Red Oak Spring Water. Absolutely pure . Delivered fresh from the spring; 4 gallons, 40c. 518 9th n.w. 'Phone Main 3940.

The Red Oak Spring Company regularly advertised its water in local newspapers, such as in this 1905 notice, "How to Avoid Typhoid." *From the* Evening Star, *August 17, 1905.*

to "be healthy" and to "avoid typhoid." The company was established at a time when typhoid fever, dysentery and other waterborne illnesses had been plaguing the city for decades, making Washingtonians rightfully fearful of the water they drank. Water bottling companies, including Red Oak Spring Company, seized on the fears of residents and advertised their waters—whether true or not—as "pure." Although there were a number of other mineral water companies in existence in the city, the majority of those brought water in from elsewhere. The Red Oak Spring Company was one of only a few spring water companies to capture and bottle water within the District limits.

After construction in 1905 of the McMillan Sand Filtration plant at McMillan Reservoir on North Capitol Street, which treated the city's Potomac River water supply for the first time, the popularity of mineral water declined and the Red Oak Spring Company went out of business. In deteriorating condition, but poised for rehabilitation, the springhouses still stand adjacent to each other on the grounds of the National Arboretum.

Epilogue

In 1946, according to the U.S. Census Bureau, forty farms were still active within the city. The bureau defined a farm as "an agricultural enterprise of three acres or more, or a smaller tract with an annual production of $250."[105] The largest farms included those operated by institutions, such as the Old Soldiers' Home, St. Elizabeths and Gallaudet University. But a forty-acre farm near South Capitol Street and Southern Avenue and two farms, one ten acres and the other three on Riggs Road NE near the District line at Eastern Avenue, also made the list. Each of these private farms produced vegetables for sale at Union Market, had chickens and a cow or horse or two and, much like in the past, relied on family members and workhorses for labor. But by the 1960s, when the Wahler Bros.' Congress Heights dairy at 3312 Wheeler Road SE ceased operations, it was the last known farm operating in the city.

By then, the formerly cultivated lands had given way entirely to newly cut and laid streets, new residential neighborhoods and new dwellings lining the suburban-sized lots, leaving the city's rural heritage behind. The former farmhouses and their agricultural and domestic outbuildings, once common and visible elements of the cultural landscape, are now fewer and harder to detect. Still, on closer inspection, one can find those that do survive, either in full view or nestled behind toward the interior of squares or reoriented, remodeled and incorporated into Washington's many streetscapes.

EXTANT RESOURCES OF THE

DISTRICT'S RURAL PAST

ROSEDALE STONE HOUSE, circa 1740
3501 Newark Street NW
The Rosedale Stone House refers to the onetime free-standing house and now the stone wing at the rear of the Rosedale farmhouse in Cleveland Park. The stone house predates the frame farmhouse, built by Uriah Forrest shortly after his purchase of the property in 1793. The stone house is in two sections, both covered with gable roofs, and comprises five rooms, including the original kitchen with a large fireplace and side oven.

THRELKELD MARKER, 1770
Tenleytown NW
The Threlkeld marker is a stone property marker with the name "Threlkeld" and the date "1770" incised into it. Henry Threlkeld, and later his son, John, owned extensive property within the bounds of what would become the District of Columbia. In 1791, John Threlkeld consolidated his holdings as Alliance, where he lived at his estate of Berleith, in today's Burleith neighborhood. After the Organic Act of 1801 established Washington County as a political entity separate from the City of Washington and Georgetown, John Threlkeld sat on the county's levy court.

ROSEDALE FARMHOUSE, circa 1794
3501 Newark Street NW
Rosedale Farmhouse is a two-story wood frame farmhouse built by Georgetown businessman and promoter of the federal city General Uriah

Forrest. The previous year, Forrest and his business partner, Benjamin Stoddert, had consolidated several large purchases of land into a tract that they called Pretty Prospects. On the Pretty Prospects land, Forrest built the Rosedale farmhouse, incorporating a preexisting stone structure (Rosedale Stone House) as the rear wing and kitchen. Uriah Forrest and his wife, Rebecca (Plater), lived permanently at Rosedale, where they cultivated crops and established a large vegetable and herb garden near the house. The estate remained in Forrest family hands until 1920.

THE REST, circa 1800
4343 Thirty-Ninth Street NW
The Rest in Tenleytown is a brick house originally constructed by Charles Jones and later expanded to include its distinctive tower element. Jones, who is thought to have built the house for his sister, was the owner of Clean Drinking Manor in Montgomery County, including Jones Mill on Rock Creek. A millstone that is partially embedded in front of the house on the grounds of the Rest is reported to have come from the now-demolished Jones Mill.

ABNER CLOUD HOUSE, 1801
4940 Canal Road NW
Abner Cloud, a miller from Pennsylvania, purchased the riverfront farmland in 1795, established a mill and built this house in 1801. The oldest building on the canal today, the house was about two hundred yards downstream from his mill. The basement of the house was used to store grain and flour, while the family lived in the upper floors. Cloud purchased the nearby Whitehaven estate, which he rented out in the early nineteenth century to Thomas Main, who operated a nursery on the property.

PEIRCE SPRINGHOUSE, 1801
2401 Tilden Street NW
The Peirce Springhouse was built in 1801 as part of Isaac Peirce's development of an agricultural and milling complex that at one point grew to almost two thousand acres. In addition to the springhouse, several other buildings associated with the Peirce complex still stand, including the Peirce barn/carriage house, the Peirce Still House and Peirce Mill itself, constructed in 1829. The springhouse is the oldest surviving building in the Peirce Mill complex and a rare surviving rural domestic outbuilding.

Woodley, circa 1801
3000 Cathedral Avenue NW
Phillip Barton Key came to the city in 1800 as chief judge of the U.S. Circuit Court and purchased 250 acres of his brother-in-law Uriah Forrest's Pretty Prospects land. There he built Woodley, a sophisticated Federal house in today's Woodley Park neighborhood. The house, located at the height of a hill overlooking the Potomac River and the city below, was one of the first country houses to be built on the outskirts of the fledgling city.

Whitehaven (Thomas Main House), pre-1805
4928 Reservoir Road NW
It is not clear who built the house known as Whitehaven on Reservoir Road or when exactly it was constructed, but in 1805, agriculturalist Thomas Main rented the property from its owner, Abner Cloud. While living on the property until his death in 1814, Main experimented with, cultivated and operated a nursery, where he sold thorn bushes, in particular, the American hawthorn, which he promoted for use in hedges and for ornamental purposes.

Peirce Wagon Barn/Stable, 1810
2401 Tilden Street NW
The Peirce Wagon Barn/Stable was constructed around 1810 as part of the Peirce farm complex. The barn is located on the north side of Tilden Street, just north of the mill.

Peirce Still House, 1811
2400 Tilden Street
The Peirce Still House, part of the Peirce agricultural and mill complex, was originally built in 1811 as a barn but converted into a whiskey distillery after 1864. It resumed its original use as a barn in 1878; in 1924, the structure was completely remodeled and expanded to become a private residence, known today as the Peirce Still House.

Conrad Sherrier Farmhouse, 1820s
5066 MacArthur Boulevard NW
The Conrad Sherrier Farmhouse on MacArthur Boulevard in the Palisades was built in the 1820s, but it was moved from the north side of the boulevard (then Conduit Road) to its present site on the south side sometime before 1881. The Victorian-era bay front was later added onto the vernacular farmhouse

building. Conrad Sherrier was the patriarch of the Sherrier family, longtime farmers in the Palisades, after whom Sherrier Lane is named.

LINNAEAN HILL (PEIRCE-KLINGLE MANSION), 1823
3545 Williamsburg Lane NW
Linnaean Hill is a stone house built in 1823 by Joshua Peirce on an eighty-two-acre tract of land that was given to him by his father, Isaac Peirce. Joshua ran a successful commercial nursery operation on the site and lived at Linnaean Hill, which he named in honor of the Swedish botanist Carl Linnaeus. The property includes several outbuildings: a carriage house, potting shed and utility shed.

HOLT HOUSE (JACKSON HILL), pre-1827
Washington National Zoo
The Holt House, also known as Jackson Hill, was built by 1827, though little is known about its early history. The house and property were purchased in 1842 by Henry C. Holt, a medical doctor who came to Washington from Philadelphia. The house was named Jackson Hill in 1841, supposedly for its associations with Andrew Jackson, but there is no documentary evidence to support any Jackson associations.

THE HIGHLANDS, 1817–27
3825 Wisconsin Avenue NW
Joseph Nourse, appointed by George Washington in 1789 as the first register of the treasury, built the Highlands sometime between 1817 and 1827 on a large tract of land along today's Wisconsin Avenue. The Nourse family lived at the house and operated the expansive acreage as a working farm for several generations into the early twentieth century. In 1920, Admiral Cary Grayson, personal physician to President Woodrow Wilson, purchased the Highlands property, which also included a tenant house. In 1930, the Graysons sold the tenant house and surrounding land to the District of Columbia for construction of Hearst Elementary School and, in 1946, sold the remaining property, including the Highlands main house, to the Sidwell Friends School, which occupies the house and grounds today.

PEIRCE MILL, 1829
2401 Tilden Street NW
Peirce Mill, constructed in 1829 by Isaac Peirce, was the centerpiece of the Peirce family agricultural plantation and milling operation that lasted three

generations. In the early nineteenth century, before Peirce developed the mill proper on Rock Creek, he had established a farmstead that included his farmhouse (no longer extant) and several barns and outbuildings located on the western slope of the hill leading down to Rock Creek and the site of the mill. Peirce cultivated the land and established an early nursery that would be taken over and expanded by his son, Joshua Peirce. Peirce Mill was one of about eight mills along Rock Creek and one of its most successful.

GEORGETOWN VISITATION MEATHOUSE, 1836
1524 Thirty-Fifth Street NW
This building, now referred to as the Monastery Annex, was originally built as a meathouse around 1836 to cure and store meat for the residents at the Georgetown Visitation Convent and Preparatory Schools. Originally a freestanding structure, the former meathouse now abuts the monastery building on the school site.

DUNBLANE, 1818–39
4340 Nebraska Avenue NW
The Greek Revival–style house known as Dunblane and historically located on a sixty-six-acre tract of land in Tenleytown was built as a country retreat between 1818 and 1839 by Georgetown businessman Clement Smith. In 1839, Smith sold the property to fellow Georgetowner John Mason (son of John Mason of Mason's Island), who occupied the house with his wife and family as a permanent residence rather than a secondary country home. During the second half of the nineteenth century, the property changed hands several times before it became the home of the Dunblane Hunt and the hunt clubhouse. In 1906, the Sisters of Providence purchased the property, establishing the Immaculata Seminary and Junior College on the site. Today, the American University School of Law occupies the site, including the historic Dunblane house.

BELLAIR (BROOKS MANSION), circa 1840
901 Newton Street NE
The Greek Revival–style Bellair house was built by Jehiel Brooks and his wife, Ann (Queen) Brooks, on property that was owned by Ann and had been part of Queen family lands since the eighteenth century. Although Jehiel built a sophisticated country house and designed landscapes that gave the impression that he was a man of affluence, Brooks was largely dependent on the cultivation of the land for his family's livelihood. Jehiel and Ann lived

permanently on the property, farming the land during their lifetimes. In 1887, following their deaths, the property was platted into the residential subdivision Brookland, with the couple's still-extant Bellair house preserved on a one-acre lot within its boundaries.

CORN RIGS (LINCOLN COTTAGE), 1842–43
3400 North Capitol Street NW
At the age of twenty-nine, in 1842, banker George Washington Riggs purchased a 197-acre property north of the city and contracted with local carpenter and builder William H. Degges to design and build a Gothic Revival–style country house, which was then all the rage. Riggs used the house, named Corn Rigs, as a weekend and summer retreat but maintained the property as an active working farm. Just ten years after purchasing the property, Riggs sold it to the U.S. government for use as a Soldiers' Home (now the Armed Services Retirement Home). Corn Rigs (Lincoln Cottage) served as President Lincoln's summer retreat from 1862 to 1864 and is where Lincoln drafted the Emancipation Proclamation.

WETZEL-ARCHBOLD CABIN, 1843
4437 Reservoir Road NW
The Wetzel-Archbold Cabin is a farmhouse consisting of two log wings. The first log structure was likely built by farmer Lazarus Wetzel shortly after he purchased the sixteen-acre property in 1843. Around 1850, Wetzel extended the log structure by another wing of log construction, and the two-room cabin became the nucleus of Wetzel's small farming operation. There he planted fruit trees and vegetables, and it remained home to his family for four decades. In 1931, Anne Archbold, heiress to the Standard Oil fortune, who lived on an adjacent property at Hillandale, purchased the log cabin and its surrounding acreage. In 1948, Archbold deeded the property to her daughter, who lived in the log house until 1988. In 1991, the log house was extensively enlarged by a wing at the rear.

SPRINGLAND, 1845
3550 Tilden Street NW
The house known as Springland was built in 1845 on part of the Vineyard, a two-hundred-acre tract of land and an early nineteenth-century vineyard operated by John Adlum. Today considered the father of American viticulture, Adlum was a Pennsylvania surveyor who purchased a farm in the District and experimented with growing American grapes for winemaking.

After Adlum's death in the 1830s, his daughter and her husband, Henry Hatch Dent, acquired part of the Vineyard land and built the one-and-a-half-story Springland farmhouse, which still stands. The house stood in proximity to the Vineyard House, now demolished, where Adlum's widow continued to live. A still-surviving springhouse, now on an adjacent property at 3517 Springland Lane, was originally part of the Springland domestic complex.

SPRINGLAND SPRINGHOUSE, circa 1845
3517 Springland Lane NW
The Springland Springhouse is one of a few surviving springhouses in the city. It is a low-slung stone structure, banked into its site and covered with a shed roof. Two sources of water were channeled into the building and collected in a trough, where vessels of milk, cream and other perishables would have rested to stay cool.

AMBERGER FARMHOUSE, circa 1850
5239 Sherrier Place NW
The Amberger Farmhouse in the Palisades was the home of the Ambergers, a family of farmers who owned significant acreage in the area during the nineteenth century. The house was moved to its current site on Sherrier Place between 1916 and 1937 from a nearby location.

SAMUEL AND HARRIET BURROWS FARMHOUSE, circa 1850
4624 Verplanck Street NW
The Samuel and Harriet Burrows House was built on Burrows family farmland off River Road near present-day Ellicott Street. After Harriet Burrows's death in 1923, the property was slated for residential development as part of the residential subdivision of American University Park. In 1928, before the house was demolished by the developers, an individual bought it and moved it to its current site on Verplanck Place, seven blocks south of River Road.

INGLESIDE, 1852
1818 Newton Street NW
Ingleside, in today's Mount Pleasant neighborhood, was designed in 1851 by one of America's most distinguished architects, Thomas U. Walter, who was in the District at that time working on the design of the dome and wings of the Capitol. The house, which Walter referred to as a villa, was

commissioned by a T.B.A. Hewlings from Philadelphia as his country seat. The house was executed in an Italianate villa style that was made popular in the mid-nineteenth century by publications such as A.J. Downing's *The Architecture of Country Houses.*

FENWICK FARM SPRINGHOUSE, 1855
1640 Kalmia Road NW
This brick and stone springhouse off upper Sixteenth Street on the grounds of Lowell School was part of the early- to mid-nineteenth-century farmstead owned and operated by Philip Fenwick. Following Fenwick's 1863 death, his daughter Mary (Fenwick) Van Riswick and her husband, John Van Riswick, acquired Fenwick's farm and continued to operate it under the supervision of an overseer while they lived in the city. The Van Riswicks built their own country house, Van View, east of the Fenwick farm, facing today's Thirteenth Street between Jonquil and Kalmia Streets.

CEDAR HILL (FREDERICK DOUGLASS HOUSE), 1855–59
1411 W Street SE
Frederick Douglass's house was originally built by John Van Hook in 1855–59. Van Hook was one of the founders of the Union Land Improvement Company, which laid out and developed Uniontown (today's Old Anacostia), Washington's first suburb, and he built his house just on the new suburb's outskirts. In 1871, Frederick Douglass purchased the property, which he named Cedar Hill, and lived there until his death in 1895.

HAREWOOD LODGE/GATEHOUSE, 1856–57
Harewood Road NE
The stone building known as the Harewood Lodge is the sole surviving building associated with William Wilson Corcoran's 191-acre Harewood estate and farm. Designed by architect James Renwick, the Harewood Lodge served as a gatehouse and porter's lodge at the eastern entrance to Corcoran's estate and is the earliest known use of the Second Empire style in Washington. Corcoran's estate, landscaped with winding and picturesque lanes through wooded copses, was open to visitors and their carriages. In 1872, the U.S. government purchased Harewood to expand the grounds of the U.S. Soldiers' Home (Armed Services Retirement Home), keeping the Harewood Lodge in use as a gatehouse for many decades. The lodge, which has since been separated from the Armed Forces Retirement Home, sits on a five-acre parcel at its southeastern edge bordering Harewood Road NE.

TUCKER-MEANS FARMHOUSE, 1858
1216 Upshur Street NE
Enoch Tucker built his farmhouse on a fifty-acre parcel of land where he raised and sold fruit and fruit trees until his death in 1869. By 1879, Lewis Means, a longtime Tenleytown farmer and cattle drover and dealer, had acquired the tract. Means owned and operated the Queenstown Cattle Auction, which was held at the Queenstown Station on the Metropolitan Branch of the B&O Railroad, just west of the farm property, within the heart of the Brookland neighborhood today.

DIETRICH AND AUGUSTA EDEL FARMHOUSE, 1859
804 Lawrence Street NE
The Edel Farmhouse was built by 1859 by gardener Dietrich Edel on a 4.9-acre property in today's Brookland neighborhood, where he raised garden vegetables that he sold at Center Market and Northern Liberties Market downtown. The house originally faced west, but in 1916, it was re-oriented to face the newly laid street and a rear wing was removed.

OSBORN STORE, pre-1859
5910 Georgia Avenue NW
The Osborn Store, a two-story wood frame structure with a mansard roof, was likely built before 1859, making it the oldest known building in what was the rural crossroads community of Brightwood. The store was owned by A.G. Osborn, grocer, feed dealer and justice of the peace. A building on this site appears on the 1861 Boschke Map.

JOST-KUHN HOUSE, 1859
1354–56 Madison Street NW
Benedict Jost, a restauranteur and wine merchant in downtown Washington, built this Italianate villa in 1859 on a twenty-four-acre property that he and his wife owned just south of Brightwood. Initially Jost sought to rent the house, advertising it to a "fashionable family," but he and his family eventually moved to the property, which included the house, a barn and surrounding cultivated acreage. After Jost's death in 1869, his widow remained in the house for the next ten years, until she remarried. In 1882, German-born Gustav Kuhn, a piano tuner and dealer, and his wife, Louisa, purchased the property.

SCHOTT FARMHOUSE, 1859
1710 Thirty-Fifth Street NW
This wood frame house just outside of the Burleith subdivision of the historic Berleith property is one of several pre–Civil War houses along the street. This one, which was owned by Arthur Schott in 1869 and sat on a sizeable parcel, may have been farmed, but additional research is necessary to make this determination.

UNDERWOOD HOUSE, circa 1860
4308 Forty-Sixth Street NW
This house, known locally as the Underwood House for its late nineteenth-century owner, is thought to include a pre–Civil War structure at its core, though additional research is needed to confirm this date.

MARY DENMAN HOUSE, circa 1860
3703 Bangor Street SE
The Denman house in the Hillsdale neighborhood in Southeast was built by George Washington Young on his Nonesuch property for his daughter, Mary, upon her marriage to Colonel Denman. Mary (Young) Denman was born at Nonesuch but grew up at Upper Giesboro, after her father purchased the Giesboro property in 1833 and moved his family there. The Denman House is the only standing building associated with the Young family, descendants of Notley Young, one of the original proprietors of the federal city.

FARMHOUSE, 1861
2817 Evarts Street NE
The two-story, two-bay frame house at 2817 Evarts Street NE was most likely moved to its site from the Evarts Street right of way in the early twentieth century when the street was cut and laid. The 1894 Hopkins Map clearly shows the house along the route of the street (then designated as Emporia Street), and the same footprint is apparent on the 1861 Boschke Map, indicating that the house was built by then.

SCHEELE-BROWN FARMHOUSE, 1865
2207 Foxhall Road NW
This modest two-story, two-bay frame house was built in 1865 by Augustus Scheele, a butcher born in Georgetown and the son of a German immigrant. For ten years, the Scheeles established and operated a sizeable slaughterhouse on the property, a venture that butcher and farmer Walter

Brown took over from the Scheeles and that the Brown family continued to operate for the next forty years. In 1903, the house was moved about 190 feet south-southwest on the site, where it remains today.

HOWARD HALL, 1867
607 Howard Place NW
General Oliver Otis Howard was a commissioner of the Freedmen's Bureau and helped found Howard University. In 1867, he built his residence, Howard Hall, on the grounds of the university. Howard Hall is the only one of four original Howard University buildings to survive.

ANGERMAN FARMHOUSE, 1868–73
589 Columbia Road NW
John Angerman built this two-story, three-bay frame farmhouse between 1868 and 1873 on land previously owned by J. Major. The farmhouse was moved in 1911 following subdivision of streets to align with present-day Columbia Road (previously named Morris Street). At the time of the farmhouse move, the property was still in agricultural use.

NOURSE TENANT HOUSE, circa 1870
3950 Thirty-Seventh Street NW
This stone house, once part of the Highlands estate and now the Hearst Playground fieldhouse, was constructed as a tenant house by the Nourse family, descendants of the original owner/builder of the Highlands. Later owner Admiral Cary T. Grayson, President Wilson's personal physician, used the stone cottage as a private clubhouse until 1930, when he sold the property to the District of Columbia for construction of Hearst Elementary School.

VAN VIEW, 1868–71
7714 Thirteenth Street NW
John and Mary (Fenwick) Van Riswick built Van View between 1868 and 1871 on a sixteen-acre parcel that had been part of the 125-acre farm of Philip Fenwick, Mary's father. Van View served as the country home of the Van Riswicks, who primarily lived in the city, but they operated Van View as a working farm under the supervision of a manager. Following her husband's death, Mary Van Riswick moved to Van View.

GEORGE BARKER FARMHOUSE, 1873
3333 M Street SE
In 1872–73, George M. Barker was assessed for five farmhouses that were part of his 61.49-acre farm east of the Anacostia River. This frame house, one of those five, survived the residential subdivision of the property in the 1920s. The house is located askew on its gracious corner lot at the intersection of Thirty-Fourth and M Streets SE and sits up on a hill above the grade of the street.

CLOVERDALE, 1876
2600 Tilden Street NW
Peirce Shoemaker built his house, Cloverdale, in 1876 adjacent to Peirce Mill and on the site of his great-uncle Isaac Peirce's house (demolished). Cloverdale was remodeled in 1910 and remains in private hands, within the boundaries of Rock Creek Park.

ENDERS FARMHOUSE, 1878
4330 Yuma Street NW
This house in Tenleytown appears on the 1878 G.M. Hopkins Map and was likely built by Englebert Enders, an immigrant from Germany who operated a dairy farm on the property.

DEANE HOUSE, 1878
4421 Jay Street NE
The Deane House, historically located on a fifty-four-acre part of the larger Sheriff family farm, was built for Julian Deane, the grandson of Levi Sheriff, who operated one of the largest plantations in Washington in the mid-nineteenth century. The Deane House, converted into a church in the 1980s, is the oldest surviving house in present-day Deanwood.

BARRY TAVERN, 1879
5018 Rock Creek Church Road NE
Local tradition holds that this building on Rock Creek Church Road is an old tavern building. The building indeed appears as a store on the 1879 Hopkins map, under the ownership of a Robert Barry.

JONES FARMHOUSE, 1876–81
3326 Quesada Street NW
The Jones Farmhouse, built between 1876 and 1881, appears to have replaced an older farmhouse on the site, a 10.5-acre farm owned by Richard S. Jones throughout the second half of the nineteenth century. The property remained in Jones family hands into the 1920s.

NOONAN FARMHOUSE, 1881
3039 Davenport Street NW
This house historically occupied a 26.36-acre property identified on the 1881 Carpenter Map under the name John Noonan. Noonan sold 51 acres to the Chevy Chase Land Company, including this house lot, as part of the land company's plans to develop the suburb of Chevy Chase. The house, a sizeable, two-story wood frame structure that has been re-clad in brick, escaped demolition during the neighborhood's development. It sits back from and is askew to the street and the other houses facing Davenport Street.

MORGAN FARMHOUSE, 1881
38 Riggs Road NE
This house was built in 1881 by H.J. Morgan on a one-acre parcel of land that was carved out of a larger fifty-six-acre farm.

HARLAN FARMHOUSE, 1881
6615 First Street NW
The Harlan House, built in 1881, was part of a seventeen-acre farm complex near Takoma Park owned by Mary and Woodford Harlan in the last quarter of the nineteenth century. The Harlans actively farmed the property throughout their lifetimes, though Woodford also had a career with the federal government. After Mary's death, Woodford subdivided his acreage in 1909 for residential development, moving his house to face the newly cut First Street in the process. Woodford remained in his house to oversee the subdivision process and sale of lots until his death in 1926.

HARLAN TENANT HOUSE, 1882
6615 Harlan Place NW
The Harlan Tenant house was built in 1882 on the seventeen-acre Harlan farm. In 1909, when the property was subdivided, Harlan Place was cut through and the tenant house was rotated on its lot to face the street.

WATROUS FARMHOUSE, 1881–87
1506 Missouri Avenue NW
The farmhouse at 1506 Missouri Avenue was built between 1881 and 1887 on a two-acre property on the south side of Military Road. In 1887, as noted on the G.M. Hopkins Map, the property was owned by A. Watrous, but it passed through multiple hands over the next hundred years. In 1915, the house was moved within its site to its present orientation facing Missouri Avenue.

BARNS AT SAINT ELIZABETHS HOSPITAL, 1884–85
St. Elizabeths Hospital
The dry barn at St. Elizabeths was built in 1884–85 and is one of two barns on the institutional campus.

SHERWOOD FARMHOUSE, 1886
1400 Shepherd Street NE
The Sherwood farmhouse was built in 1886 by James Sherwood, who purchased several lots that had been divided out of the two-hundred-acre Cuckold's Delight, an eighteenth-century property occupied today by the Franciscan Monastery, Holy Name College and part of the Brookland neighborhood. Sherwood lived in the house with his family and farmed the property for years while simultaneously investing in real estate development in Brookland. The Sherwood farm, along with adjacent lots, was purchased by Holy Name College, where the farmhouse remains today.

DOUGHERTY FARMHOUSE, circa 1887
3009 Douglas Street NE
The house at 3009 Douglas Street was moved to the site, according to a 1923 Permit to Move. A nearby building on a large parcel under the name of C.J. Dougherty on the 1887 and 1894 Hopkins map is likely the original house site, though additional research is necessary.

HENDERSON CASTLE WALL, 1888
2200 Sixteenth Street NW
The red Seneca sandstone wall on the west side of Sixteenth Street just north of Florida Avenue is all that remains of Henderson Castle, an estate built in 1888 by John and Mary Henderson on Meridian Hill, just beyond the city limits. John Henderson was a former U.S. senator from Missouri, and Mary

Henderson became an influential developer of Meridian Hill. Henderson Castle was the Hendersons' permanent residence in Washington.

TWIN OAKS, 1888
3200 Macomb Street NW
In the 1880s, Gardiner Greene Hubbard, a wealthy Washington lawyer and founder of the National Geographic Society, purchased a thirty-nine-acre tract of land that had been carved out of the Rosedale farm property in today's Cleveland Park neighborhood and built an extensive early Colonial Revival mansion. Modeled after the grand estates of Newport, Rhode Island, and designed by the Boston architectural firm Allen and Kenway, the gracious twenty-six-room Twin Oaks commands its site on a hill above the residential neighborhood.

WIDMAYER HOUSE, 1894
7329 Blair Road NW
This house on Blair Road near Takoma was constructed in 1888 before the 1893 subdivision of West Takoma.

SHERRIER FARMHOUSE, 1890
2428 Chain Bridge Road NW
This Sherrier family farmhouse on Chain Bridge Road in the Palisades originally stood above Conduit Road and was moved to this site after 1894. The Sherriers, after whom Sherrier Road is named, were longtime farmers in the area.

WILLIAM VOIGT FARMHOUSE, 1890
4220 Jenifer Street NW
This house on Jenifer Street in Tenleytown is thought to be the house historically associated with the twenty-acre William Voigt farm, originally located on Belt Road between Jennifer and Keokuk Streets and moved to its present site in 1911.

WILLIAM HEIDER FARMHOUSE, circa 1890
4232 Ingomar Street NW
The William Heider farmhouse was built on the twenty-acre Heider property in Tenleytown. In 1938, the house was moved to its current lot at 4232 Ingomar Street NW.

HILD HOUSE, 1890
5031 MacArthur Boulevard NW
The two-story Queen Anne–style Hild House in the Palisades was built in 1890 by G.E. Hild on a small one-acre site just before the area was platted for residential subdivision.

GEORGE M. LIGHTFOOT HOUSE, 1892
1329 Missouri Avenue NW
In 1892, Frederick Bex, a carriage maker, built this house on a ¾-acre tract in the rural crossroads community of Brightwood. The house was named for a later owner, African American George M. Lightfoot, a professor of Latin at Howard University who lived there from 1931 until his death in 1947. The house was located adjacent to Vinegar Hill, a free-black community that emerged by the 1830s in Brightwood.

U.S. NAVAL OBSERVATORY ADMIRALS HOUSE, 1893
1 Observatory Circle NW
Now the residence of the vice president, the house on Observatory Circle was originally built in 1893 as the residence of the superintendent of the Naval Observatory.

CASTLEVIEW, 1893
4759 Reservoir Road NW
Castleview, an imposing red Seneca sandstone castellated Gothic manse, was built in 1893 in the Palisades by Jacob B. Clark, an investor in the Palisades Land Company. Clark built his house just beyond the bounds of the residential subdivision on a 12.78-acre tract of land. Between 1918 and 1923, the property became the Florence Crittenden Home for troubled teenage girls until it closed in 1986 and is now home to the Lab School.

WESTOVER GATES, pre-1894
4200 Massachusetts Avenue NW
Charles Glover built his country estate, Westover, on a thirty-two-acre tract of land on the south side of Massachusetts Avenue near today's Ward Circle before 1894. The house was demolished but entrance gates survive along Massachusetts Avenue, east of Ward Circle. In 1924, Glover donated eighty acres of land adjacent to his property that later became Glover-Archbold Park.

BURROWS FAMILY FARMHOUSE, pre-1897
4716 Forty-Eighth Street NW
This house is one of several Burrows family farmhouses in the Tenleytown area and likely dates to the mid-nineteenth century. A photo of the house appears in the 1897 promotional brochure for American University Park, showing the farmhouse in its rural setting with a barn at the back of the house. The brochure refers to the house as the "old Mansion House." The original site of the house has not been determined, but the house is known to have been moved or reoriented on its present site to face Forty-Eighth Street after the subdivided area was laid out with streets and building lots.

FRANCIS D. SHOEMAKER FARMHOUSE, 1894
600 Geranium Street NW
The house, at present-day 600 Geranium Street NW, appears at the far east end of the twenty-acre Francis D. Shoemaker property fronting Blair Road on the 1894 Hopkins Map.

McCENEY FARMHOUSE, 1894
1441 Kearny Street NE
This is one of two farmhouses that stood on a 9.9-acre lot (Lot 4) divided out of Henry McCeney's portion of the 200-acre Cuckold's Delight. The farmhouse, which is shown on the 1894 Hopkins Map, survived the subdivision of the land into the residential neighborhood of Brookland.

McCENEY FARMHOUSE 2, 1894
1525 Kearny Street NE
This is one of two farmhouses that stood on a 9.9-acre lot (Lot 4) divided out of Henry McCeny's portion of Cuckold's Delight. The farmhouse, which is shown on the 1894 Hopkins Map, survived the subdivision of the land into the residential neighborhood of Brookland.

LOOMIS TENANT HOUSE, 1894
2400 Twentieth Street NE
This house appears to have been a secondary dwelling on part of a 12.5-acre property under the name of Mary Loomis that also included a main house and outbuilding. When the Winthrop Heights subdivision was expanded, the main house and outbuilding were demolished, but this secondary structure survived.

LOWRIE TENANT HOUSE, 1894
4513 Sheriff Road NE
This house appears on the 1894 Hopkins Map and may be one of the tenant houses on the 54.84-acre Margaret Lowrie farm, part of the larger Levi Sheriff property that was the last tobacco plantation in the District. However, additional research is necessary, as it may also be one of the first houses built after the property was subdivided into Burrville.

LOWRIE TENANT HOUSE 2, 1894
5316 Gay Street NE
This house also appears on the 1894 Hopkins Map and may be one of the tenant houses on the Margaret Lowrie farm. However, additional research is necessary, as it may also be one of the first houses built after the property was subdivided into Burrville.

RILEY HOUSE, 1894
2357 Twenty-Fifth Street SE
This house may be the house on the 7.362-acre Riley property as shown on the 1894 Hopkins Map, making it the last known nineteenth-century building of the Good Hope settlement.

OWL'S NEST, 1897
3031 Gates Road
The handsome Shingle-style house known as Owl's Nest, designed by architect Appleton P. Clark, was built as a rural country home for journalist William L. Crounse in 1897. The house illustrates the transition of Washington County from farmsteads to scattered suburban country houses on large lots, to denser suburban neighborhoods laid out according to the Permanent Highway Plan.

FRIENDSHIP ESTATE (REMNANTS), 1898
3800 Wisconsin Avenue NW
John R. McLean built Friendship beginning in 1898, ultimately developing an extensive estate, including a mansion designed by notable architect John Russell Pope, formal gardens with statuary, a tennis court and a pool. In 1942–43, the federal government purchased the property and demolished the house for construction of a dormitory for women war workers, leaving the estate wall and some statuary in place on the former estate. The property was later developed into McLean Gardens, which also retained the wall and statuary.

FRANCISCAN MONASTERY BARN, 1898
1400 Quincy Street NE
A barn at the Franciscan Monastery is the remaining portion of a larger barn, the stable and silo of which burned down in a fire (date unknown). The barn is located east of another barn attached to a greenhouse.

BEAUVOIR GATEHOUSE AND GATES, 1900
3500 Woodley Road NW
The Beauvoir gatehouse, designed by architect Waddy Wood, and associated gates just south of the gatehouse are all that remain of Francis Newlands's Beauvoir estate, built around 1900. The site is occupied by Beauvoir School.

RED OAK SPRING COMPANY SPRINGHOUSES, 1904
3501 New York Avenue NE
These two striking brick structures with conical roofs on the site of today's National Arboretum were associated with the Red Oak Spring Company. Leopold Luchs purchased the land as several lots from the Hickey estate of Greenvale in 1879, and in 1905, he started his commercial spring water company, capturing and bottling water for distribution to city residents and businesses.

FRANCISCAN MONASTERY GREENHOUSE AND BARN, 1915
1400 Quincy Street NE
The greenhouse and attached barn at the Franciscan Monastery were built in two phases. The barn or stable appears on the 1894 Hopkins Map and was part of the McCeeney farm before the Franciscans purchased the site. In 1915, the Franciscans built the greenhouse against the existing barn structure.

NOTES

Chapter *1*

1. MacMaster and Hiebert, *Grateful Remembrance*, 15–16.

Chapter *2*

2. Pippenger, *District of Columbia*, 4.
3. National Register of Historic Places [hereafter NR], "L'Enfant Plan," 8–9.
4. Pippenger, *District of Columbia*, 7.
5. As quoted in Arnebeck, *Through a Fiery Trial*, 48.
6. *Daily National Intelligencer*, March 21, 1818.
7. Hawkins, "Landscape of the Federal City," 27.
8. "The Mansion House for Sale," *Daily National Intelligencer*, September 11, 1817; "For Sale or Rent," *Daily National Intelligencer*, March 21, 1818.
9. *Daily National Intelligencer*, October 18, 1802.
10. Arnebeck, *Through a Fiery Trial*, 37.
11. Pippenger, *District of Columbia*, 7.
12. *Daily National Intelligencer*, October 12, 1867.
13. Letter from Commissioners to Captain Ignatius Fenwick, April 19, 1794, as transcribed in the papers of Louis D. Scisco Research Collection, 1924–55, Historical Society of Washington, D.C.

14. Letter from Daniel Carroll to the Commissioners, January 15, 1799, as quoted in Clark, "Daniel Carroll of Duddington," 9.

15. As quoted in Eberlein and Hubbard, *Historic Houses*, 394.

16. Ibid, 394–95.

17. "Raze Old Mansion: House of Eighteenth Century Gives Way to Progress, Built by Abraham Young," *Evening Star*, August 31, 1912.

18. Ibid.

Chapter 3

19. As quoted in "Cultural Resources Management Plan, Bolling Air Force Base, Washington, D.C.," by Air Force Center for Environmental Excellence Environmental Conservation and Planning Directorate, 3–28.

20. *Sunday Star*, December 17, 1916.

21. Helm, *Tenleytown*, 7.

22. John Murdock's home, the first substantial dwelling in the Tenleytown area, was eventually acquired by American University. The chancellor's house at the university was later erected on the site.

23. *Daily National Intelligencer*, November 28, 1809.

24. As quoted in Mann-Kenney, *Rosedale*, 8.

Chapter 4

25. Ibid., 29–30.

26. "For Sale," *Daily National Intelligencer*, April 18, 1817.

27. Van Horne, ed., *Correspondence and Miscellaneous Papers*, 898, as quoted in Scott, "Brentwood," unpublished research paper in the author's possession.

28. Goode, *Capital Losses*, 38–39.

29. Henley, "Past Before Us," 375–77.

30. Smith, *First Forty Years*, as quoted in Henley, "Past Before Us," 376–77.

31. *Columbian Mirror*, January 16, 19 and 23, 1793, as cited in NR, "Theodore Roosevelt Island," 8–36.

32. *Washington Times*, May 4, 1902.

33. NR, "Theodore Roosevelt Island," 39.

34. Warden, *Chorographical and Statistical Description*, 141–42.

35. Ibid., 144.

36. Ibid., 139.
37. NR, "Theodore Roosevelt Island," 8–38.
38. National Park Service [hereafter NPS], "Cultural Landscapes Inventory, Theodore Roosevelt Island," 26.
39. *Washington Times*, May 4, 1902
40. Main, *Directions*, as quoted in Powell, "Whitehaven," 2.
41. Smith, *First Forty Years*, 394–95.
42. Ibid., 395.
43. Powell, "Whitehaven."
44. As quoted in *Sunday Star*, July 29, 1917.
45. Adlum, *Memoir*, 3–4.
46. Aaron Nix Gomez, "'Cultivated with So Much Success': The Vines and Vineyards of Washington, D.C., 1799–1833," Hogshead, September 20, 2013, https://hogsheadwine.wordpress.com/2013/09/20/cultivated-with-so-much-success-the-vines-and-vineyards-of-washington-d-c-1799-1833.
47. Gahn, "Major John Adlum," 135.
48. Ibid., 136.
49. "For Sale," *Daily National Intelligencer*, December 14, 1814.
50. NR, "Linnaean Hill," 27.
51. Shoemaker, "Historic Rock Creek," 46.
52. NR, "Linnaean Hill (Amendment)," 26.

Chapter 5

53. Henley, "Past Before Us," 413.
54. As quoted in NR, "Scheele-Brown Farmhouse," 8–24.
55. "Slaughter Yards Contaminate the Water in the Reservoir," *Washington Post*, January 8, 1890.
56. Torrey and Green, "Free Black People," 23.
57. Payne's Cemetery, African American Heritage Trail, Cultural Tourism, D.C.
58. Far East Community Services, "Deanwood," 13.
59. NPS, "Peirce Mill," 26.
60. Lanier and Herman, *Everyday Architecture*, 53.

Chapter 6

61. "Robert Anderson's Plan to Provide for Old Soldiers," 26th Congress, 1st session, 1840, H. Doc. 138, 2, as quoted in NR, "Armed Forces Retirement Home," 8–108.
62. Ibid., n. 26.
63. Ibid., 8–114.
64. U.S. Department of War, "Report of the Board of Commissioners of the Soldiers' Home," Annual Report of the War Department for the fiscal year ended June 30, 1898 (Washington, D.C.: Government Printing Office, 1898), 539, as quoted in NR, "Armed Forces Retirement Home," 8–122.
65. "The Environs of Washington," *New York Times*, June 28, 1870, 2.
66. NR, "Harewood," 22.
67. St. Elizabeths Cow Barn, Historic American Buildings Survey drawings, 2005.
68. William Parker Cutler and Julia Perkins Cutler, *Life, Journals and Correspondence of Rev. Manasseh Cutler, LL.D.* (Cincinnati, OH, 1888), 2:142–43, as quoted in Otis, "Washington's Lost Racetracks," 142.
69. Swerdloff, *Crestwood*, 53–56; advertisement in the *Evening Star* promoting the new grandstand, July 7, 1857; ads in the *Evening Star*, 1863, promoting stage coaches for Crystal Springs; advertisement in the *Washington Post*, December 6, 1877.
70. *Daily National Intelligencer*, June 28, 1859; May 15, 1860.
71. *Washington Post*, January 10, 1890.

Chapter 7

72. Leech, *Reveille in Washington*, as quoted in NPS, "Civil War Defenses of Washington," 53.
73. Lee, *Mr. Lincoln's City*, 13.
74. Cooling and Owen, *Mr. Lincoln's Forts*, 9.
75. Barnard, "Report on the Defenses," 85.
76. NPS, "Fort DeRussy," 32.
77. Ibid.
78. As quoted in NR, "Civil War Defenses of Washington," 6.
79. NPS, "Fort Bunker Hill," 31.

80. "Civil War Washington, D.C., Giesboro Point Calvary Depot, Parking for 30,000 Horses," Civil War Washington, D.C., August 17, 2011, http://civilwarwashingtondc1861-1865.blogspot.com/2011/08/geisborough-point-cavalry-depot-parking.html.

81. "Elizabeth Thomas," Senate Document No. 53, 58th Congress, 3rd session, December 5, 1904.

82. Lutz, ed., *Letters of George E. Chamberlin*, 311.

83. Sergeant H.H. Richardson of Company H in a letter dated July 27, 1862, as quoted in Spicer, *History of the Ninth and Tenth*, 112.

84. As quoted in Helm, *Tenleytown*, 54.

85. Dryden, *Peirce Mill*, 39.

86. *Evening Star*, June 17, 1861.

87. Townsend, *Washington, Outside and Inside*, 640.

88. McKevitt, *Meridian Hill*, 44.

89. NR, "Tenleytown," E-8.

Chapter 8

90. Harrison, "'Evil of the Misfit Subdivisions,'" 30.

91. Ibid., 34.

92. Lampl and Williams, *Chevy Chase*, 9.

93. Harrison, "'Evil of the Misfit Subdivisions.'"

94. *Washington Post*, September 17, 1886.

95. *Evening Star*, August 31, 1912.

96. Richardson, *Alexander Robey Shepherd*, 53.

97. *Washington Post*, February 28, 1909.

98. D.C. Permit to Move #2877, October 29, 1909.

99. *Evening Star*, June 22, 1919.

100. *Independent Statesman*, 1882.

101. NR, "Holy Name College," 19.

102. *Evening Star*, April 16, 1896.

103. Ibid., May 3, 1887.

104. Ibid., March 19, 1874.

Epilogue

105. "'Down on the Farm,' in Washington," *Sunday Star*, May 12, 1946.

Bibliography

Adlum, John. *A Memoir on the Cultivation of the Vine in America and the Best Mode of Making Wine.* Washington, D.C.: Printed by Davis and Force, 1823.

Arnebeck, Bob. *Slave Labor in the Capital: Building Washington's Iconic Federal Landmarks.* Charleston, SC: The History Press, 2014.

———. *Through a Fiery Trial: Building Washington 1790–1800.* Lanham, MD: Madison Books, 1991.

Barnard, John G. "A Report on the Defenses of Washington to the Chief of Engineers." U.S. Army Corps of Engineers, Professional Paper No. 20. Washington, D.C.: Government Printing Office, 1871.

Bedell, John, Stuart Fiedel and Charles Lee Decker. *Bold, Rocky and Picturesque: The Archeology and History of Rock Creek Park.* Philadelphia: Eastern National, 2013.

Boese, Kent. *Park View.* Charleston, SC: Arcadia Publishing, 2011.

Bowling, Kenneth R. "The Other G.W.: George Walker and the Creation of the National Capital." *Washington History* 3, no. 2 (Fall/Winter 1991–92): 4–21.

Castle, Guy. "Giesborough as a Land Grant, Manor and Residence of the Dents, Addisons, Shaaffs and Youngs," *Records of the Columbia Historical Society* 53/56 (1953–56): 282–92.

Clark, Allen C. "The Abraham Young Mansion." *Records of the Columbia Historical Society* 12 (1909): 53–70.

———. "Daniel Carroll of Duddington," *Records of the Columbia Historical Society* 39 (1938): 1–48.

Cooling, Benjamin Franklin, and Walton H. Owen. *Mr. Lincoln's Forts: A Guide to the Civil War Defenses of Washington*. Lanham, MD: Scarecrow Press, 2010.

"Cultural Resources Management Plan, Bolling Air Force Base, Washington, D.C." Air Force Center for Environmental Excellence, Environmental Conservation and Planning Directorate, Brooks Air Force Base, Texas, 1996.

Dennée, Timothy. "A Civil War–Era Directory of Washington County, D.C. and Nearby Maryland." Unpublished paper, 2015, D.C. Historic Preservation Office. Original source materials are at the National Archives and Records Administration, in Part II of Record Group 393, Records of the United States Army Continental Commands: Brigadier General Martin D. Hardin circular dated August 15, 1864, in "Circulars [Received by the Second Brigade of Hardin's Division, 22nd Army Corps], July 1864 to August 1865," Entry 6696. The First Brigade's "Register of Residents Within [the] Limits of [the] Command" is Entry 6681; the Third Brigade's "List of Citizens and Their Residences" is Entry 6717.

Downing, Margaret Brent. "The Earliest Proprietors of Capitol Hill." *Records of the Columbia Historical Society* 21 (1918): 1–23.

———. "Literary Landmarks." *Records of the Columbia Historical Society* 19 (1916): 22–60.

Dryden, Steve. *Peirce Mill: Two Hundred Years in the Nation's Capital*. Washington, D.C.: Lergamot Books, 2009.

Eberlein, Harrold Donaldson, and Charles Van Dyke Hubbard. *Historic Houses of Georgetown and Washington City*. Richmond, VA: Dietz Press, 1958.

Far East Community Services Inc. "Final Report on the History and Building of the Northeast Community of Deanwood." D.C. Historic Preservation Office, Washington, D.C., 1987.

Farley, Joseph Pearson. *Three Rivers: The James, the Potomac, the Hudson: A Retrospective of Peace and War*. New York: Neale Publishing, 1910.

Feeley, John J., Jr. *Brookland*. Charleston, SC: Arcadia Publishing, 2011.

Floyd, Dale. *A Historic Resources Study: The Civil War Defenses of Washington*. Parts I and II. Washington, D.C.: U.S. Department of the Interior, National Park Service, National Capital Region, 1998.

Gahn, Bessie Wilmarth. "Major John Adlum of Rock Creek." *Records of the Columbia Historical Society* 39 (1938): 127–39.

Gilmore, Matthew B., and Joshua Olsen. *Foggy Bottom and the West End*. Charleston, SC: The History Press, 2010.

Gilmore, Matthew B., and Kim Prothro Williams. "Moving Buildings: The Case of the Burrows Farmhouse." *Washington History* 28, no. 2 (Fall 2016): 49–52.

Goode, James. *Capital Losses: A Cultural History of Washington's Destroyed Buildings.* 2nd ed. Washington, D.C.: Smithsonian Books, 2003.

————. *The Evolution of Washington, D.C.: Historical Selections from the Albert H. Small Washingtoniana Collection at the George Washington University.* Washington, D.C.: Smithsonian Books, 2015.

Green, Constance McLaughlin. *Washington: A History of the Capital, 1800–1950.* Princeton, NJ: Princeton University Press, 1962.

Gutheim, Frederick. *The Potomac.* New York: Rinehart & Company, 1949.

Gutheim, Frederick, and Antoinette J. Lee. *Worthy of the Nation: Washington, DC, from L'Enfant to the National Capital Planning Commission.* 2nd ed. Baltimore, MD: Johns Hopkins University Press, 2006.

Harrison, Michael R. "The 'Evil of the Misfit Subdivisions': Creating the Permanent System of Highways in the District of Columbia." *Washington History* 14, no. 1 (Spring/Summer 2002): 26–55.

Hawkins, Don. "The Landscape of the Federal City: A 1792 Walking Tour." *Washington History* 3, no. 1 (Spring/Summer 1991): 11–33.

Helm, Judith Beck. *Tenleytown, D.C.: Country Village into City Neighborhood.* 2nd ed. Washington, D.C.: Tennally Press, 2000.

Henley, Laura Arlene. "The Past Before Us: An Examination of the Pre-1880 Cultural and Natural Landscape of Washington County." PhD dissertation, Catholic University of America, 1993.

Henley, Laura Arlene, and Robert Verrey. "Report of Results of the Brookland Community/Catholic University Historic Resources Survey, Northeast Washington, D.C." November 1987.

Henning, George C. "The Mansion and Family of Notley Young." *Records of the Columbia Historical Society* 16 (1913): 1–24.

Hines, Christian. *Early Recollections of Washington City.* Washington, D.C.: Junior League of Washington, 1981.

"A Historic Resources Study: The Civil War Defenses of Washington, Part 1." Prepared by CEHP for the National Park Service, Washington, D.C., 1998.

Hood, James Franklin. "The Cottage of David Burnes and Its Dining Room Mantle," *Records of the Columbia Historical Society*, vol. 23 (1920): 1–9.

Hutchins, Stilson, and Joseph West Moore. *The National Capital: Past and Present.* Washington, D.C.: Post Publishing, 1885.

Hutchinson, Louis Daniel. *The Anacostia Story: 1608–1930.* Washington, D.C.: Smithsonian Institution Press, 1977.

Junior League of Washington, Thomas Froncek, ed. *The City of Washington: An Illustrated History.* New York: Alfred A. Knopf, 1977.

Kilbourne, Al. *Woodley and Its Residents*. Charleston, SC: Arcadia Publishing, 2008.

Kreisa, Paul P., and Jacqueline McDowell, "Phase 1A Archeological Assessment of the Shepherd Parkway Interchange/Access Road Alternative for the St. Elizabeths West Campus Redevelopment Project, Washington, DC." Prepared for General Services Administration, 2009.

Lampl, Elizabeth Jo, and Kimberly Prothro Williams. *Chevy Chase: A Home Suburb for the Nation's Capital*. Crownsville: Maryland Historical Trust Press, 1998.

Lanier, Gabrielle M., and Bernard L. Herman. *Everyday Architecture of the Mid-Atlantic, Looking at Buildings and Landscapes*. Baltimore, MD: Johns Hopkins University Press, 1997.

Lee, Richard M. *Mr. Lincoln's City: An Illustrated Guide to the Civil War Sites of Washington*. McLean, VA: EPM Publications, 1981.

Leech, Margaret. *Reveille in Washington, 1860–1865*. New York: Harper Books, 1941.

Lewis, Tom. *Washington: A History of Our National City*. New York: Basic Books, 2015.

Lutz, Caroline. *Letters of George E. Chamberlin, Who Fell in the Service of his Country near Charleston, VA, August 21, 1864*. Springfield, IL: H.W. Rokker's Publishing House, 1883.

MacMaster, Richard K., and Ray Eldon Hiebert. *A Grateful Remembrance: The Story of Montgomery County, Maryland, 1776–1976*. Rockville, MD: Montgomery County Historical Society, 1976.

Main, Thomas. *Directions for the Transplantation and Management of Young Thorn or Other Hedge Plants, Preparative to Their Being Set in Hedges: With Some Practical Observations on the Method of Plain Hedging*. Washington, D.C.: A &G. Way Printers, 1807.

Mann-Kenney, Louise. *Rosedale: The Eighteenth Century Country Estate of General Uriah Forrest, Cleveland Park, Washington, D.C.* Washington, D.C.: Youth for Understanding, 1989.

McDaniel, George. "Images of Brookland: The History and Architecture of a Washington Suburb." Historical and Cultural Studies, no. 1, George Washington University Graduate Program in Historic Preservation. Washington, 1979.

McKevitt, Stephen R. *Meridian Hill: A History*. Charleston, SC: History Press, 2014.

McNeil, Priscilla. "The History of a Land Grant," *Washington History* 14, no. 2 (Fall/Winter 2002–3): 6–26.

————. "Rock Creek Hundred: Land Conveyed for the Federal City," *Washington History* 3, no. 1 (Spring/Summer 1991): 34–51.

Miller, Iris. *Washington in Maps, 1606–2000.* New York: Rizzoli International, 2002.

National Park Service. "Cultural Landscapes Inventory, Fort Bunker Hill." Washington, D.C., 2016.

————. "Cultural Landscapes Inventory, Fort DeRussy." Washington, D.C., 2014.

————. "Cultural Landscapes Inventory, Kenilworth Aquatic Gardens." Washington, D.C., 2010.

————. "Cultural Landscapes Inventory, Linnaean, Rock Creek Park." Washington, D.C., 2003.

————. "Cultural Landscapes Inventory, Peirce Mill, Rock Creek Park." Washington, D.C., 2004.

————. "Cultural Landscapes Inventory, Theodore Roosevelt Island." Washington, D.C., 2001.

————. "Historic Resources Study: The Civil War Defenses of Washington, Part I." Washington, D.C., 1998.

National Register of Historic Places. "Armed Forces Retirement Home— Washington." Washington, D.C., 2007, #07001237.

————. "Civil War Defenses of Washington/Fort Circle Parks." Washington, D.C (Draft), 2015.

————. "Franciscan Monastery and Memorial Church of the Holy Land." Washington, D.C., 1992, #91001943.

————. "Grant Circle Historic District." Washington, D.C., 2015, #15000718.

————. "Jost-Kuhn House." Washington, D.C., 2016, #16000127.

————. "Kalorama Park and Archeological Site." Washington, D.C., 2016, #16000193.

————. "L'Enfant Plan of the City of Washington, District of Columbia." Washington, D.C., 1997, #97000332.

————. "Linnaean Hill." Washington, D.C. (Amendment), 2011, #11000466.

————. "Multiple Property Document: Tenleytown." Washington, D.C.: Historic and Architectural Resources, 1791–1941, 2005,

————. "Pierce Springhouse and Barn." Washington, D.C., 1973, #73000222.

————. "Pierce Still House." Washington, D.C., 1990, #90001295.

————. "Rosedale." Washington, D.C., 1973, #0011975.

———. "Scheele-Brown House." Washington, D.C., 2016, #SG100001213.

———. "Springland." Washington, D.C., 1990, #90001114.

———. "Wetzel-Archbold Farmstead." Washington, D.C., 1991, #91000395.

Nelson, Megan Kate. *Ruin Nation: Destruction and the American Civil War*. Athens: University of Georgia Press, 2012.

Osborne, John Ball. "The First President's Interest in Washington as Told by Himself," *Records of the Columbia Historical Society* 4 (1901): 173–98.

Otis, Lara. "Washington's Lost Racetracks: Horse Racing from the 1760s to the 1930s," *Washington History* 24, no. 2 (2012): 142.

Overbeck, Ruth Ann, and Lucinda P. Janke. "William Prout, Capitol Hill's Community Builder," *Washington History* no. 1 (Spring/Summer 2000): 122–39.

Pippenger, Wesley E. *District of Columbia Original Land Owners 1791–1800*. Westminster, MD: Willow Bend Books, 1999.

Powell, Dr. William C. "Whitehaven." Unpublished document, n.d. D.C. Historic Preservation Office Vertical Files.

Richardson, John P. *Alexander Robey Shepherd: The Man Who Built the Nation's Capital*. Athens: Ohio University Press, 2016.

Robertson, Charles. *American Louvre: A History of the Renwick Gallery*. Washington, D.C: Smithsonian American Art Museum, 2015.

Saul, John A. "Sketch of Nurseries in the District of Columbia." *Records of the Columbia Historical Society* 10 (1907): 38–62.

Schipper, Ross, and Dwane Starlin. *Burleith*. Charleston, SC: Arcadia Publishing, 2017.

Scisco, Louis D. Research Collection, 1924–1955 (MS 0259). Historical Society of Washington, D.C.

Scott, Pamela. "Brentwood," unpublished research paper in the author's possession.

Shoemaker, Louis P. "Historic Rock Creek," *Records of the Columbia Historical Society* 12 (1909): 38–52.

Smith, Kathryn Schneider. *Port Town to Urban Neighborhood: The Georgetown Waterfront of Washington, D.C., 1880–1920*. Washington, DC: Center for Washington Area Studies, George Washington University, 1989.

Smith, Kathryn Schneider, ed. *Washington at Home: An Illustrated History of Neighborhoods in the Nation's Capital*. 2nd ed. Baltimore, MD: Johns Hopkins University Press, 2010.

Smith, Margaret Bayard. *First Forty Years of Washington Society*. New York: Charles Scribner's Sons, 1906.

Spicer, William Arnold. *History of the Ninth and Tenth Regiments Rhode Island Volunteers.* Providence, RI: Snow & Farnham, Printers, 1892.

Stewart, Alice Fales. *The Palisades of the Washington, D.C.* Charleston, SC: Arcadia Publishing, 2005.

Swerdloff, David. *Crestwood: 300 Acres, 300 Years.* Washington, D.C.: Humanities Council of Washington, D.C., 2013.

Torrey, Babara Boyle, and Clara Myrick Green. "Free Black People of Washington County, D.C.: George Pointer and His Descendants." *Washington History* 28, no. 1 (Spring 2016): 17–31.

Townsend, George Alfred. *Washington, Outside and Inside: A Picture and a Narrative.* Chicago: James Betts & Company, 1874.

Van Horne, John C., ed. *The Correspondence and Miscellaneous Papers of Benjamin Henry Latrobe.* Vol. 3, *1811–1820.* New Haven, CT: Yale University Press, 1988.

Warden, D.B. *A Chorographical and Statistical Description of the District of Columbia, the Seat of the General Government of the United States.* Paris: Smith Printers, Rue Montmorency, 1816.

Williams, Garnet P. "Washington, D.C.'s Vanishing Springs and Waterways," Geological Survey Circular 752, U. S. Department of the Interior, no date.

"The Writings of George Washington Relating to the National Capital." *Records of the Columbia Historical Society* 17 (1914): 3–232.

INDEX

Y

About the Author

Kim Prothro Williams is an architectural historian with the D.C. Historic Preservation Office. For more than twenty-five years, she has been researching and writing about historic buildings and communities in D.C., Virginia and Maryland, with her primary focus being to evaluate buildings for listing in the National Register of Historic Places. Kim has been involved in the study and documentation of a range of individual buildings and building types, of many neighborhood and institutional historic districts and thematic-based properties. Kim has a particular interest in the planning history, the evolution of place and vernacular building types, both urban and rural. To that end, Kim has, in recent years, undertaken efforts to identify D.C.'s historic alleyways and alley buildings, rural buildings and other outliers that have survived the transformation of their environment.

Kim is a published author of books, articles and heritage trail brochures dealing with the built environment. Two of her books, *Chevy Chase: A Home Suburb for the Nation's Capital* and *Pride of Place: Rural Residences of Fauquier County, Virginia*, address the transformation of the agricultural landscape.

Visit us at
www.historypress.net